Sacred Art

What a gift Imelda Almqvist's work is for our global community! Rarely have I met someone with such a spiritual and creative force. Imelda has truly studied through research and her spiritual practices, the deeper ceremonies that shamans have performed for tens of thousands of years. Shamans and shamanic cultures share the mysteries of the universe through their art. Imelda has brought the power of Sacred Art alive so we can once again inspirit our lives, our living spaces, and our community. *Sacred Art* is a remarkable book filled with a wealth of insights and stories that will inspire you to step into the magical world of art and craft.

Sandra Ingerman, author of *Soul Retrieval* and *Medicine for the Earth*

Throughout history, we humans have made sense of the world through art and symbols that transcend the linear thinking and entrapment in language of a world restricted by beliefs and the current perceptions of our culture. Art liberates the soul and responds to the questions that can't be answered or asked in the ineffable world that defies description. In her latest book, *Sacred Art*, Imelda shows how any one of us can access the sacred world of the soul by becoming a hollow vessel for spirit to authentically and artistically express itself through us. Performing the practices in this book will turn your life into an artistic expression of your soul's longing!

Michael Stone, teacher, writer, shamanic practitioner and host and producer of KVMR's Conversations and the Shift Network's Shamanism Global Summit, www.WellofLight.com

When you meet teachers so full of knowledge usually they are dead, so you can only read their books! When you can work with someone like Imelda in person, you should grab the opportunity!
Katharine Lucy Haworth, UK

The title of this book brings the heart into the throat, because yes – didn't art begin this way? And if so, is it too late? Can we find a way forward by returning to a place where 'Art' is deliberately carried out within a larger framework of sacred and spiritual practices that gently guide each person along a path to the best possible life? Author Imelda Almqvist takes you through a set of personal intuitive decisions that accumulated of their own accord until she realized that she has never been painting or teaching a branch of modern art, but crafting 'a Mystery school experience' for students from all over the world.
Anita Sullivan, poet, US

This book is timely. Creativity as Sacred Art is medicine as old as mankind. It is much needed now. The world as we know it is spiralling out of control. As old structures disintegrate and make way for something new, we are called to reach for the tools our ancestors knew to help us steady our balance and walk with grace into the landscape of the unknown. Imelda delivers both the tools and the manual for the journey. Drawing on her gifts, talents and experiences as woman, mother, artist and shamanic practitioner she reveals what had long been forgotten, hidden with purpose or negated by agents of logic. Allow this book to be a portal. Listen to the gods between the lines. See worlds open up with each page. And thus you will remember yourself.
Judith Bogner, Broadcaster, Journalist, Actress, Shamanic Practitioner, Germany

Imelda Almqvist has given us an excellent and timely reminder that the heart of artistic creation is none other than the heart of

any fully-dimensioned life: Reverence.

Todd Wiggins, author of *Zeitgeist*, *Father* and Professor of English, Paris

Imelda Almqvist has created a unique and valuable resource in *Sacred Art: A Hollow Bone for Spirit*. She takes the reader on a worldwide journey across the ages, through sacred art as an expression of the human spirit and of our relationship with the rest of the cosmos. But more than that, she engages the reader in their own process, leading them through activities in every chapter that deepen the understanding of both the creation of sacred art and the spiritual connection that creation provides. This is a profoundly valuable experience, both in the knowing and in the doing, an aspect of life that is often lacking in the modern world, our own personal Mystery School. This book fills that void, offering us all a way to reconnect with our deeper selves and with the universe itself. In the end, then, we receive the greatest gift of all: a way to reconnect with each other.

Laura Perry, author and artist. You can find Laura's books, Tarot deck, and more at lauraperryauthor.com

Imelda Almqvist's generous writing achieves a magical harmony between teaching and empowering. Her personal background anchors ideas of the numinous and other-worldly in the familiar, and she wears her considerable experience as both a shaman and painter with a lightness and kindness that is inspiring. The words 'sacred' and 'art' can be contentious enough when handled separately, so, to have been guided so assuredly makes this a book to read and return to.

Keone, visionary artist poet, author of *The Parable of His-Story*, co-curator of Sacred Art, Aberglasney

Imelda is a prolific and superb artist of the highest order! She teaches courses in the fertile space where shamanism meets art.

The heart of Creation is also the heart of the creative process. The union of the ancient art of shamanism and sacred art brings essential healing and renewal to our planet. Imelda addresses all these dimensions in her courses and in this new book. I would read anything Imelda writes. Her research is impeccable!
Dory Cote, shamanic practitioner and teacher, The Center for Earth Light Healing, Brunswick, ME, USA

Imelda's latest work embodies sacred art, not only embracing its importance historically, but sharing the wisdom of art as it supports our evolution throughout time. She reminds us that art has assisted us in our growth and healing, through the sharing of our stories and visions. She speaks not only from the perspective of a brilliant artist and art historian in her own right, but as a shamanic practitioner, who recognises the healing that occurs as we express ourselves creatively. This book empowers us as we explore the precious and limitless potential that each of us possess, that can be illustrated through the sacred life that we create.
Dr. Janet Elizabeth Gale Msc.D, Shamanic Practitioner and Teacher, Founder of Sulis Healing (www.sulishealing.com) and author of *The Rush Hour Shaman: Shamanic Practices for Urban Living*

In this unique and illuminating work, Imelda thoroughly demonstrates how an understanding of shamanism may change the face of art history. The reader is treated to a magical mystical journey that walks him /her into multiple layers of human life to support this notion. The book explores history, myth, world cultures, spiritual practices gender and cosmology to illuminate how interaction with shamanism and engaging with the process of making spirit-led art may shift the Western view on art.

What I particularly love about this work is the practical application in each section of its development. This book is a

must-read for anyone wishing to validate and express their soul through the shamanic ritual of Sacred Art.

Sassona (Sony) Baron MA, MA, RCC, Psychotherapist, shamanic practitioner, family constellation facilitator

Paintings are spirits like songs are. We step up, change state and invite relationship with the beauty and movement that the sound and images gift us. There are pieces of art Imelda created that participate in my healing practice. I recall seeing them for the first time some years ago thinking 'Oh there You are, wondered when I would find You!'. These beloved helpers are stored away from everyday activity and emerge only in preparation for shamanic work; once set out, they change the feel of the room, ignite the visceral senses in the physical and I find I am bolstered for the work to come.

Jill Hunter, shamanic practitioner, London UK

Imelda has a rare gift of communing and co-creating with the Spirit world in the most authentic and creative way which empowers and heals those who come in contact with her teachings and her sacred work. As a truly gifted shamanic teacher and healer, Imelda has now created an extraordinary book that records her deep knowledge of ancient wisdom brought to life by her sacred art. We are very fortunate to have Imelda bringing this sacred body of work to us!

Jacqueline Teoh, Shamanic Practitioner and Teacher, Singapore

Imelda is one of the geniuses of our time ... Her talents are best described as: artful healer, wisdom-keeper and teacher.

This book takes the reader on to exploring the sacred ways of the shaman through art and its magnificent passageways of hollow bones, egoless tales and masterful mind-bending ways of walking with her, into the realms of the alchemist process ...

Using art as the way to transport oneself from ordinary to

extraordinary!

Terry Morgan, astrologer, healer, shamanic practitioner and teacher, US

Imelda is a gifted artist, as well as being a brilliant writer. Her words and her art take you into the magical place that is Sacred Art. This book is a must for anyone who feels a connection to their own creativity. Making art can be a very sacred and enlightening experience. Imelda shares her rich perspective on allowing the creative process to come through the artist's heart, guided by spirit.

Art has the potential to heal, this book shines the light on how that healing is universal. Through her words, she is able to weave a beautiful picture of the history of art and its connections to our ancestors as well as contemporary times.

Alec Davis, teacher, artist, and shamanic practitioner, Present Journeys, Seattle, Washington

Sacred Art

A Hollow Bone for Spirit:
Where Art Meets Shamanism
(Art as Mystery School process)

Sacred Art

A Hollow Bone for Spirit:
Where Art Meets Shamanism
(Art as Mystery School process)

Imelda Almqvist

MOON
BOOKS

Winchester, UK
Washington, USA

JOHN HUNT PUBLISHING

First published by Moon Books, 2019
Moon Books is an imprint of John Hunt Publishing Ltd., No. 3 East Street, Alresford
Hampshire SO24 9EE, UK
office1@jhpbooks.net
www.johnhuntpublishing.com
www.moon-books.net

For distributor details and how to order please visit the 'Ordering' section on our website.

Design: Stuart Davies

UK: Printed and bound by CPI Group (UK) Ltd, Croydon, CR0 4YY
US: Printed and bound by Thomson-Shore, 7300 West Joy Road, Dexter, MI 48130

Also by Imelda Almqvist

Natural Born Shamans - A Spiritual Toolkit for Life

We operate a distinctive and ethical publishing philosophy in
all areas of our business, from our global network of authors to
production and worldwide distribution.

Contents

About the Author

Imelda Almqvist is an international teacher of shamanism and sacred art. Her book *Natural Born Shamans: A Spiritual Toolkit for Life (Using shamanism creatively with young people of all ages)* was published by Moon Books in 2016.

Imelda was a presenter on the Shamanism Global Summit in 2016 and 2017 as well as on Year of Ceremony with Sounds True in 2018. She divides her time between the UK, Sweden and the US. This is her second book.

Cover Painting

I made the painting for the cover of this book to reflect the energetic blueprint of this book and its key message. The title is Hollow Bone. It shows the Sacred Feminine and Sacred Masculine as complementary forces cradling and nourishing all of Creation between them. Their fish tails symbolise the swimming and creative flow between all worlds. In the sacred space enclosed by God and Goddess, Father/Mother God we see the worlds and the journey of human consciousness, represented by two human beings climbing the Tree of Life. In this painting, Death and Rebirth have their place as do Light and Shadow. We have Free Will, however, we are always held and guided through our hollow bone to Spirit.

I dedicate this book to my three beautiful sons who created along with me as soon as they could hold a felt tip and make sandcastles. To my husband who never draws anything but is a master of project management and a stable loving force in my life. To my deceased father who dutifully drove the 17-year-old me to interviews at art schools in Amsterdam (even though he never understood why anyone would want to paint!). To my mother who modelled the template of running a school in your own living room so the working mother is never too far away from her children! Last but not least, to all artists on all continents (living or dead, well known or long-forgotten) who made or make sacred art, no matter what cultural trade winds are (or were) blowing.

Acknowledgements

I would like to thank all the people who have attended my courses in a variety of locations for their commitment to this work and for the artwork, process and insights so generously shared with me. A school without students is only a dream, not a reality! Without students, I would not be a teacher and I could not have learned even one per cent of what I share in this book by locking myself in my studio and enjoying creative solitude!

I especially thank Susan Rossi for writing the Foreword and for the 'hare-brained' idea of bringing this work across the Atlantic to the US. Hare is a very ancient and very powerful animal in the mythology of Old Pagan Europe, Susan!

I thank my sacred art students who took time to write the second part of the Foreword together, which we renamed Forward. You are my community, my sacred art network and I know you will embark on many visionary sacred art projects that will put me in the shade (where any teacher belongs sooner or later)!

Special thanks to Sandra Ingerman who accepted my invitation to write one page as a painter (most people of course know her as an author and master shamanic teacher)!

Anita Sullivan, for reading the manuscript with the precision only a poet masters, and making valuable suggestions for small additions to the text.

Lucya Starza for editing my first book (*Natural Born Shamans: A Spiritual Toolkit for Life*) and for the brilliant suggestion of including an activity for every chapter of this book!

Nimue Brown, for being a top-notch publicist and stalwart supporter of budding authors!

Last, but not least, I express gratitude to my own teachers at art school in Amsterdam, on the art therapy course in the UK, and of course all my teachers of shamanism. Until I wrote this

book I did not realise quite how much I have learned about art from my own teachers, especially those who taught my much younger (read *Before Motherhood*) self!

Frog Singing the World into Creation

By Sandra Ingerman

For thousands of years shamans and spiritual teachers have been teaching about the importance of bringing the sacred into every minute of our life. By doing this we are reshaped; we learn how to flow with the changes of life as well as the natural processes of death and rebirth and the power of the shadow and light.

For me, painting brings the sacred into my life, but also my living space. I paint like a five-year-old, but our house is filled with only my paintings. I don't have the skill to bridge what I see in my mind to paint a beautiful being in nature or the sunrise or sunset. But I choose colours that produce joy in my soul. I love the energies and frequencies that emerge from the different colours I choose. Every single one of my paintings tells a shaman story. I paint stories like 'Frog singing the world into creation' where Frog's musical notes appear there are trees and a beautiful landscape. Where the frog has not sung, the images are grey. The energy of this painting was spirit led and is stunning, exquisite, and puts a smile on the face of everyone who sees it.

When I go to get my paintings framed I am always asked if my child painted this. Well I have no children, but my inner child, who only remembers the beauty of life, did.

As Imelda Almqvist shares in her stellar book *Sacred Art*, we can bless ourselves and all of life through our art.

I am a spinner. I spin fibre into yarn. As I spin, I sing mantras about love, light, healing, and peace. And then I crochet blankets, scarfs, little squares I put around my house where the magic of spirit fills up every space. Imagine sleeping under a blanket made in love and holy space!

Everyone can produce sacred art. We just have to open up and let ourselves be inspired by what our soul wishes to share

1

energetically, whether this be the power of creation stories, prayers for peace or swimming in dark waters and being lost until we come out into the light. Sacred art helps to shine a light on the next step of our path; it also reminds us that life is precious and a gift. Whether images created are metaphorical or literal, they stir a deep knowing about the sacredness of life in our heart and in our soul. And as Imelda shares, we then learn that our sacred art is also how we sculpt our life.

Sandra Ingerman

Sandra Ingerman is a ceremonial painter and spinner in Santa Fe, New Mexico

Foreword

by Susan Rossi

Who interprets the divinity inherent in nature for us today?
Who are our shamans? Who interprets unseen things for us?
(Bill Moyers)

It is the function of the artist to do this. The artist is the one
who communicates myth for today
(Joseph Campbell)

I first encountered Imelda Almqvist as a member of Sandra
Ingerman's online global community of shamanic teachers; both
Imelda and I are members. Her posts revealed unique ways of
approaching teaching, shamanism, world issues and almost
any topic brought to the forum. She wrote with enthusiasm and
heart and I save many of her posts as resources to use to spur
my own work in different directions. I also subscribed to her art
and shamanism newsletter, which is where this 'hare-brained
tale' really begins.

In the summer of 2015, her newsletter offered information
about an upcoming course she was co-teaching in Andalucia,
Spain called 'Gnosis of the Land'. My curiosity was piqued:
working with ancient rock art, energetic 'dragon' lines in the
land, ritual to restore the land to harmony and to experience
'direct knowledge of the divine'. I sent an email inquiring for
further details and after reading it, realized that this trip would
be beyond my means at that time. I emailed Imelda explaining
this and said that if she were ever on the East Coast in the US, I
would love the opportunity to meet her and discuss her work.
She replied, hoping I am sure to send me on my way, providing
a video of the work done in the Rock Art Sacred Art workshops

3

over several years prior. The video achieved the opposite effect, serving to make me besotted (as Imelda likes to say) about this work. It took me into a state of altered consciousness or 'altared' (sacred) space, to a place not in rational, ordinary reality – a place beyond the mind – to soul space. I watched the video several times, weeping at its beauty and the power of how the music, images and Imelda's words wove a deep opening into the mysteries of life, death, creation and destruction and the human role in restoration and regeneration. The music was evocative of Hildegard of Bingen's *viriditas,* the green fire of Life that pulses and flows through everything. The pulsing Spirit living in this video wove me into its alchemical web and would not let me go. (Watch for yourself and see whether you find it to be so: Youtube: Gnosis of the Land by Imelda Almqvist https://www.youtube. com/watch?v=wz9n5SwcjsI) This work had *Genius*, in the Roman sense of being infused with the presence of the Divine.

I was firmly woven in about halfway through the video where Imelda stated: 'Portals are keyholes that unlock sacred mystery.' As a shamanic artist, I had been working with canvas as a portal that opened to what wanted to come through and be seen on its surface. I would write words inviting power, healing, grace, ancestors, whatever arose for me as the reason for painting on the blank canvas before beginning a painting, sometimes using the canvas as a drum to invite Spirit to 'land' there. So I already knew about the portal as keyhole, but I had never seen or heard it so eloquently and beautifully presented. She had me and there was simply no going back! I wanted to know how she worked with the *Genius* of Sacred Art as she taught and practised it. I wanted to learn about art as shamanism in the way that she practised it.

I invited Imelda to present her Sacred Art Practitioner work in the US and offered to sponsor it and handle all the back office work of making arrangements for space and housing, writing and sending promotional pieces and all of the Ordinary Reality

pieces of manifesting the work here. After careful assessment of me for mental stability, and many times asking if I was *sure* I wanted to take this on she agreed and wrote a course syllabus. I surely wanted to work with this woman, so I followed the White Rabbit down the Rabbit Hole (learning only later that Imelda's home in London, UK is called Rabbit Hill).

Inviting Spirit into the creation of this work for the US throughout 2015 revealed the specific nature of the restoration and regeneration of what was needed. There would be no simple transfer of the European curriculum into an American version. As the US class took form, it morphed from the UK version to reflect the gnosis of the land in Pennsylvania where it was to take place. Imelda's Spirit-led visioning showed her that the healing of the ancient rifts between colonizers and colonized peoples and between colonizers and the Earth required restoration of harmony between the Sacred Masculine and the Sacred Feminine – the rebalancing of the Out of Balance Warrior God. A group of prospective students co-dreamed with us into the field of Sacred Marriage, the Hieros Gamos and the rebirth of the Child of Light. As we began to weave the strands of US Sacred Art Practice into being, we were shown in greater and greater relief where and why this work was needed. We did not imagine back in 2015 that we would have seen the Dakota pipeline controversy centring on land and water rights and protection or the current flood of revelations regarding sexual harassment and sexual 'power-over' in the workplace, to name a just a few. We also did not realize how our work of invoking the Sacred Marriage would be reflected back to us from the heavens with Mars and Venus, the great cosmic Masculine and Feminine, appearing together in the crystal January 2016 night sky, on the opening nights of our first class session. As the class circle has started to say, 'You cannot make this stuff up.' As an astrologer I felt in my bones on those nights the truth of Thomas Berry's statement *'we discover ourselves in the universe and the universe discovers itself in*

us' (Thomas Berry, *The Sacred Universe*).

On an individual level, participants in the Sacred Artist work experienced *gnosis* in revelatory ways. One student *saw* her own beauty in a mirroring process for the first time ever and truly fell in love with herself. Another drew icons of the fiery Sun on her arm to heal facial burns and avoided permanent scarring. In dreaming work with archetypal gods and goddesses, others saw obstacles they created for themselves and how to dissolve them. When we step outside of the boundaries of ordinary time and space and allow Cosmic Consciousness – Spirit – to move into and through us we become portals open to Sacred Mystery, to infinite potential possibility. The first time I painted using the canvas as a portal, I experience a healing of my relationship with my grandmother and lineage issues on that entire side of the family. I did not know this would happen when I started that painting, but I wrote the words 'heal my fear' on the canvas and drummed on it, and that healing is what happened. The end result of the work holds power, but it is the process we go through to get to that end result – the creative work that we do – that brings us to that point. And the end result – the song, the painting, the dance, the ritual that we created – mirrors back to us that power that we called in.

Sandra Ingerman, a brilliant shaman and teacher with whom both Imelda and I have had the privilege to study said, 'Shamanic art does not represent power. It IS power.' We change ourselves and the energetic patterns of which we are part when we invite the energy of Life – of Creation – to move through us andwe open to what will happen. We become the portal and the canvas. The painting, the dance, the music, the ritual we are creating will tend us; will tell us what wants to happen next. And we will see this new story reflected back in the world outside us. We become the hollow bone, Creator's paintbrush and instrument. In the piece preceding this foreword, you have read Sandra's words about re-membering the world through creativity. You

will have felt the joyous energy of her creative process imbued in those words flowing from the page to you, besotting you to open your own portals of creative exploration.

Sacred Art – A Hollow Bone for Spirit: Where Art Meets Shamanism will take you into 'altared' consciousness. Imelda is a shaman-artist with resources such as I have not encountered anywhere else. In this book, she offers you processes to work as Sacred Artist and invites you to dance with the power of creativity in your own unique way. She called my invitation to her to bring this work to the US 'hare-brained'. I thought that was simply funny until she shared with me the rich history of Hare energy in many cultures, full of transformational Trickster energy, fertility and creativity. Follow her down the Rabbit Hole in a journey to your own creative source and personal mythos and bring it into form with your unique creative power.

Susan Rossi, Sunday 17 December 2017, Haddonfield, US
Susan Rossi is a shamanic teacher, artist and astrologer. Her website is https://flyingtotheheart.com/

This Foreword is followed by the Forward written by participants in my sacred art practitioner programmes
When I sent out an email requesting contributions from people who participated in my sacred art practitioners programmes who wished to write one, several people replied calling this the 'Forward' rather than Foreword. Something had come to attention and indeed teaching is all about moving the work forward and paying the gifts we receive forward!

Forward

Tina Smith

Art touches all of us, everyone, all ages, all walks of life. Sacred Art touches us too. It touches our souls and moves us in ways we didn't even know were possible. It soothes and comforts. It heals. It questions and it answers. It definitely takes on a life of its own.

What is Sacred Art? I wasn't even sure until I took Imelda's class. Now it's all I want to do! I want to teach others and help them perform their own sacred art.

Imelda is a passionate and creative teacher with a versatile background and imaginative style. She is truly a gift to the world and I thank my lucky stars to have had the opportunity to take her 'Sacred Art Teacher Training' class.

Imelda's first book, *Natural Born Shamans*, has been incredibly useful to me for helping my young grandsons find their artistic expression. I only wish I had this kind of encouragement and practical guidance when my kids were young. But one thing I learned in Imelda's class is that healing affects the present and the past as well as the future. Helping my grandsons will make them better world citizens in the future but will also help my daughter be a better parent now (and me a better grandparent now). And I believe this is healing our lineage. Past sins are forgiven and healing happens.

Imelda's teachings also help my son with special needs to express himself more fully. She really encourages people of all abilities to draw, paint, dance, sing, wiggle, whatever, to articulate their own sacred journey!

Thank you, Imelda, for all your teaching and all the lessons yet to come.

Tina Smith, Levittown, PA, US

Sarah Rehfuss Bastian

I have been creating art for most of my life whether through writing, music or various other mediums, but my remarkable journey with sacred art began in October 2016 during a Compassionate Spirit Release workshop. While in a journey I was greeted by a woman named Ariadne who told me to 'follow the red thread' which led into a darkened underground labyrinth. When I came back from the journey I realized that I needed to 'follow the red thread' somewhere in my life, but had no idea where. At the end of the workshop, one of the presenters announced an upcoming two-year course in sacred art that called to me briefly, but was soon forgotten. Over the next two months, I continued to see postings about the Sacred Art workshop, but didn't really tune in until I noticed that the first module was working with the Lady of the Labyrinth. All of a sudden it made sense and I knew that Ariadne, known in ancient Crete as the Lady of the Labyrinth, had been guiding me towards sacred art, an ancient method for transformation.

I have found that sacred art is not only a creative process but also a healing and growth process which has provided me with the opportunity to surrender parts of myself that no longer resonate with who I am. Each piece of art that I have undertaken, with the help of my allies, has held an important teaching for me and has been another step in the process of creating and reinventing myself in the world more authentically. Not only have I been able to experience my own transformational process but also I have been blessed to witness the power of sacred art in a group. In a recent training circle, I experienced a brief moment as an observer to a multi-level healing process that was taking place. I understood from that experience that our lives are microcosms of the larger global macrocosm. Our personal journeys mirror the group journey, which in turn reflects the global journey. In that moment, the suffering and healing potential that I witnessed felt not only individual, but also global. It was at that moment

when I recognised that the valuable possibilities offered through the process of sacred art not only provide an opportunity for personal healing and growth, but also global transformation.

Sarah Rehfuss Bastian, MS, Systemic Constellation Facilitator, www.awakenedheartandmind.com

Donna M. Merrill

When I first learned about Sacred Art, I thought this sounds brilliant but I'm not creative or artistic! What I have learned by studying with Imelda for a short time is that it is not the actual 'art' you produce that matters but rather the portal it opens within to access the sacred in you and the universe. The process being more important than the product or technique completely freed me to drop into the space where creation happened – that sacred portal where connection is the goal. I have been deeply touched by your work and it has stretched my vision of myself as a creative being completely. Thank you.

Donna M. Merrill, US

Helena Partridge

I learnt from Imelda to see and open to the sacred in ways I couldn't before. For example, I used to feel dejected as a teenager because I would look at the hills and trees I loved so much, but feel them remote and indifferent. I felt somehow adrift because of this, dispossessed. I know now that it was just my modern brain getting in the way. I learnt practices from Imelda that restored to me the visceral experience of the aliveness of the non-human world and my connection with it.

When I create from this place of communion, something new happens. I painted a 'Memory Tree' on a wall at my mother's care home recently to display photographs of the residents during their younger days. I felt quite nervous, as I had never painted a mural before. But as I began to paint, I experienced a wave of connection with Oak Tree roll into the place of my fear. I sensed

myself rooted in the earth with Oak Tree, and one with her as we reached upwards with generous sheltering arms, sprouting so many coronas of life-giving leaves. I felt as though I was co-operating with the spirit of Oak Tree in an act of love for the residents of the care home. When I stepped back, I saw that Oak Tree was alive on the wall. I couldn't have made this happen on my own. I know I was able to allow it because of experiences like learning how to sense and receive Monkey Puzzle Tree in Imelda's garden, and channelling Rowan in a conversation between the trees.

I have wanted to connect with the sacred through what I make for years. I also wanted to express that in a simple but heartfelt way, to uplift and nurture others. I had no idea how to do this. I still have my outsized and wilful ego to contend with, but I am so grateful that the SAP Training gave me the foundation I needed in order to begin.

Helena Partridge, UK

Marie Lloyd

This is a much needed book. For those of us who think we can't draw, can't paint and for whom 'being creative' belongs to a certain type of person, this is the book! Sacred Art is the birth right of everyone walking the planet. The simple yet radical act of making a piece of art in honour of the divine or your spirit kin is potent soul medicine. Our ancestors knew the power and healing of bringing form to the formless, shape to spirit and the transformations we create when we co-create hand in hand with spirit. For those of you trembling on the threshold of this partnership in art, however that may manifest itself to you I salute you. Take off the mask of ego and brave your right to 'get it wrong' knowing that there is no wrong. There is only a process. There is only a journey; both of which offer to you a way to become holy and indeed wholly yourself. Making Sacred Art will pour such joy and magic into your veins that you will truly

wonder at the love, depth and endless possibilities so generously offered to you from behind the Trembling Veil. Be inspired by ancient teachings here and let them drum remembering back into a body and soul that hear the old rhythms of the ones that knew how to truly worship and how to truly heal.

Marie Lloyd, Pazh of Pollen Practitioner, London, UK

Gail Walker

Using Sacred Art to access spiritual teachings allows me to bypass my ordinary ways of thinking and knowing in two key ways.

First, the mythic layer of my imagination is evoked when Imelda shares her extensive and multicultural knowledge of myth, ritual and ceremony. I gain access to images and movements utterly new to my consciousness.

Second, the work of turning those contents, the images and movements, into form, anchors and embodies this material into my psyche. Turning sacred inspiration into sacred form allows me to be more congruent with the wisdom that has been revealed. Both receiving new knowledge and acting with that knowledge are necessary in the creation of Sacred Art.

Thus, multiple circuits are engaged. I am changed both by the inspirations/revelations themselves and by embodying and then emanating those changes in my daily living.

Gail Walker, LPC, BC-DMT

Katherine Wood

Before our US Sacred Art Practitioner group assembled for the first time, I was guided in a journey to make a rattle for each person in our circle. I constructed these rattles from the same elk skin, an elk who was thrilled to continue living in the form of sacred tools for our SAP community. I asked the World Tree to provide a staff for each rattle and journeyed for the symbols to paint for each person.

I gifted Imelda and Susan with their rattles at the first gathering and then paid close attention as I got to know each participant through which rattle was hers. I then mailed these surprise gifts out to each in preparation for our second gathering.

At our first rattle reunion, the rattles gathered together in the centre of our circle when we weren't working with them. It was very special to see them together and to rattle them together, but naturally, there is always something bigger at play. By the end of our second circle, I became aware that these rattles were their own energetic entities. No longer tools, they had become individual and collective members of our circle in their own right. The elk, the World Tree, and the symbols now dance with us into even greater possibilities.

Katherine Wood, Vibrant Tree Ministry, Northglenn C, US

Jane Moynihan

True creativity, like a pulsing red ochre, runs through the artery of all human hearts and connects us deeply with the sacredness of life. It saddens me when I hear people say they are not creative. We live in a time where art is either relegated to the hobby corner or elevated to the exclusive club for the 'talented few', and reduced to an hour on the educational curriculum.

Imelda shows us creativity is a universal birth right. This book asks us to broaden our view of Sacred Art, from simply a form of religious expression, to a way of seeking new knowledge about ourselves and the world with the capacity to transform, heal and move us.

It is with such gratitude that I was able to train with Imelda as a Sacred Art Practitioner. Her teaching completely changed my approach to art and was a profoundly transformative experience personally. It helped me to rekindle trust in my imagination, to fearlessly dive deep into those rich inner worlds, and have the courage to bring something back to share. Children do this naturally when they give you a drawing. At the end of the

training, and with childlike wonder, I found myself involved in an exhibition, and took an important step putting my artwork and writing online. It is a great joy for me to retrace that original journey in this book, and I wholeheartedly recommend this to everyone interested in living more creatively. Imelda offers plenty of exercises and tips on how to access your own palette of colours and begin really being creator of your own life.

Jane Moynihan, London, UK, https://stoneandstar.weebly.com

Susan Bakaley Marshall

Sacred art surrounds us. It is inside us as we create our lives, express ourselves in a blessing way with kindness to others; it's in the melding of our creativity and expression that manifests as images in art, writing, or music; it's in our hearts as we love the beauty of our world. Sacred art comes from the soul – our individual spirit place – and from the collective consciousness of humanity and all sentient beings.

As a teacher and mentor, Imelda powerfully guides us into shamanic experience – going deep within our visions, working with our dreams, being in touch with spirit, creating webs of connection. With her help, we draw upon these wells of inspiration and manifest them into the world as sacred art. Our creative work feeds the heart of the world.

Susan Bakaley Marshall, MPS, ATR, 'ART from the heART', www. thirteenthmooncenter.net

Olivia Woodhouse

In 1997, the Young British Artists (YBAs) were powerful. Even the newly elected Prime Minister Tony Blair wanted, by association, some of their cool and charisma. PR and the age of the celebrity had just begun. Along with thousands of other people, I visited Sensation, the YBA's exhibition put on by the publicist Charles Saatchi. Flipping through the catalogue, I noticed there was a full-page photograph of each artist. This was given equal status

to the work produced. As a recently graduated Art History student, I noticed this because it was unfamiliar. This was so far from the medieval artists and craftsmen, often anonymous, who were my heroes from the age of 16.

Since I was a teenager, I have been exploring spirituality, psychology, art and the places where the three meet and overlap. At times, I have felt out of step with the dominant culture that I live in. Finding Imelda's course was like finding an oasis in a desert. Through Imelda's teachings, I have been shown ways to combine my shamanic and art practices. I have discovered how to enter a dreaming space where the soul may speak and to manifest something from there. This space is so much bigger than me that I am usually surprised to see what comes down and through my hands. At times, it can feel that what is produced is not of my choosing or doing. I have discovered that sacred art making is a way to imbue an object with power and create a direct connection to Spirit. It can also be a form of meditation, a transformer of energy, a healing method, a soul retriever of people, histories and landscapes and a way to psychopomp.

On the last component of the SAP training, I experienced bereavement. I took two months off to make sacred art and sink into the grief. When I look back at that time I see that many tears were shed and objects made that held, dissolved some of the pain and cut cords. But there was also something else. I discovered thanks for what I had learnt on the SAP training; that strong life experiences provide energy that can be harnessed and transmuted through sacred art. I used that power to fuel my art practice. I made gifts for other people including the unborn soul I had miscarried. I also found a great deal of fun and humour that wanted to be woven into the work I was making. This became important in helping me step into and be with the grief. I notice that the art from that time shines because something so much bigger than myself is present. The gifts had a quiet but unmistakable impact on the receiver.

I am so grateful to Imelda for showing me how I might facilitate healing in myself and others. It is very satisfying and brings me closer to my teenage art heroes. Thank you Imelda for being a beacon (or Inuksuk?!) and showing the way.

Olivia Woodhouse, www.wildwoodhealingarts.com, UK

Azul Arco Iris

Imelda's work occurs in the balance somewhere between a very practical and knowledgeable account of the sacred practices of our globe and the mysterious, rhythmic calling into the deep, obscured, and synchronistic majesty of what we call Life.

The way she puts into practical use the wisdom of diverse and varied ancient cultures creates an incredibly grounded framework and context within which to let one's spirit fly! Through the microscopic details she builds a foundation from which we envision a full and expanded (even limitless) view of the cosmos and possibilities for connection.

One becomes convinced of not only the importance of bringing the sacred into the mundane, but, more profoundly to acknowledge simply that the sacred is already in everything! She invites us to embrace this and work with this process to find deeper and more meaningful connections to our own personal journeys, as well as inspiring others to come together. We then see how connected we all already are ...

Azul Arco Iris, Marketing Specialist & Course Manager, The Shift Network; Co-creatrix, The Goddess Oasis

Mia Tolusic

I have worked with Imelda as an assistant in her two-year Shamanic Practitioner course which she teaches in London. Imelda is an amazingly gifted and knowledgeable teacher with an incredible and inspiring connection to Spirit. It is a true honour and blessing to work and learn from her. In the Soul Retrieval module, as originally created and taught by Sandra Ingerman,

students are asked to be shown and to draw the Sacred Image of their clients' soul. It is here that Imelda's many gifts and talents truly shine as she creates a powerful marriage of Sacred Art and Shamanism and takes us into the magical place of in-between. Being a witness to everyone's Art, seeing how both the making and receiving of a Sacred Image made everyone light up from inside and smile broadly on the outside put a big smile on my face too! A powerful and healing piece of work!

Mia Tolusic, shamanic practitioner,
www.behindtheveil-shamanism.com

Glossary

This page provides a glossary (or dictionary) for frequently used words and phrases taken from the following fields of study: shamanism, anthropology, psychology, psychiatry, rock art studies, linguistics, etymology and mysticism. For easy reference, I have listed the terms alphabetically.

Active Imagination

Jungian psychology places a heavy emphasis on dream interpretation and the contents of the unconscious mind. During the process of active imagination, Jungian analysts encourage clients to translate the contents of dreams without adding any analysis from the conscious mind. The goal of this process is to understand the workings of the unconscious mind.

Active imagination is intended to bring about a state of *hypnagogia*. This is the state in-between sleep and wakefulness, where people may be partially aware that they are dreaming. Jung argued that active imagination can be achieved naturally during intense states of relaxation such as when listening to a story or drifting off to sleep. (For beautiful examples of this way of working, I recommend the book: *Body and Soul: The Other Side of Illness* by Albert Kreinheder.)

Most shamanic work takes place in the same zone (often using drumming or music to bring on a mildly altered state of consciousness) and in the twenty-first century we see related fields such as *story medicine.*

Animism

The spiritual belief that objects, places and creatures all possess a distinct spiritual essence. Potentially, animism perceives all things – animals, plants, rocks, rivers, weather systems, human-made objects and even words and thoughts – as animated: living things!

Archetype

A word coined by C. G. Jung, who also called them primordial images. They are inborn tendencies that shape human behaviour. Myths and universal stories contain well-defined themes that appear in any age and everywhere. We often meet these themes too in the fantasies, dreams or illusions of persons alive today (ask any psychotherapist!). Some examples are mother figure, hero, trickster, king or queen, the fool, the double, the villain, the journey, the fall, the ordeal ... Archetypes constitute the structure of the Collective Unconscious, they are psychic innate dispositions to experience and represent basic human behaviour and situations.

Archetypal Medicine

This refers to a form of healing, actively working with archetypes and blueprints of human consciousness through symbolism and myth that starts in the spiritual realm and then spreads to the emotional and physical planes. C. G. Jung proposed that our 'forgotten gods' have become diseases in Western society: the warrior archetype represented by the god Mars starts wars in modern times, the god Pan seeds panic and the archetypal crab might just turn into actual cancers if the signs go unheeded. The gods are aspects of us. If we repress or forget them they will appear as destructive forces active in our lives. By giving them their place willingly and honouring them, they lead us back to health, balance and harmony (inside and outside ourselves).

Collective Unconscious

This can be thought of as a universal library or layer of human knowledge and experiences since the beginning of time itself. It cannot be learnt; it is innate in all human beings and often seeks expression through stories, mythology, art and symbolism. Today we might speak of a hologram rather than a library!

C. G. Jung stated that the religious experience needs linking to

the experience of the archetypes of the Collective Unconscious. This means that God/Goddess is lived as a psychic experience of the path that leads one to the realization of one's psychic wholeness (adapted from http://www.carl-jung.net).

Core Shamanism
(The following definition is from the website of the Foundation for Shamanic Studies founded by Michael Harner.)

Core Shamanism consists of the universal, near-universal, and common features of shamanism, together with journeys to other worlds, a distinguishing feature of shamanism. As originated, researched, and developed by Michael Harner, the principles of Core Shamanism are not bound to any specific cultural group or perspective. Since the West overwhelmingly lost its shamanic knowledge centuries ago due to religious oppression, the Foundation's programmes in Core Shamanism are particularly intended for Westerners to re-acquire access to their rightful spiritual heritage through quality workshops and training courses.

Training in Core Shamanism includes teaching students to alter their consciousness through classic shamanic non-drug techniques such as sonic driving, especially in the form of repetitive drumming, so that they can discover their own hidden spiritual resources, transform their lives, and learn how to help others.

Ego
Different disciplines tend to give a slightly different definition of Ego. In shamanism, we perceive it as the part of us that has our own most selfish interests at heart. It can dream large (even grandiose!) but *we cannot live without it*. One of my students once called it the Air Traffic Control Manager: it keeps us safe by guarding the needs of our everyday self while we are in a human body. The human ego adores attention and praise and

screams loudly when we ask it to step aside (so we can do spirit-led work). Shamanism teaches that Death is the death of the ego as much as the death of the human body – but never the death of the soul. There is a continuation of consciousness after death.

Existential Therapy

This is a philosophical method of therapy that operates on the belief that inner conflict within a person is due to that individual's confrontation with the four great givens of existence. As noted by Irvin D. Yalom, those are the inevitability of death, freedom and its attendant responsibility, existential isolation and finally meaningless. These four givens are referred to as the ultimate concerns and they compose the framework in which a therapist conceptualizes a client's issues to arrive at a treatment method.

Grace

According to the Merriam-Webster online dictionary, Grace is unmerited divine assistance or a state of sanctification bestowed by Divine powers. In my own words Grace relates to Divinity (powers greater than ourselves) completing an act that is almost beyond human capacity or bestowing blessing beyond comprehension once humans truly hollow out and connect back to source from a place beyond ego. I have observed Divine Grace in action in humbling yet mind-boggling ways on all courses I teach and ceremonies I lead.

Holy

Old English *halig*, 'holy', consecrated, sacred, godly, ecclesiastical. The primary (as in pre-Christian) meaning is not possible to determine but was probably 'that what must be preserved whole or intact, that cannot be transgressed or violated'. It is connected to the modern words healthy and whole (Adapted from www.etymonline.com).

'Mythology Therapy'

This is a phrase coined by me for the healing power of ceremonial work in sacred art processes that involve active engagement with beings from mythology all over the world. I just ran a search and discovered that there is an existing discipline called *Mythotherapy,* referring to a therapeutic method based on myth:

Mythotherapy is an interdisciplinary therapeutic method which uses myths and sacred texts and mythological findings for therapy; and at the same time uses psychology, cognitive sciences, cognitive behaviour therapy, anthropology, philosophy and ancient knowledge and wisdom for therapeutic intentions.

Numen (Latin)

Divinity, Divine presence or god. Also divine will. The classical Roman author Marcus Tullius Cicero (born c. 106 BCE) wrote of a 'divine mind' (*divina mens*), a god 'whose numen everything obeys' and a 'divine power' (*vim divinam*) 'which pervades the lives of men'.

The Numinous

The adjective numinous was coined by Rudolph Otto, one of the most influential thinkers in the field of religion in the first half of the twentieth century. It literally means 'of a god, possessing divine power'. Rather than focussing on comparing religions, as many great thinkers and theologians (?) before him did, he attempted to analyse the experience that lies at the very heart of any religion. He concluded that this experience has three components, often summed up in the Latin phrase mysterium tremendum et fascinans. As a mysterium, the numinous is 'wholly other' (*ganz andere,* in the original German), entirely different from any human experience in everyday life. It evokes a reaction of silence. The mysterium is also tremendum: it provokes terror and awe because it presents as overwhelming power. The numinous is said to be *fascinans*: our word fascinating

is related to this. In origin, the word relates to enchantment and the casting of spells! Ultimately, the numinous is merciful and gracious: it is potent and attractive despite fear or terror. (I recommend Otto's book *The Idea of the Holy – Das Heilige* in the original German – to all serious sacred art students.)

Religion

A religion is an organised cultural system of beliefs, behaviours, rules and practices that connect humanity to a greater or transcendental power. Please note that this is a 'home-grown'definition as scholars do not agree on what precisely constitutes a religion.

What I tell my art students is that it is derived from the Latin verb *religare* and that literally means 'binding back'. Re=back and, for example, our word ligament comes from the root stem *ligare*. It later came to mean obligation, bond or reverence as secondary meanings. The core meaning is binding human beings back to Divinity.

Religious Art

Religious art is inspired by religious teachings, concepts or motifs, generally made with an uplifting intention: it is hoped that contemplating religious artwork will focus people's minds on larger truths and spiritual priorities (as defined within the tradition concerned).

Sacrament

In the traditional Roman Catholic sense of the word, a sacrament is an outward sign or manifestation of an inner state of grace.

Grace is a gift from God, not from the priest or bishop (etc.). The priest is only a conduit for Divine blessings and energies. This is very similar to the way that a shaman (shamanic practitioner) is a hollow bone for spirit. The difference between the two is that shamanism does not impose authority figures between people

and their god(s). It places more emphasis on direct revelation and a personal relationship with the Divine.

Sacred Art

The core principle behind sacred art is that it is created to honour and express something beyond the realm of the everyday and the visible. It seeks to express the Divine and map the sacred. It is not concerned with the name or greater glory of the artist. (You may remember that medieval art does not carry the signature of the artist!) Sacred Art is art in service of powers and realms greater than ourselves. In contrast, Modern Art has become very conceptual and ego-led. It often shows a fragmented world where the figure of the artist is central.

Spirit

Spirit to me is Life Force in its purest sense. It is eternal and animates the cosmos. While on Earth, I am not so much a human body with an indwelling spirit as timeless spirit having a human experience so I can learn and evolve.

Spirituality

The word spirituality in modern usage could be said to refer to the deepest values and levels of meaning by which people live. It embraces the idea of an ultimate or immaterial (or absolute, eternal) reality.

In this book, I use the word in the meaning of commitment to a spiritual path and quest to find the essence of one's core being. This core is sometimes also referred to as the authentic self, true self or higher self (depending on the school of thought or author).

In this book, I will emphasize that the true commitment to a spiritual path brings the necessity to embrace the hardships and face the ordeals this path brings. Spirituality based on 'love and light' alone is ultimately dangerous because it ignores the shadow.

Soul

For me, our soul is the timeless and Divine part of us. It is what animates us (a body without soul is a corpse). The soul does not die when the body dies. My soul is the larger constellation Outside Time that holds all the blueprints and imprints of my journey through the Cosmos. I may have been many things: man, woman or animal and my soul holds the sum of them all, the hologram of my journey through the cosmos.

Story Medicine

The telling of stories is a crucial aspect of any healing process. After a shamanic healing session with a client, we tell them The Healing Story. Storytelling ignites the human imagination, it allows us to reframe events and discover the heroic aspects of our everyday lives. It can also provide fresh scripts and ideas, helping us break out of established ways of relating and perceiving the world.

Preface

Why a Book about Sacred Art?

To become human one must make room in oneself for the immensities of the universe.
(Teaching from the Native Indian Peoples of South America)

Spiritual processes are matters of life and death, and that is why the sacred is so often secret and taboo, protected from the criticism of the profane or secular eye.
(David Tacey, *Gods and Diseases*)

The whole secret of mysticism is this: that man can understand everything by the help of what he does not understand. The morbid logician seeks to make everything lucid, and succeeds in making everything mysterious. The mystic allows one thing to be mysterious, and everything else becomes lucid.
(G. K. Chesterton)

The power of sacred art

About five or six years ago, I was commissioned to make a painting for the mother of a friend. The friend's father had recently died and she wanted her mother to have a painting dedicated to her Dad, honouring his passing but also reminding her mother of the continuation of consciousness after death. I was guided by my own helping spirits to make a painting of Archangel Raphael, also known as the supreme healer in the angelic realm. Behind him, I painted souls moving up to Heaven guided by celestial beings. (The father was a priest so I felt needed to work within his personal cosmology.) A few years later, I received an emergency email: there had a been a house fire. Thankfully my friend's mother got out unscathed but everything else had gone

up in smoke. Was I willing to make a new painting? I said, 'of course I will!' As events unfolded, I heard that the painting had actually survived – I offered to clean off any soot and/or repair smoke damage. Once my friend arrived on site I was told that the painting had been in the kitchen, where the fire had started. The fire had consumed everything and done untold damage. However, the painting (acrylic paint on canvas!) survived without any smoke damage. I didn't even need to clean and restore it. That illustrates the power of sacred art.

Reviving the Ancient Library of Alexandria

I am writing this book to share 30 years of practical experience in this field: my own art practice as well as teaching sacred art to groups all over the world.

There are many high quality books on the market about art and there is also a considerable collection of books available about art theory. Most chapters in this book have footnotes at the end where sources are referenced and further reading suggestions appear. As a person with incurable book addiction, I have a large private library of books. My students make excellent use of this library! I sometimes joke that I am reviving the Ancient Library of Alexandria (which sadly burned down in 48 BCE).

Sacred art is catalogued largely under the heading religious art or the art of indigenous peoples. It gets only a passing mention in books about mainstream art (if that) or it is presented as something only made by certain groups of people such as Native Americans, Australian Aboriginal People and so forth. We also speak of Folk Art and Outsider Art (art made by artists who fall outside mainstream trends and fashions) or Primitive Art (a choice of words I will challenge very seriously in this book!), referring to art made by non-Western (tribal) people. This book describes such forms of art (and many others) in the hope of putting those expressions on an equal footing to (so called) Western Art.

A book about art but no pictures?
I invite you to keep a laptop (or iPad, tablet etc.) at hand while reading this book so you can visit my own website and follow other recommendations as you read. I am extremely fortunate to be a published author (and forever grateful to the Moon Books Team for their faith in my unconventional work! Thank you for welcoming me to the Moon Books Family!). This is my second book but writing about creative and innovative work within shamanism generally does not quite make the bestseller list! Books with illustrations and pictures are incredibly expensive to produce and at this stage in my writing career, there is no budget for that. However, most of the artwork referred to in this book (with the exception of art made in the private realm or in ceremonial space by my students) can be found online, just a few clicks away.

Apology
To this, I add that it is not possible to write a book about sacred art that is truly inclusive of all that deserves its place. I have tried my best to write a wide-ranging book on the subject. I have given examples from all over the world to balance the focus of Art History on the History of male-dominated Western Art (the way I myself was taught). This book includes, for instance, references to the art of children and of people with mental health histories, body art, geoglyphs and performance art. Having said that, far more was left out than included. To, truly, do the subject justice, I would need to write an encyclopedia of about 24 chunky volumes (the kind of resource we used before the internet and before Wikipedia!). Therefore, I apologise for all and any omissions – the selection was mine and undoubtedly reflects my own interests, biases and limited knowledge. I hope that others will write the 'missing chapters and missing books' so our culture regains a true understanding of what sacred art is!

Cultural appropriation

It is hard to find a book that examines and presents the guiding principles common to the vast array of wonderful art forms from all over our planet. Not only that, reading coffee-table books and admiring the glorious photographs can easily make one feel like an outsider: this is not my culture – I am not going to make sand paintings or cave art or carve wooden masks for ancestor worship – and indeed, in our modern world we need to tread with extreme care around the issue of *cultural appropriation*. This phrase (which originates in sociology) refers to a process where elements of one culture end up adopted by members of another culture. In our times, this process has acquired the specific meaning of Western people taking the traditions, ceremonies and sacred objects of indigenous/tribal peoples for their own use – without the consent of the elders of the original tribes. In reality, this might mean Western people holding *sweat lodges*, speaking of their *totem animals*, hosting *vision quests* or even offering *ayahuasca ceremonies* or *ritual use of Peyote mushrooms* (all common real-life examples). A detailed discussion of this issue falls outside the scope of this book but I urge all readers to be aware of this dimension.

I invite all my own students of shamanism to embark on quests exploring the traditions their ancestors followed (and I set them specific tasks and projects to that effect). For me personally, this has meant an ever-deepening journey into the ancient shamanic practices of Northern Europe. Just for the record, I wish to say here that in Norse Shamanism we have unique terms for the things mentioned above: sweat lodge – *sauna or house of the ancestors,*[1] totem animal – *fylgja* (literally following spirit), vison quest – *utiseita* or sitting out in nature to receive visions. There is no equivalent to yahuasca ceremonies but the Vikings were said to lace their mead with fly agaric mushrooms!

This demonstrates that many of these phenomena appear in very different cultures, wearing a different cultural coat. For

that reason we cannot realistically say that indigenous or tribal peoples have the sole and only right to do these things, but I would urge everyone to work within their ancestral culture wherever possible (using the appropriate terminology) and to work under the guidance of tribal elders when venturing into other cultures, always seeking clarity on permission issues. If you are new to shamanism I suggest you check out the work of Michael Harner,[2] the anthropologist who bundled together common features from shamanic cultures all over the world and gave Western culture something called *core shamanism.*

Trees as the thoughts of God

What I do know from my own inbox, gradually coming to the boil (and then never going off the boil again), is that a growing number of people do not feel a strong resonance with the contemporary art on display in galleries and museums today. They do not feel attracted to the mainstream art courses offered by their local community college (or indeed the prestigious art schools in big cities) either. Their souls crave making art from a different place within themselves, the same place that tribal artists work from.

This way of working also gave rise to medieval art in Europe. In the medieval period, trees were perceived as the thoughts of God and everything had its place in a larger Divine Plan. The cosmos was seen as coherent and Divine. (Some historians have commented that today we live in a *'chaosmos'* instead, a fragmented universe.) In other words: some modern people's heart's desire is to make sacred art, spirit-led art again, art that is infused by other worlds and luminous beings. In Western culture we still court ridicule and obscurity when we do this.

'Spiritual art is not cool'

While I was at Art School in Amsterdam (between the ages of 18–22 years) in the late 1980s, my teachers told me that I did

not lack talent, energy or self-discipline. They said that I had a great future ahead of me – *if only I could stay clear of making overtly spiritual art*. No one would ever take my work seriously if I persisted in making spiritual art. Here we need to remember that teachers at art colleges need to produce graduates who become successful and reflect well on their own reputation as teachers. Every era (and generation of teachers) thus imposes its own limitations on art students. (This is inevitable and I often rack my brains to think what limitations I impose on my own students and if I am right to do so.)

I got top grades and in our graduation show, all my work sold out. Amsterdam-based gallery owners came and made note of my name. Success as a professional artist seemed within reach but I decided to make a sideways move: I left Amsterdam and moved to Stockholm where, free of the feedback from teachers, I decided to focus entirely on making spiritual art. This is what I am still doing today (30 years later). I have never looked back and I have never regretted this move. I could not make a different kind of art as that would not feed my soul and keep me tethered to spirit.

I happily operated under the radar for about two decades. By this, I mean that my art evolved and I gained clarity about my personal path as a painter. There was a steady flow of paintings leaving the studio and finding good homes in art collections, on book covers and in magazines. I considered myself fortunate: I was doing what I loved and people found their way to my door, so I had a small but steady income from sales and regular commissions. This fitted extremely well around raising three small children! I was not expecting this happy state of affairs to change – *until the day that everything changed ...*

This was the day that the spirits came and demanded I embark on serious training in shamanism (the wake-up call is described in my first book, *Natural Born Shamans*[3]). I had no choice but to do as they asked. I enrolled in shamanic practitioner training and

my overriding motivation *was to make even better paintings of other worlds so other people could see those worlds too.* What had passed me by was that the word *practitioner* refers to facilitating sessions for others! The training required me to do case studies, so I did a lot of shamanic healing work in the multi-cultural setting that is London, UK. I discovered that I had a talent for this – probably because I worked in very creative ways, activating the latent creativity in clients. I learned that *once our creativity flows, our innate capacity for self-healing awakens too.* I also learned that we must not hog our divine-given talents to ourselves (or ignore them); we actually owe the world and others a sharing of and full commitment to these talents.

My colleague Jacqueline Teoh invited me to hang an exhibition of my paintings in Geneva, Switzerland, combined with a presentation on shamanism. The people present asked me to please return and teach others to paint and work the way I work myself. So, I did! The earliest version of my sacred art introduction course was born. The weekend course soon led to a follow-on two-year sacred art practitioner programme that first ran in London. Over time, I was invited to teach sacred art in other locations.

My discovery was simple but life changing! My life's calling is teaching courses where Art meets Shamanism, opening safe sacred space for people to make art in close communication and partnership with their own spirit allies as well as ancient gods, goddesses and other Divine beings. This soon becomes Mystery School work: taking people into the zone where powerful initiations await and alchemy on the level of soul occurs. It is a place where the gods and goddesses themselves involve in partnership with human beings. (There is nothing more terrible (or dangerous) than a 'forgotten god', as this book will demonstrate!)

I truly do appreciate that shamanism is not everyone's cup of tea but I still observe that shamanism offers tried-and-tested

(safe) methods of accessing other worlds and their inhabitants. Shamanism teaches that death is another birth, back to the realm of Spirit. It offers initiations and great transformation. Once we discover the process of direct revelation, writer's block or artist's block are no more. Essentially this means plugging yourself into the most vibrant current of life force known to humankind, a place fecund with potentialities. It is my belief and observation that great artists and writers (composers, architects, etc.) have always worked from their Inner Shaman because often their best and most uplifting work reflects timeless worlds we can visit using our own imagination.

Before training in Shamanism, I used to think of my own imagination as a place confined within my own head. My shamanic awakening blew the back of my head right off with the metaphoric shotgun. Suddenly I found All That Is, the whole Cosmos, within me. I realised that I had made only limited use of my imagination up to then.

Activity #0 Undertake a Pilgrimage before Reading this Book

I ask everyone who does the weekend introduction workshop in making sacred art with me to undertake a pilgrimage. I also ask every client who comes for a shamanic healing session to undertaking a pilgrimage in preparation.

Today we live in a world where things are seen as *fundamentally incoherent*, whereas in medieval times the assumption was that things were fundamentally coherent: part of a Divine Plan where everyone and everything was connected and had its place and role in the greater scheme of things (i.e. Creation). Miracles were part of everyday life and pilgrimages were seen as a micro cosmos of the journey throughout a human life. In the Middle Ages, the way to make sense of life was to *'Follow the Light'*. Works of art only had meaning insofar as they managed to reveal the 'splendor veritas' or Light of Truth. In other words:

they honoured and reflected the work of the Great Creator. Our culture and society have cut us off from the Divine. In our secular society, we deprive ourselves of a source of immense inspiration, spiritual guidance and loving moral support.

Please undertake a small pilgrimage. You do not need to go far but the destination needs to have meaning for you. This could involve a visit to a church or traditional sacred place. It may also involve a place in nature: a forest, a beach, a standing stone etc. Some people will stay close to where they live, others might go further afield. It may be as small as visiting a favourite tree or place in nature or your sacred journey may take several days. Wherever you go, make it an act of attention: absolutely everything that occurs has meaning!

Please make this pilgrimage in a way that is unusual for you. If you always drive – walk or take a bus instead. The people you meet along the way will play their part in your journey. You may be surprised at the gifts and synchronicities embedded in your encounters and conversations with them!

I also invite you to incorporate an element of 'time travel' into this piece of work. Dress up either as a younger self, an older self, or as a self that expresses 'a choice you didn't make' (or unlived life). Perform the task 'in character' and see what you learn. (This may range from wearing a necklace your grandmother gave you, an item of clothing that recalls your younger (or older!) self, having a haircut that reflects a different period in your life, or a full costume made for this specific occasion!)

When you reach your destination as a pilgrim, cast out the question (to the spirits of place): *please give me guidance on my sacred dream!*

I invite you to bring something to the place of your pilgrimage: offerings for the spirits or the gods (as you understand them) and take something home from your pilgrimage to remind you of the journey. This need not be an object, can also be a photograph, sketch, some notes written in a spiritual diary, a song. Use your

intuition, you will know!

Notes

1. Beautiful article by Raven Kaldera about the sauna as the House of the Ancestors in northern shamanism: http://www.northernshamanism.org/sauna-making-building-the-house-of-the-ancestors.html
2. *The Way of the Shaman* by Michael Harner, 1992, HarperSanFrancisco
3. *Natural Born Shamans – A Spiritual Toolkit for Life: Using Shamanism Creatively with Young People of All Ages* by Imelda Almqvist, 2016, Moon Books (JHP).

Chapter 1

What Is Sacred Art?

The craftsman knows what he wants to make before he makes it ... The making of a work of art ... is a strange and risky business in which the maker never knows quite what he is making until he makes it.
(R. G. Collingwood, 1889–1943, English philosopher, *The Principles of Art*, 1938)

Art does not reproduce the visible; rather, it makes visible.
(Paul Klee, 1879–1940, Swiss painter, *The Inward Vision*, 1959)

When I first encountered Imelda's work the following words came to me –
And that is one of the intentions of the art you create – people may be afraid of their depths, but captivated by the beauty of the imaging that comes through your work, they forget to be afraid. The paintings awake an ancient memory of the sacred relationship between human and nature and instead of being afraid, a yearning for a return to that state of grace calls out to them; that then translates into 'how can such beauty be frightening?' So much is possible when fear is removed.
(Jill Hunter, Shamanic Practitioner, London UK)

What is art?

Before we can arrive at a working definition of sacred art we need to take a step back and ask ourselves, first, what is art? The English language is interesting in that it uses the word art for a multitude of things: from fine art and children's art to arts and crafts, martial arts and so forth. I am Dutch and in my mother tongue *kunst* (the literal translation of the word art) is more

elevated (perhaps best translated as Fine Art) where artists make *kunst* but we speak of *kinder tekeningen* (literally drawings made by children but referring to any art made by children).

ART (Noun) – *from the Oxford English Dictionary Online*

1. The expression or application of human creative skill and imagination, typically in a visual form such as painting or sculpture, producing works to be appreciated primarily for their beauty or emotional power.
2. The various branches of creative activity, such as painting, music, literature, and dance.
3. Subjects of study primarily concerned with human creativity and social life, such as languages, literature, and history (as contrasted with scientific or technical subjects).
4. A skill at doing a specified thing, typically one acquired through practice.

Art can be many different things. The word art is used very widely in English (a recent Google search threw up *the art of stealing*! There is that!). However, Art with a capital 'A' refers to Fine Art, art made to send a serious message to others, art that may well carry pretensions and projections (prestige). We will have a closer look at all of those aspects in this book.

What does sacred mean?

What then is sacred? Again let us take a step back and first define the word sacred. The word sacred comes to us from the Latin word *sacer: that which is consecrated or dedicated to the gods or anything in their power, and is set apart:*

Sacer (Latin), ἱερός (Greek).
Sacred or holy, dedicated to divinity, consecrated or hallowed.

Sacred (adjective)

1. Connected with God or a god (deity, divinity) or dedicated to a religious or spiritual purpose, therefore receiving respect or even veneration.
2. (Describing writing or text) embodying the laws, teachings or doctrines of a religion.
3. Religious or spiritual as opposed to secular or profane.

So, then, what is sacred art?

Here is my own definition, arrived at when I first found myself explaining the difference between contemporary art and sacred art to a large audience in Geneva in the year 2011:

> The core principle underlying sacred art is that it is created to honour and express something beyond the realm of the everyday and the visible. It seeks to express the Divine and map the timeless realm of all things sacred (as opposed to the everyday or profane).
>
> Sacred art is not primarily concerned with the name or greater glory of the artist. (Medieval art did not carry the signature of the artist!) Sacred Art is art in service of powers and realms greater than ourselves, to Divine Beings as we understand them – a humbling experience.
>
> In contrast, some Modern Art has become conceptual and ego-led. It often shows a fragmented world where the artist is central: look at me!

To make sacred art we need to move beyond the desires and ambitions of our own ego and work in partnership with the timeless and eternal realm that is the spirit world. The functions and limitations of the human ego will be explored in more detail in Chapter 3. For now a quote to clarify things:

The longing (of the soul) has an ancient allegiance to the evolution of our souls. If we want to discern the difference between the desires of the ego and the longing of the soul, we can always rest in the knowledge that the longing that calls to us will always facilitate a deepening relationship to our lives, while ego-driven desires only serve to separate us from our potential. The longing promotes a glorious life journey of shaping and being shaped that results in holiness and wholeness, whereas the ego almost always leads us into the land of distraction, disconnection and fragmentation.
(Frank MacEowen, *The Mist-Filled Path*[1])

What makes sacred art different from contemporary art?

The problem with calling art *modern art* is, of course, that sooner or later it is followed by something else again; we then resort to a phrase such as post-modern (which is a contradiction in terms really) and then what do we call the next thing?

While I was at art school conceptual art was still cool: using art to express an idea. Though my own course was rigorous and old-fashioned by modern standards (by this I mean that we studied anatomy and life drawing, perspective, art theory and spent years perfecting the art of drawing portraits and actually achieving a likeness) this approach was on the way out. When I speak to art students today (I live right next door to the Goldsmith's College Campus here in London) I hear that such disciplines no longer play a prominent role in fine art courses and that *achieving a likeness* almost amounts to a dirty phrase – who bothers with that today? (Here I would just like to point out that for many centuries artists made their name and living from exactly that skill and some people continue to do so today. I have painted my share of portraits over the years.)

The Great Within

I am a teacher of sacred art and shamanism. My personal journey involved training in core shamanism. (My own journey, and teachers, is described on my website.) This led to years of working as both a practitioner and teacher based within core shamanism. However, as time went on and my awareness continued to expand, I felt myself pulled back to Norse Shamanism, where my journey started. The Norse gods 'grabbed me' at age 19 and they continue to grip and guide me today. They called me home to Scandinavia where I am currently starting a school of Norse Shamanism called True North.[2]

When I teach my sacred art programmes I do not actually work within either core shamanism or Norse shamanism (though I do present valuable material from both). I take my students into the place I call the Great Within. This is our inner world, the limitless spaces within our own psyche and soul. In my introduction workshop, I use a labyrinth and I have people walk to the centre and out again *twice* (once with their eyes open and again with their eyes closed, guided by another human being). I teach that everything in the external world can also be found and worked with on the inner planes. In that sense, I teach a spirit-led way of making art that does not belong in a particular school of shamanism. The way I work deliberately encompasses and teaches the guiding principles behind Medieval Art in Europe as well. It aims to be more universal and reflect the history of sacred art as I have come to understand it.

Are we all artists?

Over time many divisions occurred (I will talk in more detail about splits and divisions in Chapter 5). Following my own years in art school, art students no longer needed to be able to draw or achieve a likeness or achieve technical perfection. This means making art became an activity open to everyone and even more so once digital media arrived on the scene. Today everyone

can enhance and manipulate photographs on their smart phone! Have we all become artists? In a very real sense I *do* believe that we are all artists, as that is an underpinning belief in all art courses I teach (and therefore written into the energy signature of this book).

However, as with everything in life, there is a shadow side. Is it right that people who have not spent years achieving skills in painting and drawing can now call themselves visual artists or makers of fine art? It would seem so. This is wonderful because it makes the art process accessible to anyone anywhere – meaning that we are seeing highly individual artistic creations in every possible location. Yet I will admit that this also feels a little strange to me: what used to be the main requirement for centuries (if you wanted to be an apprentice of a painter or sculptor), *meaning actual skill in drawing and painting and a willingness to spend years perfecting those skills*, has been thrown overboard. Have we thrown out the baby with the bath water? Only time will tell.. We are fortunate to live in times of unheard of change and opportunity (as well as turmoil).

In this book, I will also address another shadow aspect: that many people today who feel called to make art are not actually doing so because they are stopped by internal saboteurs and limiting beliefs. In this book we will wade into a tricky landscape and we may just dip our toes into controversy.

Activity #1 Releasing Our Limiting Beliefs

Start a list of limiting beliefs (meaning long-held ideas or self-talk that stop you from actually making art). Write those on a piece of paper.

(For example, I always got the lowest mark in class; my parents laughed when I tried to draw the family dog; I will just make a fool of myself; I break out in a sweat just to think of anyone looking at what I draw ...)

Then make a fire (in a safe place, observing all rules and

cautions for your location!). *Speak to the Spirit of Fire and ask it to eat your limiting beliefs.* Feed your list to the flames, sing or shout or clap your hands and feel those beliefs leaving you forever. Wave them off. Feel the space this opens up within you.

If you could get someone to witness this, the process will be even more powerful and this person can remind you (on challenging days in the future) that those beliefs are gone. They could also provide a soundtrack for you by singing, rattling or even drumming! Any instrument or just the human voice will do.

Now ask yourself the question: as there are no limits to what I can create now – what will I create?

Notes

1. *The Mist-filled Path Celtic Wisdom for Exiles, Wanderers and Seekers* by Frank MacEowen, New World Library, 2010
2. True North webpage http://www.shaman-healer-painter. co.uk/info2.cfm?info_id=224450

Chapter 2

Rock Art – Where the Worlds Touch

Art outlives governments, creeds, societies, even civilizations.
Art is what we find again when the ruins are cleared away.
(Katherine Anne Porter)

Modern man understands a painting when it reproduces
what the eye sees, whereas symbolic – prehistoric – man
understands a painting when it expresses what is known to
his mind.
(G. H. Luquet, 1930)

It would seem that a zoomorphic age preceded the
anthropomorphic age, a period dominated by 'God become
Man'. The universe of prehistoric art belongs mainly to the
first period, as that of ancient Egypt continued to do, the
animal being at the root of powerful religious urges in a
world still close to untamed nature.
(Jean Pierre Mohen, *Prehistoric Art*, 2002)

Prehistoric art

Let's start at the beginning ...

In Art History, **prehistoric art** is defined as art that was
produced in pre-literate prehistorical cultures. This generally
continues until a culture either develops writing (or a similar
way of record keeping) or makes contact with another culture
that uses methods for record keeping. After that point, we speak
of **ancient art** for older literate cultures. The end date for that
term (and period) varies greatly for different parts of the world.
*(Please note that by writing about this we are imposing our own
organising system and cultural lens!)*

The very earliest human artefacts that show evidence of workmanship with an artistic purpose remain the subject of debate. Art clearly existed about 40,000 years ago (in the so-called Upper Paleolithic era) but there is even evidence of artistic activity dating as far back as 500,000 years ago. From the Upper Paleolithic through the Mesolithic we find cave paintings and portable art such as figurines and beads. In the Neolithic, evidence of early pottery appears as well as sculpture and megaliths.

> The Neanderthals were burying their dead, placing tools in graves and perhaps chunks of meat as if for use in an afterlife or spirit world. Bear skulls and ibex horns arranged in patterns around some graves suggest rituals.
>
> Deep art is art located in utter darkness, far from daylight, twilight zones and living places.
>
> It suggests rituals, ordeals, ceremonies and journeys underground for mystical reasons.
>
> (John Pfeiffer, *The Creative Explosion*[2])

The advent of metalworking in the Bronze Age brought new media for creative expression as well as an increase in stylistic diversity. It was also claimed to bring the creation of objects that had no obvious other function *(please note that this is an assumption, not a fact!)*. By the Iron Age, civilizations with writing had arisen in and from ancient Egypt, via ancient Sumer and Mesopotamia (around 3100 BCE), to ancient China.

Some cultures, most notably the Mayan Civilization independently developed a writing system during the time they flourished, but this was later lost. From the art history point of view, these cultures are classified as prehistoric, especially if their writing systems have not been deciphered.

Rock art

I am a great lover of rock art. Our family often travels considerable distances (or sails to remote locations) to view rock art. In 2016, we bought a house in Sweden in an area where there is a lot of rock art. I am starting a school there and this means that I can take my students (of sacred art and shamanism) on field trips. This is a great source of delight for me!

When I come face to face with ancient rock art, time dissolves. Voices and messages from a completely different era reach out to me and come alive. I do not need an interpreter, priest or anthropologist to assist me with this – though I greatly appreciate the information archaeologists and historians do unearth and share. At the end of the day, it is my experience that rock art communicates with us *directly*. Ancient shamanic techniques can assist this process of direct revelation greatly.

Is rock art ART by the definition we use in our culture today?

I often remind my students of sacred art that some of the creative expressions we call art today were created within a very different cosmology and worldview. One clear example of this is rock art.

Though ancient rock art will likely retain an aura of mystery (after all the people who made rock art in, e.g., the Ice Age, Iron Age or Bronze Age are not around to offer explanations), specialists tell us that rock art was often made in a ceremonial setting. It may well have been created as part of fertility magic, hunting rites or as part of an initiation or collective rite of passage. Then again, it may have been created for different reasons altogether!

This would still come under the heading *art* (see the definitions discussed in Chapter 1) but we do need to reflect on the way our own cultural assumptions, associations and projections colour our perception. The people who made cave art many centuries ago might not have thought of art as a leisure

activity or a hobby (the way many people in our society view it. Think of the expression Sunday Painter!). The making of art and power objects was deeply embedded in tribal life and it was as an activity every bit as serious and vital to healthy community life as, say, hunting, childbirth or honouring the ancestors.

Not only that, the symbols and images used often had a collective or ritual meaning understood by the whole community: a circle means a waterhole, a stick figure means a human being and so forth. Human footprints might not indicate 'I was here' (the way it is common to leave graffiti in our times, sprayed on walls, messages carved on public toilet doors etc.) but could for instance indicate a walking between worlds. *'This cave provides good access points to the spirit world'* or *'place your hands here on these handprints and you too will be touched by the spirits and see into other realms!'* I hasten to add that a) I am making these examples up because we do not have hard evidence and b) you should never touch rock art because this will greatly add to the deterioration of it. It is always best to keep a safe distance so future generations can also enjoy these messages from the past. As John Pfeiffer puts it: commercialism and tourism can undo in a few years what nature has preserved for millennia.

Early cultures were nomadic and people were always on the move. This meant that they could and did not own the amount of things we consider essential for modern living. I guess that not owning things (and carrying only the essentials with you) was a sacred art in its own right!

Early people lived in tribes but there were many differences between local tribes. Think of the Inuit peoples today: we have the Inuit of Greenland, of Northern Canada, of Alaska. Their territories span a vast section of the circumpolar world. Though we call them 'the Inuit', they never were one tribe just as the many different peoples of ancient Europe were never one tribe. I am writing this chapter the week that the UK activated Brexit and began negotiations to leave the EU so I think I can safely say

that we Europeans aren't one tribe even today.

What can shamanic techniques teach us about what was really going on when early peoples made rock art?

One author who writes beautiful and thought-provoking books about rock art and cave paintings is David S. Whitley. He is an archaeologist who has decided to branch out and not stick to the standard archaeological topics of tool technology and diet. Instead, he has turned to *ethnography* – anthropological accounts of tribal religions and practices. According to his Amazon author page, he sees this as a springboard for examining the ultimate origin of art and religion.

As a teacher of shamanism, I cannot help but muse that the work of archaeologists or rock art specialists could expand in such interesting ways if they invested in some shamanic training. Worlds would open up quite literally! Then again, I also appreciate that these professions operate a very different set of rules and (academic) standards from my own.

In one book about rock art[1] he writes that:

'in Western neuropsychological terms, the shaman's trance was an altered state of consciousness in which he experienced aural, bodily and visual hallucinations. A trance could be induced through a combination of isolation and sensory deprivation, physical stress (fasting, extreme exertion or pain), drumming or dancing and ingesting hallucinogens.

One definition of the word 'hallucination' is: 'an experience involving the apparent perception of something not present'. In this book, I will repeatedly make the point that even things we cannot perceive can be present.

Not everything that exists takes physical form. Non-material things can make their presence felt very strongly, just think of love or envy. Before getting too meta-physical, just think of the

way many of us are capable of reading energy (to some extent). Have you ever walked into a room where two people had an argument very recently? Have you ever sensed that someone is angry with you and thinking unpleasant thoughts about you? And a bit more 'way out': have you ever felt touched by the presence of a deceased loved one?

Stepping outside time

Shamanism teaches that ultimately Time is (what I will call) an organising dimension on Earth. It is not the true nature of anything. When we practise shamanism we step Outside Time where All That Was (and even All That Will Ever Be) remains accessible to us. Using the technique called shamanic journeying (in core shamanism) nothing stops us from visiting Paleolithic times and sites, or cultures on the other side of the Planet, or even cultures we have no written record of. We don't need to physically visit places to make soul visits!

Going deeper into shamanism, you will soon discover that the spirits do not always tell us *absolutely anything*, for many good reasons. However, they will tell us what we most need to know, or what we are ready (at this time) to hear. The scope of that evolves as we evolve. It is always an adventure, those Journeys into the Unknown!

Journey into the Unknown: other worlds are real

When we learn about using altered states of consciousness, we start accessing other dimensions. Different traditions have different words for this: The Other World (Celtic), spirit world (core shamanism), energetic parallel world (more scientifically-minded writers), The Dreamtime or Dreaming (Australian Aboriginal), other dimensions, Land of the Dead, realms unseen ... the astral planes ...

Ultimately, it doesn't matter what we call those realms. The point I am making here is that those worlds are real, as real

as our everyday world (which happens to be material). These worlds have inhabitants and codes of conduct (it is never a great idea to offend anyone, wherever you go!). There are dangers and delights. *(Think of many fairy stories where someone tumbled into an Other World and made the mistake of eating or drinking something – meaning that they could not return to our world. Or think of stories where people do manage to return but discover that during five days in the Other World, five hundred years have passed on Earth and nothing looks the same, loved ones aren't there any more ...)* Personally, I think that if folklore from all over the world demonstrates these themes, we are being presented with a timeless truth or reality.

Spirit allies and guides to Otherworld territories

When we embark on a journey, in our everyday world, to a very exotic place (for argument's sake let's say going on safari in Namibia!) we often arrange to travel with a tourist guide for a number of reasons. This will help us stay safe, we may see more interesting things than if we find or our own way around and the local knowledge is made available to us. Exploring the Spirit World is not so different from this. Spirit Allies will come forward and offer to accompany us. This means we learn a great deal, see places we'd never know existed otherwise and we will stay safe and return from our adventures.

For that reason I am disappointed when prominent people writing about rock art, explaining that early cultures all had shamanism in common, use phrases such as *hallucination* or *optical illusion*. Not only does this not do justice to what really occurs in these cultures but it also boxes in the understanding of academics and scientists. *We all do this, all of the time!* Once we get too set in our ways and our beliefs, we stop processing new information. This interferes with our commitment to on-going learning and bringing the world truly fresh and innovative work. I suppose this is also why we die and perhaps are born again on Earth if we have more learning to do. Between ageing and

cultural conditioning our ability to learn slows gradually but steadily. Life Herself gets out the secateurs (the Grim Reaper). All of us become food for new generations, new growth, new beginnings.

Reciprocity

One key principle in shamanism is that fair energy exchange keeps all relationships in balance, not only between humans (though that is a good start) but also between human beings and the environment. This means not over-hunting, not cutting down too many trees. It also means giving back, meaning that we do not just take from the Earth and her natural resources but we always give something back. This may be a prayer, a song or planting seeds for new things to grow. It may be an offering to the spirits of place. Once we understand this principle, we see how fundamental it is to the tribal way of life. It acknowledges that no man is an island; that we cannot survive on our own, that we need to live in a harmonious and balanced relationship with both this world and the inhabitants of other worlds. Ignoring that fact produces the deforestation, global warming, heavily polluted oceans and extreme divides between wealth and poverty our world knows today.

Ceremony

Ceremony is at the very heart of tribal communities. What is Ceremony? It is many things at the same time: celebration, honouring, marking time of year, ancestor worship. It can be a formal event occurring as a result of a special occasion or to commemorate something or a special series of acts performed in an established manner or custom.

My personal definition of ceremony is that although it is perfectly possible to perform small ceremonies by ourselves (in partnership with our helping spirits), most of the time it is about a group of people moving into an altered state of consciousness

together and performing symbolic actions in a place where the spirit world intersects our everyday reality. Seen from other worlds it is a series of symbolic actions performed in sacred space. This opens the door on blessings and good outcomes manifesting in our everyday life. The gods have been appeased. The ancestors have been venerated. We have drawn down blessings on our communities, our land and our future.

In the twenty-first century ceremonies performed by tribal peoples have become a bit of a tourist attraction. An adventure trip overseas may well include attending a special community event. Tourists will of course bring their video cameras. In my experience, two things will then happen: the local people will mind the presence of the outsiders because they are not part of the community and they are not joining in with the spirit of the event. Or (if communities are open to tourism and perhaps strapped for cash) it has been known to happen that a spectacle for tourists is put on but this is for show and carries only a passing resemblance to the true ceremonies performed behind the scenes. This is not unlike the current fashion for going on a spiritual holiday to 'meet shamans in the wild'. Some dubious things go on and it is best to be aware of this.

Anthropologists who attend ceremonies have written about primitive people worshiping masks (for instance) and completely failed to see that the mask is a sacred object and tool allowing someone to hollow out so an ancestor or Divine being can use their body, briefly, to be present and speak. Some people call this trance possession but I think that sounds a little scary. Personally, I prefer the terms *hollowing out* and *bringing forth*.

Whatever terminology we use, understanding this soon blows out of the water reams of writing about primitive people worshipping masks or statues. That perception misses the point of what truly goes on. Once we do understand that, we start understanding what makes sacred objects *(empowered objects, see Chapter 12)* so different from everyday tools. There is the hammer

you have in your toolkit and then someone may wear a necklace with Norse god Thor's hammer .The difference lies in meaning, context and consecration.

Initiation and rites of passage

This is an area where archaeologists and anthropologists do better. Rites of passage are often mentioned in the books and texts I have read. Many people know that tribal peoples host puberty rites for teenagers, marking the point where a child becomes a young adult. What is, perhaps, less well known is that they have rites for many other moments as well: warriors coming home from battle (needing spiritual cleansing, transition and serious honouring for sacrifices made), older people becoming Elders of the Community and perhaps receiving a ceremonial name, menstruation huts where women gather at the time of Dark Moon, special rites to honour ancestors and seek their guidance and blessings. Always remembering that we all die one day and we, too, join the Ancestors, Outside Time.

It is wonderful that these rites are documented. I just wish we would not only read about them but take the teaching to heart and act on the inspiration by offering those rites of passage to our own communities. Increasing numbers of people (my own colleagues and students proudly included) are rediscovering this and finding new ways of doing this.

Magical mode

Today we live in a culture that is a rather odd marriage of Christian ideology and scientific principles. Before Christianity arrived, Europe was pagan. Even those people who were not shamans, herbalists or witch doctors in their communities lived from a magical mind set.

I do not romanticise this! I happen to believe that the witch trials could only happen because the magical mode (in addition to miracles and feeling vibrantly alive) brings its own shadow

side: *superstition*. Witch hunts only made 'sense' in a cultural constellation where outlandish accusations were taken seriously and the Church was enforcing one dominant mode of perception (uncritical faith in the Christian God), to the exclusion of all other (and much older) ways of perceiving reality. For a truly wonderful book exploring this, I recommend *The Witches Ointment* by Thomas Hatsis.[3]

Having said that, magic is the birthright of all human beings. It is not just the domain of young children, witches and wizards. Our soul craves it. It does not stop existing simply because dominant culture pretends that it doesn't.

Membrane between worlds

In shamanism we often speak of a Veil between the worlds. In ancient Greece, human beings were said to drink from the river Lethe (the river of forgetfulness) before incarnation. The thought behind this is kind: it allows us to focus on the here and now and not live in a permanent state of overwhelm. However, always focusing on what is right in front of us can morph into tunnel vision, meaning that not only we do not focus on there being 'more between heaven and earth', we stop believing altogether that something exists beyond physical/material reality. According to Greek myth, after death we drink from the river Mnemosyne (the goddess who was the personification of memory) and remember the larger picture again!

When tribal peoples create rock art and paint on the walls of, e.g., caves, that wall becomes a membrane or Veil. Those paintings become portals because they open doors on other worlds. They give us a glimpse of what people, who lived long before our time, saw when they connected to the spirit world (game, ancestors, weather spirits, tricksters, deities ...). When we stand in front of those very ancient expressions of the human creative impulse, we can drop into our heart (release the concerns of the monkey mind that is always jumping and telling

us stories about ourselves) and view this art from a different level of awareness. When we do so, the art itself speaks. We do not need archaeologists or anthropologists to make up stories for us. The stories, memories and magic themselves will arrive through the process of direct revelation. We will hear them in our hearts and in our souls.

The Ngarinyin 'Cave to Canvas' movement

'Our paintings are a performance of renewing the spirit,' says Ngarinyin artist, Pansy Nulgit. 'The land, the law and the canvas cannot be separated.'[5] The Ngarinyin people live in the North West Kimberley area of Australia. Their pictures and their stories are *'mamaa'* or sacred. They are known for painting Wandjinas: figures that are deeply spiritual to the people of this area, the Mowanjum people. The Wandjina is their supreme creator being. Traditionally their paintings of Wandjina were never shown outside their clan or community. However, in the mid '90s Ngarinyin elders decided to allow outsiders access to their rock art and cave paintings. They also began painting their stories onto canvas.

Ngarinyin elders Paddy Neowarra and David Mowaljarlai were invited to speak at UNESCO Paris in 1997 on the significance of their rock art. Neowarra and Mowaljarlai also visited the Cro-Magnon Lascaux caves in the South of France. Neowarra is a custodian of ancient caves in his own country and when he entered the Lascaux Caves he said:

> It was their Wungud country. I could see the ancestor's way of life and belief from these paintings. But, it made me feel sad they did not have the story really of these caves no old people left to know the story.

On their return to Australia, Neowarra and Mowaljarlai began the Ngarinyin 'Cave to Canvas' movement to train the

younger people to interpret their caves through the guidance of the elders putting their stories onto canvas. This movement will undoubtedly help to preserve their culture for future generations.[5]

Activity #2 Stones as the Ancient Bones of Mother Earth

Go for a walk and find a stone or small rock. In class, I would say, *be found by a stone or rock!* Find a calm place where you can be undisturbed for a while (out on the land would be preferable). Switch off your iPhone and other electronics for at least 15 minutes! Feel the weight of the stone in your hand. Stones have been called 'the bones of Mother Earth' by tribal peoples. This stone was around long before you walked the planet and will still be here when your bones have again returned to the embrace of the Earth. Ask the stone to speak to you. The reply may come in a number of ways: the sound of the wind, a deep inner knowing or strong emotion welling up, memories or images appearing in your mind's eye, a piece of music coming to attention, the words of people walking past and talking so you catch only a key phrase or snippet. When you feel that you have communicated with the stone, ask it another question: would it like to stay where it is or perhaps come home with you to assist in your life? Would it like to be painted?

(If the stone communicates a wish to be painted I recommend buying a pack of Posca pens[2] with fine tips. They are pens filled with paint that produce great results. The fine tips allow you to do very fine detail – much harder to produce with a tiny paintbrush! There is no mess involved. You can easily carry them in a daypack and work out on the land or anywhere of your choice!)

Notes

1. *A Guide to Rock Art Sites: Southern California and Southern Nevada* by David S. Whitley, 1996

2. *The Creative Explosion: Inquiry into the Origins of Art and Religion* by John E. Pfeiffer, Joanna Cotler Books, 1983
3. Uni-Ball POSCA PC-5M pens can be ordered on, e.g., amazon.
4. *The Witches' Ointment: The Secret History of Psychedelic Magic* Paperback by Thomas Hatsis, Park Street Press, 2015
5. Online article in the Australian Times: http://www. australiantimes.co.uk/wanjina-aboriginal-cave-rock-art/

Chapter 3

Spirit and Soul

Spirit

Spirit to me is Life Force in its purest sense. It is eternal and animates the cosmos. While on Earth, I am not so much a human body with an indwelling spirit as timeless spirit having a human experience so I can learn and evolve.

Soul

For me our soul is the timeless and Divine part of us. It is what animates us (a body without soul is a corpse). The soul does not die when the body does. My soul is the larger constellation Outside Time that holds all the blueprints and imprints of my journey through the Cosmos. I may have been many things: man, woman, animal, river or wind and my soul holds the sum of them all, the hologram of my journey through the cosmos.

A working dictionary

Quick reminder: you will find a glossary of frequently used words and terms at the very beginning of this book.

Before we move deeper into mystery we need to clarify the meanings I have assigned to the words Spirit and Soul for the purpose of this book. Other people (and other schools of thought) will use those words interchangeably, or use a different definition for both. To avoid confusion I will be very specific about how I use these concepts in my work and classes.

The word spirituality

Spirituality is a tricky word. We all think we know what it means, but it means different things to different people. Research has shown that some of the most vicious ego-battles and psychic

warfare play out in so-called spiritual professions. That can make charities or schools of spirituality pretty unhealthy and risky places to work! Earlier this year the publisher asked me to review a book titled *Modern Machiavelli* (by Bruner and Eager). I declare this essential reading for spiritual and altruistic people![1]

When people approach me requesting an interview, variants come into play such as *spiritualism*. For me that phrase refers to the Victorian era, when a large number of people engaged in attempting to communicate with dead people (they performed seances).

It has been suggested that the word spirituality carries historical associations of supernatural intervention (and perhaps even superstition) as well as suggesting a dualism between body and spirit, or mind and matter. This is not helpful in an era where we are trying to return to a more holistic perception of the body, mind and spirit phenomenon. Having said that I cannot personally see us coining a 'better' phrase at this late hour – but who knows!

What cannot be denied is that 'the spiritual' has split off from 'the mainsteam' *(please see the more detailed historical description in Chapter 5).* This brings both gifts and shadows. At the time of writing, shamanic practice is an unlicensed (and therefore unregulated) profession in the UK. On the one hand, this means that I have been able to do things with clients that the rules of other professions would not allow and often those things have brought miracles and instant breakthroughs. This all depends on the work being solidly spirit-led *(never ever ego-led!)* The flip side is that people of little training and even less integrity are operating in this same field, messing things up and tarnishing the reputation of all skilled practitioners. For that reason, I will issue one warning early on: choose your teacher of shamanism and/or sacred art with extreme care! Where possible, go on personal recommendations and word-of-mouth!

The Holy

In this book *Das Heilige*, translated into English as *The Idea of the Holy*, German author Rudolph Otto[2] opened the door on a profound exploration of the healing power of the numinous field. It is a wonderful small book and I recommend it to all my art students. The word 'holy' is another example of a word people hardly dare use any longer because it invites ridicule or makes you appear as a religious fanatic. In my courses I have tried to reclaim this word by unabashedly speaking of Whole, Holy and Healthy again, words that are etymologically related. I am also actively trying to 'reclaim' the words sacrament, Divinity, Grace and pilgrimage, by using them in course descriptions and interviews.

One sad perception is that spirituality is commonly viewed as 'woowoo': unsubstantiated, impractical, floaty ... What I have discovered in my work is that the realm of spirit has many profoundly practical and healing applications. And if you think the word healing is *woowoo*, please replace it by the word therapeutic! In my work the most profound insights, the miraculous and near-instant breakthroughs in healing old patterns or wounds all come from the sacred realm.

> True help is always reciprocal: whatever we help serves us. The word therapy means 'healing' but its original meaning was 'to serve the gods'. Similarly, the Mayan word for human meant 'one who owes the gods'. We serve the gods, internally and externally, in a dance of reciprocal generosity. When we work for the gods, they work for us.
> (Caroline Casey, *Making the Gods work for us*[3])

Author Caroline Casey calls herself a 'visionary activist astrologer'. She invites all of us to think of our lives as a detective novel, looking for clues to our destiny and our gift to the world. Our life is a web of meaningful patterns, she says.

She explains that there are two primary Buddhist paths toward enlightenment. Himayaha means lesser vehicle and it is a path of strictly personal salvation whereas Mahayana or the greater vehicle is devoted to the salvation of all creation. I appreciate that this may sound just a little grandiose in a small book about a BIG subject but I couldn't agree with her more that vision and spirituality without social responsibility become ungrounded, narcissistic and even plain dangerous. Think of Germany in the 1930s. Later I will mention C. G. Jung's essay titled "Wotan" about collective possession by a god.

The beauty of art is that it takes physical form. By painting or drawing (to this add the disciplines of your choice) we create something that takes on a physical manifestation and existence outside of ourselves. The therapeutic benefits of that process have been well documented in the field of art therapy. And just for the record, our word *matter* is etymologically related to the Latin word *mater* (meaning mother). The word *matrix* is derived from the same root.

Spirit

Spirit is a tricky word. It is another of those words that is hard to define. It is something you will never forget when you experience it. Being touched by the Divine is a life-changing experience (which is why tribal peoples actively seek it through rites of passage, ceremony and initiation). However, for the purposes of this book we need a working definition.

Our English word spirit comes from the Latin word spiritus (breath). It has many different meanings and connotations but the common denominator to them all is *a non-material substance in contrast to our physical body and material life on Earth.* It is closely related to the Hebrew word *ruach* and the ancient Greek word *pneuma.*

It is often used in the metaphysical sense to refer to either consciousness or personality. We speak of a spirited-person or

being in high spirits. In this usage, we soon hit the distinction (if one can be made) between spirit and soul, as both are non-material. To me soul is a more personal thing (speaking as someone who has performed many *soul retrievals*.[4] For me soul refers to the larger unity that any being is Outside Time, on the eternal level. Meaning that my soul is larger than what I conceive of as my waking self in this life and it holds a higher perspective. While I (wearing a human coat and choosing different personalities the way actors accept roles in performances) may well cycle in and out of incarnations on Earth, my soul remains unchanged, permanent, timeless.

Spirit to me is Life Force in its purest sense. It is what animates the cosmos. Not just me and other human beings, also trees, rocks, clouds, mountains etc. As a shamanic teacher, I am very much an animist; one of my core beliefs is that absolutely everything has in-dwelling spirit we can connect with and need to honour. (And yes that even includes buildings, factory-made chairs and computers.) Life immediately becomes much easier when we acknowledge this (we are no longer trampling on or offending spirits wherever we go!) and far more magical. Nothing is quite what it seems. Behind an everyday object or any situation, we always find a larger magical world of beings and meanings. For now I ask you politely but urgently to (try to) suspend any disbelief, only for the time it takes you to read this book! Try on a different mode of perception, just for a few hours.

Spirit and the spirits

What I just wrote instantly identifies another distinction we need to make: *Spirit* and *the spirits*. Spirit (and Native American people's reference to the Great Spirit) comes very close to God/ Goddess, Buddha Mind (Buddhism being the only religion without a god), the Ineffable, the Unknown and Unknowable, the Prime Mover etc.

To me this is the ultimate origin (Father/Mother God if you

like) of all spirits. It is Sacred Mystery. Before physical reality existed, there was Spirit. One day 'All That Is' returns to Spirit in an immense cosmic life cycle beyond human comprehension. Some religions teach that even worlds come and go. They do not last forever. Spirit does.

Because spirit infuses everything and is absolutely everywhere, we also speak of *the spirits.* To me everything has in-dwelling spirit (I just mentioned animism). Writing this page, in my London city home, I am aware of the Spirit of this House; the spirits of my sacred objects and my drum; the spirits of the books I love surrounding myself with; the spirits I have embodied on canvas in my own paintings on the wall; the spirits of the plants and trees in our garden; the spirits of place; the weather spirits and the spirits of the directions ...

Then there are my Helping Spirits, my Team. They go wherever I go. They arrange incredible scenarios for me to walk into (always beyond my wildest imagination!) because they are in service to my learning process, to accelerating the evolution of my consciousness. They always have plans for me and are not shy about communicating those – but they will sometimes withhold information until they feel I am ready to hear.

Those Helping Spirits can take many different forms (and they actively enjoy playing around with this!). In core shamanism, they are often referred to as power animals (as they love taking animal form but that is just a form, not their ultimate identity). Christianity teaches us that we all have a guardian angel and many books have been written about heavenly helpers. (Ancient Europe knew Swan Maidens[5] long before angels arrived on the scene.) Our compassionate ancestors come forward to watch over us. Often the timeless essence of spiritual teachers (if long dead in this reality) is willing to connect with us Outside Time. I am just trying to illustrate the point that the spirits hail from a place that is resolutely non-material and they positively enjoy appearing to us in ways that have special meaning for us and

them both. Their true cosmic state is *timeless essence.*

Ecstasy: standing outside oneself

There is of course another meaning of the word spirits: products of a yeast-based process of fermentation of a liquid brewed for the purpose of having fermentable sugars. Unlike beer or wine, spirits of the alcoholic variety are the result of a second step called 'distillation' that further fortifies them. In plain English, they are beverages with a very high alcohol content!

I just want to mention them here in the following context: when Western People invaded Native lands they brought (among other things such as smallpox and deadly diseases) alcohol. In many cases (and many places) the aboriginal/tribal spirit-led way of life was annihilated. Even today, alcoholism is a huge problem in Native American, Inuit, Australian Aboriginal (and so forth) communities.

Spirit and the spirits were replaced by alcoholic spirits. It is a disgrace and Western culture can learn a lot from examining this particular inversion or flip into deep shadow manifestation. If we are willing to open our eyes, it can show us the way back to Spirit; or to quote David Tacey:[6] 'When the gods become diseases, we can only heal the diseases by returning to the gods'. The analyst Robert Johnson[7] would say, in a similar vein, that Western Culture does not have a healthy relationship with the god Dionysus, the god of intoxication and exaltation.

As Western culture lost the religious or spiritual experience of ecstasy (literally 'standing outside oneself') ,we have succumbed to the pseudo-ecstasy of drugs and alcohol. Robbing indigenous inhabitants on all continents of their lands and gods and then introducing them to the Western (ab)use of alcohol is nothing short of criminal. Alcohol abuse (in turn leading to related issues such as violence and sexual abuse) is a problem of massive proportions in indigenous populations forced to share their land with white Western settlers.

Soul

For me our soul is the timeless and Divine part of us. It is what animates us (a body without soul is a corpse). The soul does not die when a human body does; there is a continuation of consciousness after Death. I personally believe (and observe in shamanic healing work) that it sees us through many cycles of death and rebirth, both symbolic and physical.

Our soul can be contacted and provide guidance for our everyday self. By this I mean our 'I', our everyday identity, in which ego plays a part. Different schools of psychology offer various models for understanding the human everyday self. Freud spoke of a subconscious or id as well as waking mind. Jung even spoke of a Collective Unconscious: a pool or reservoir of experiences and knowledge all of us tap into, even our long-dead ancestors contributed to this, it is a timeless entity.

I think of my soul as the larger constellation Outside Time that holds all the blueprints and imprints of my journey through the Cosmos. I may have been many things once upon a time: man, woman or animal, wind or water – my soul holds the sum of them all, the hologram of my journey through the cosmos and all potentialities I activated during that journey.

It falls outside the scope of this book to discuss 'who is right (if indeed anyone is and if it is not the case that different schools of thought are all studying different aspects of the proverbial elephant!). What is relevant for this book is that the existence of these concepts indicates that there is more to us than only our walking self, the state of consciousness we perceive as a coherent identity (assuming we enjoy good mental health). Psychiatry and the fields that study mental health provide additional indications that there is more to us than we commonly believe in our culture and that those layers and contradiction drift to the surface when our identity or memory (the cohesive everyday self) is affected in some way. (For a wonderful book exploring the workings of the human soul I recommend *Soul Retrieval:*

Mending the Fragmented Self by Sandra Ingerman.[4])

Ego

I cannot write a book about sacred art without mentioning the role of the human ego.

Different disciplines tend to give a slightly different definition of Ego. In shamanism, we perceive it as the part of us that has our own most selfish interests at heart. It can dream large (even grandiose!) but *we cannot live without it*. One of my students once called it the Air Traffic Control Manager: it keeps us safe by guarding the needs of our everyday self while we are in a human body. The human ego adores attention and praise and screams loudly when we ask it to step aside (so we can do spirit-led work). Shamanism teaches that Death is the death of the ego as much as the death of the human body – but never the death of the soul.

Years of experience (my own art practice and teaching art) has taught me that when people get stuck making art, they are attempting to work from an egoic state. Perhaps they set out to make a 'great piece of art' for which they wish to receive acclaim; or perhaps they are bravely trying to make something but their ego is acting as a saboteur, telling them that they will make a fool of themselves etc. When you investigate, you end up dealing with Mr or Mrs Ego!

The most powerful thing we can do, for ourselves and for others, is learning and teaching how to step outside the egoic mindset. In shamanism, we call this *hollowing out* or *becoming a hollow bone.* We drop the fears, messages and expectations of the ego. We put those aside. We actively invite powers greater than ourselves to work through us. Once we can do this, any kind of creative block dissolves. We see it for the illusion it is: the illusion that all our best ideas and creative achievements come from us. Actually, they only come *through us*, from a place vaster than our personal imagination. Therefore, the well never dries

up. There is no need to experience the soul-destroying headache of (say) writer's block.

Activity #3 Drawing a Mandala as a Mirror of Your Soul

Grab a sketchbook and pen or pencil (any piece of paper, even the back of an envelope will do in a pinch!) and find a place where you can be undisturbed for a while.

Take a moment to become aware of your own monkey mind (meaning the part of you that engages in perpetual mind chatter and self-talk). Ask it to go quiet. If your Inner Monkey will not cooperate, simply focus your mind away from his/her shrieks, high jumps and frantic busy-ness.

Walk deep within yourself, ask if there is a part of you that lives Outside Time meaning it is timeless and eternal. While contemplating this (and it may only be a frequency or humming sound, nothing visual) start drawing a circular shape or doodle.

Tune in as far as the process and your own psyche allow and doodle away. Then use the resulting mandala or scribble for future meditations and contemplation. Even just a plain circle or spiral is a profound (and primordial) image or symbol on which to meditate.

You will have the most rewarding results if you commit to doing this activity daily for a period of time (say at least a week or ideally a month) as you can start using the images as mirrors of your own soul and for tracking states of mind.

C. G. Jung made a spiritual practice out of drawing a mandala every day. He felt that the severe pattern imposed by a circular image puts a boundary around the disorder of the average psychic state of a human being. Meaning that by the construction of a central point, to which everything is related, or even a concentric arrangement of several rings or layers, brings a form of reconciliation with the self (or self-healing). Eastern traditions teach that mandalas represent a connection with the infinite.

Jung used mandalas drawn by patients to identify emotional disorders and work towards wholeness in personality.

Always put your iPhone on flight safe mode while you attempt any astral travel or soul flight!

Notes

1. *Modern Machiavelli* by Troy Bruner and Philip Eager, Changemaker Books, 2017
2. *The Idea of the Holy* (original German: *Das Heilige*) by Rudolph Otto, Galaxy Books, 1958
3. *Making the Gods Work for You: Astrological Language of the Psyche* by Caroline Casey, Piatkus, 1998
4. *Soul Retrieval, Mending the Fragmented Self* by Sandra Ingerman, HarperOne, 2006
5. Swan Maiden's Song, art video by Imelda Almqvist 2017 https://www.youtube.com/watch?v=zIRn_ciIoAA&t=17s
6. *Gods and Diseases: Making sense of our physical and mental wellbeing*, David Tacey, Routledge, 2013
7. Robert Johnson is an American Jungian analyst and author of many books. For starters, I recommend *Inner Work: Using Dreams and Active Imagination for Personal Growth* (1986) and *Owning Your Shadow: Understanding the Dark Side of the Psyche* (1993)

Chapter 4

Religious Art

Until relatively recently, the Diagnostic and Statistical Manual
of Mental Disorders referred to spirituality as a likely source
of mental illness rather than as a cure for illness.
(David Tacey, *Gods and Diseases*)

Every human act can be a sacred act and, performed with the
right intention, a sacred art.
(Imelda Almqvist)

Is sacred art synonymous with religious art?

When people ask me what I do for a living or when asked to
provide a short bio for interviews or public appearances, I
use the following one-liner: *I teach sacred art and shamanism
internationally.* Granted more time and a higher word count I
will also speak of my own paintings, my passion for making
art videos and mention my first book about the importance of
a spiritual toolkit for young people. Given an unlimited word
count, I try to fit in the words *mystery school, rites of passage and
initiation.* (And I doubt most people really understand what I do,
even when I am granted the most generous word count!)

From decades of conversations with people about my
professional life, I know that many people, and only few will
ever give it thought, assume that sacred art is synonymous with
religious art. This is not actually the case. Religious art is only
one very specific type of sacred art. You could say that sacred art
is one of those large rainbow umbrellas and that religious art is
one of the segments, one colour band (if you like) of that larger
umbrella (e.g., 'yellow is religious art!').

Using this umbrella metaphor Christian art would appear as

a very small sub strip in the larger 'yellow band' of religious art as, obviously, many other world (and more local) religions produce their own unique arts, crafts and images too. Think of Tibetan mandalas, Hindu depictions of Shiva dancing or the Elephant god Ganesh, Navajo sand paintings, African masks and so forth. Following my chosen analogy, Christian art might then be 'lemon yellow' while the whole spectrum of shades of yellow also includes cream, saffron yellow, lemon chiffon, canary yellow, clover-lime yellow etc. Yes, I had fun researching that but for painters, like me, colours are comparable to the Inuit's use of different words for snow. There is a limitless spectrum of colours within just one colour band!

When I say that I make sacred art (at social gatherings) people's first thoughts are usually that I paint icons of saints or representations of scenes from the Bible for churches. In the next section, we will talk briefly about icons. As regards cathedrals, one of my own paintings that remains closest to my heart (following a vision I had in Greenland in 2008) is Cathedral in Ice. *(To see it: **http://www.shaman-healer-painter.co.uk/info2. cfm?info_id=224488)** I cannot make myself sell this painting, it would be like selling my own soul, so it is not for sale. It shows what my own personal and very pagan understanding of a cathedral is.

Cathedral in Ice – Ilulissat, Kallalit Nunaat (Greenland), Friday 22 August 2008, 4 a.m.
I sleep like a log until something awakens me at 4 am. The Spirit of Greenland is calling me, 'You have always wanted to visit Greenland, but the truth is that I was calling you!' On the way from the airport you notice a flock of sea gulls gathered on a melting ice floe in the harbour. You felt tearful as you heard the spirits say this is an endangered continent. I am shown an image of Knud Rasmussen (the great Arctic explorer) setting out with his dogsled. Here is a man who

truly loved Greenland; who added nothing to the landscape and only took from the land what he truly needed. He took great pride and joy in this continent. HIs dogsled took him into uncharted territories. This is how Greenland should be visited! Look out of the window at the icebergs in the bay! You will see portals in the ice. There are whole worlds in that ice that no one has ever seen! I walk across the frozen ice sea and enter one of those portals. There is a cathedral deep inside that iceberg: a huge sacred space, half under water and half above. I see polar bears, dolphins, seals, whales and all sorts of polar animals. All are white. This is where the spirits of the dead animals live. The polar bear cubs that didn't make it through winter, the animals that died a natural death, or gave up their lives in the hunt. Their spirits live on in this sacred enclosure made of ice. A space not visited by humans, not photographed by tourists. A sacred space of eternal beauty: a Cathedral in Ice.

Icons

In the context of sacred art, icons refer to religious images, most commonly a painting from the Eastern Orthodox Church or Eastern Catholic churches. Icons can also be cast in metal, carved in stone, embroidered on cloth, painted on wood, appear as mosaics or frescoes and so forth. They are devotional images, meaning that they are often used by people to focus their minds on spiritual matters, often a specific figure (perhaps a patron saint or Mother Mary). People (including my own mother) burn candles or tea lights in front of such images asking for blessings or intercession from saints on behalf of loved ones. For instance my eldest son has an important exam in advanced mathematics tomorrow morning and my mother will be burning several candles and calling on her favourite saints and deceased ancestors to help my son do well.

Obviously, the word *icon* has additional meanings in English

(and most Germanic languages):

1) A famous person (or thing) that embodies or represents a way of life or set of beliefs that others aspire to, or look up to. For example, 'pop icon' (John Lennon, Britney Spears) or sporting icon (David Beckham). At the time of editing this book, a new icon has just hit the headlines: Meghan Markle who married Prince Harry in 2018.

2) A small picture or symbol on a computer (or smartphone or iPad) screen that you can select by clicking to give the electronic devise an instruction.

What is preserved even in those meanings is the core concept *of an image that leads the way.*

Other forms of religious art

To do justice to this subject I will also mention further examples of Christian art such as stained glass windows, statues of saints, labyrinths found in churches, frescoes and murals (think of the ceiling of the Sistine Chapel). My own mother (who is a retired teacher of textile art and expert in lace making) has made wall hangings for churches on religious themes such as the Divine Mother.

To make things a little more complicated again I would like to point out that many churches were (deliberately) built on ancient pagan sacred sites (in an attempt to obliterate earlier powerful pagan traditions and beliefs) and they often incorporate a surprising amount of pagan details and images. Perhaps the best-known example is of so called Sheila-na-Gig images: figurative carvings (often in stone) of a naked woman displaying her enlarged vulva – most likely representing the womb of Mother Earth and on-going process of Creation.

Mainstream art history refers to these as *architectural grotesques* but they are powerful pagan symbols that may relate to earlier

fertility rituals or mother goddess veneration in the area. (This remains subject to debate, scholars do not agree on this.)We find them all over the UK (where I live) but Ireland has the largest number. The Church uses a surprising number of symbols that are very pagan in origin.[1]

I often go hunting for obscure rune stones in Sweden and not infrequently end up in graveyards where runes have been moved to make way for tombstones.

From icon to idolatry: Islamic art

It is only one stop from icons and idols to idolatry!

Many readers will be aware that Islam prohibits the making of representational art. This is based on the belief that the creation of living forms is unique to Allah and Allah alone. The Quran condemns idolatry and uses the Arabic term *mussawir* ('maker of forms' or 'artist') as an epithet for God.

I once made the mistake of teaching an introductory seminar in Egyptian hieroglyphs to a large audience of university students at the SOAS or School of Oriental and African Studies, here in London. The Islamic students refused to draw the hieroglyphs that resembled a bird or human eye etc. and I quickly had to divert them to another exercise drawing Chinese characters instead (though even those are pictograms in origin but have been abstracted beyond immediate recognition!).

For all of those reasons calligraphy has become the most highly regarded and fundamental element of Islamic art. Calligraphy is an art form but it is not just art, it is about transmitting a text in a visually pleasing form. Islamic art also makes generous use of geometric patterns used to adorn both architecture and everyday objects of every conceivable type.

The educational purposes of sacred art

Another aspect of sacred and religious art I need to mention here is that in the twenty-first century, we enjoy very high rates

of literacy but this wasn't always the case, even in Europe (and still is not the case in impoverished or war-torn countries on all continents). The religious art that adorned churches (such as stained glass windows or the paintings of the Stations of the Cross) served an educational purpose as well. It allowed people to absorb the teachings and messages of religious figures and stories.

Here it may also be worth noting that Homer, the legendary author of the Iliad and Odyssey composed his epics primarily for the education, by means of art and inspiration, of people who could neither read nor write. As Pfeiffer says in *The Creative Explosion*:

> The task (of understanding cave art) would be considerably lightened if we had some versions of 'prehistoric', pre-literate myths in writing – and it so happens that we do. When a society is shifting from non-literacy to literacy [...] its earliest legends or recorded myths tend to be closely related to the last poetically transmitted myths of its non-literate days. Among the best documented and most intensively studied of Europe's early myths are those incorporated in the works of Homer. [...] Homer belonged to prehistory, to the last days of prehistory and the last days of Greece's oral tradition. In a similar way, the people of the Upper Paleolithic lived at the dawn of the oral tradition and, in a sense, started what Homer finished.

Christian art

Yet one more aspect of religious art we need to recognise is that nearly all art made in Medieval Europe was Christian art. The Renaissance period saw an increase in monumental secular works but even then Christian art continued to produce great quantities for churches and the laity. During this period Michelangelo Buonarotti painted the Sistine Chapel and caved

the Pieta; Bernini created the massive columns in St. Peter's basilica and Leonardo da Vinci painted the Last Supper. The Reformation period brought the production of Christian art to a virtual halt in Protestant countries and even caused destruction of previously made art.

I often tell my students that every era imposes its own lenses of perception, call them filters if you like. We tend not to question the filters (or biases) active in the time we ourselves live.

A secular and universal notion of art (not affiliated with or restricted to a particular religious group) arose in nineteenth-century Western Europe. Artists with a secular focus would occasionally depict Christian themes and many modern artists produced well-known works of art for churches, but this was neither their sole focus nor life-defining calling. My own paintings have been exhibited in churches and I have even made some paintings inspired by the Bible but I am not a Christian painter.

The freedom of expression artists enjoy today, paired with the huge range of materials and free YouTube tutorialshas completely changed the landscape of making art. We do well to remember that it was not always so. That art used to be made in service to religion and was either made by nuns and monks in monasteries or convents, or by private artists and their apprentices for rich people who could afford to commission their work.

General definitions

Religious art is inspired by religious teachings, concepts or motifs and it is generally made with an uplifting intention; it is hoped that contemplating religious artwork will focus people's minds on larger truths and spiritual priorities (as defined within the tradition concerned).

Obviously Christian art is made to convey the key principles of Christianity: for example, the crucifixion (a reminder that Jesus died for our sins), or Mother Mary holding Baby Jesus (the

Divine Mother watches over all of us), Moses receiving the Ten Commandments, The Final Supper etc. Therefore, you could say that most Christian art is *allusive*, it refers to themes and biblical stories that the observer (a Christian) is familiar with.

All religious imagery tends to look quite odd and impenetrable to people who are not familiar with the material it depicts. Western people may find African body painting and especially scarification (the process of cutting or branding the skin with creative designs to leave permanent marks, please see Chapter 15) hard to comprehend but often forget that African tribes would (one assumes!) find images of Jesus bleeding on the cross, crowned with thorns, equally disturbing to look at.

I will close this chapter with a comment from John Pfeiffer[3] to put human-centred thinking and human-animal relations somewhat in proportion:

Until recently, until the spread of agriculture and cities, human beings ranked low among fellow primates as far as the population is concerned. There were more orangutangs than people on earth, some 30 to 60 million versus a mere 10 million.

Activity #4 Step outside the Comfort Zone

Once we leave nursery school or Kindergarten we often find our comfort zones, meaning that we turn our back on many other activities and forms of expression.

Today I invite you to make art using materials that take you completely outside your comfort zone. If you are very competent at drawing and painting, try composing a small piece of music instead, write a poem, whistle a song, start a piece of embroidery, buy textile markers or fabric paint and decorate some T-shirts for yourself, friends or children. Have FUN doing it!

Once we break through such 'walls' there are so many discoveries to be made: we widen our range, we free up the joy

and energy we locked away when we turned our back on this form of creative expression, often decades ago. And remember that you can continue to release any limiting beliefs that come up! (See Activity #1 for a refresher!)

Notes

1. *The Book of Primal signs: The High Magic of Symbols* by Nigel Pennick, Destiny Books, 2014
2. Source: https://groups.google.com/forum/#!topic/holistic-quantum-relativity-hqr/v14g8zeATTM
3. *The Creative Explosion: Inquiry into the Origins of Art and Religion* by John E. Pfeiffer, Joanna Cotler Books, 1983

Chapter 5

Enlightenment: Period or Process?

With the veneer of modern cultural arrogance stripped away, we can see that knowledge is not the preserve of the West and that most modern scientists owe a great debt to earlier peoples.
(Martyn Shuttlework in his online article "The Path to Enlightenment")

Science is useful for the things that are seen, but for things invisible it is not so helpful. In fact it can be positively harmful if it pretends to speak with authority about the things it does not understand. The gods are best approached not through science, but through myth, religion, cosmology, poetry, the arts and music.
(David Tacey, *Gods and Diseases*)

The Renaissance and The Enlightenment

In the history of Western Culture a split occurred. All Medieval European art was Christian art but the Renaissance brought a focus on secular art. The Renaissance also brought another split. Up to then there was no separation between alchemy and science, between astrology and astronomy, between philosophy and mathematics (and so forth).

Older history books used to draw a line between the ancient Greeks and modern science at this exact point on the timeline. It was believed that intellectual and artistic contributions from other parts of the world were minimal. Today this is an untenable position: other (non-classical, non-Early-European) civilizations made very significant contributions indeed to the history of science. Think of the Mesopotamians, ancient Egyptians, Maya

and Chinese and so on. Islam helped preserve the knowledge of the ancients while adding further insights and conclusions.

We can safely say that there has been a 'Euro-Centric' view in operation for some centuries now. This dates from a period when great scientific advances and discoveries were made and science as we know it today took shape and definition.

Ancient Greece had polymaths: people who studied and taught one unified body of knowledge that in our world today has been split into different subject areas: philosophy, mathematics, astronomy, astrology, science etc.

Dating the Renaissance period is tricky. A period of intellectual revival occurred from the twelfth century onwards but it was interrupted by the Black Death of the mid-fourteenth century, which killed a staggering 30–50% of Europe's population (just try to imagine that for a moment!). The European Renaissance is often given the date 1450 CE as its starting point. Determining when the Renaissance ended is a much more difficult process, because it blended into the Enlightenment over a period of decades. Most historians agree that the second half of the seventeenth century marks the transition from the Renaissance into the Enlightenment.

By then new access to Latin and Greek science and the philosophies of antiquity began to be openly permitted. Wider distribution was made physically possible by Johannes Guttenberg's invention of the printing press in the early 1400s.

In terms of the art of this period, I will point out that the famous European artists of this period (e.g., Giotto, Donatello and Michelangelo) were engaged in trying to recapture the perceived perfection of classical times. They were trying to recreate the perfection they perceived in the ancient statues of the Greeks and Romans. This movement and focus on traditional forms, elegant proportions and symmetry is known as Classicism. The goal was achieving (or emulating) 'absolute beauty' in art. This genre was not only limited to art, it also expressed itself in

literature, architecture and music.

This can be perceived as a resurrection of the ancient Greek belief that Creation followed perfect laws and reasoning and that an artist could capture some of this *divine flawlessness*. (If you are interested in that idea, I suggest you run some searches using the key words sacred geometry.)

Classicism, Baroque and Rococo

In Europe, Classicism reappeared in the eighteenth century as a reaction to the then dominant Baroque and Rococo styles. (Baroque was very ornate and Rococo emphasized even greater ornamentation and asymmetry. In the twenty-first century, we coined the acronym OTT: Over the Top!). The new genre that immediately followed Classicism is referred to as Neoclassicism and represented a return to simplicity and symmetry.

Some scholars refer to the Renaissance as the age of observation where scholars (and even artists!) began to dissect and study things in an attempt to find scientific truth. Artists began to dissect both human cadavers and animals (think of some of Leonardo da Vinci's drawings). Architects rediscovered mathematical laws formulated by the ancient Egyptians, Greeks and Romans. It was believed that using certain ratios (mathematical proportions) would create strong and aesthetically pleasing structures. Here you could think of (and Google) the Golden Ratio $\displaystyle {\frac {a+b}{a}}={\frac {a}{b}}\ {\stackrel {\text{def}}{=}}\ \varphi ,$.

This was also the period when European thinkers began to question the metaphysical aspects of Creation. Great minds such as Newton, Leibniz, Descartes and Francis Bacon were the architects of modern science as well as philosophers. Until the middle of the Renaissance, there was very little conflict between religion, science, philosophy, astronomy and astrology. Many key figures in science practised either astrology or alchemy (often both!). Many of these early scientists explored the world

around them on all levels: physical and spiritual/metaphysical. They did not perceive, or make, a distinction between those fields.

There was a great shift from scholastic and theological thought towards empiricism. This was the first sign of a split between science and religion – today, obviously, we perceive those very different fields but it was not always so. Yet a strange strand of dualism ran through the Renaissance period; many scholars were sponsored by the Church while others had their findings suppressed or their studies tainted by accusations of witchcraft and demonology.[1] We can safely say that the grip of Church doctrine was loosened. Essentially the Renaissance was a transition period between the ancient world and our modern world. The Age of the Enlightenment blossomed against a backdrop of revolution and conflict in Europe. The Age of Enlightenment is often called the Age of Reason as well.

The conflict between religion and science

The conflict between religion and science was resolved by agreeing that the new emerging movement (that became modern science) was allowed to continue, without prejudice or penalty, as long as its investigation stuck to the physical realm of material objects and measurable phenomena. The Church continued to hold authority on all other levels of experience (the realms of spirit, soul, morality and mortality). It was agreed that each would respect those boundaries and stick to their own field.

In our day, the rules of the game are changing again because the Church has largely lost its position of moral and religious authority. In Western culture a steadily decreasing number of people attends services and live by Christian doctrines while recent developments in, for example, quantum physics have opened up major metaphysical questions.

In the science lessons my teenage sons attend, (as part of their secondary school curriculum in the UK) Isaac Newton

is often venerated as a Forefather of Modern Science and we speak of Newtonian Physics. I find this rather amusing because in reality Newton appeared to love alchemy even more than 'the new science'. Newton was a spiritual seeker who tried to marry the outer world to the inner world (as all Tribal peoples do and as the ancient Greek philosophers did). Newton could not accept the established view of the Holy Trinity (for instance) and this prevented him from taking holy orders in the Church of England. If his views had been made public at the time, he would have faced charges of heresy. Therefore, we can safely say that Newton embodied this schism or split we accept as normal today. He could only be true to himself by keeping his true convictions and beliefs secret. In other words, *Newton was not a Newtonian, just as Jesus Christ was not a Christian!*

I have heard it said that *science is the new religion*, which is bound to offend some. I have also heard it said that *science is a mythology (or belief system) in its own right* (which is bound to offend others) because it imposes its own set of rules, interpretations and expectations. It is one way of ordering 'reality' and organising perceptions around a key principle called objective consensus. In shamanic circles, we often use the word linear for this modus operandi as opposed to the multi-dimensional awareness of all worlds we aim for in spiritual work.

Just for the record, in my view there exists many different modes of human perception and they are all valid. They give a unique take on what is going on in any given situation. I only need to go as far as my own marriage to observe this, my husband lives his life by facts, evidence and causal arguments. I used to be more like him (actively ignoring my intuition and psychic flashes) but over time, I have made shamanic consciousness my main mode of perception. Things get interesting when the two of us solve problems together! From my point of view *all* of these modes we human beings have access to provide valuable information. I rely most on intuitive and spirit-led awareness

of the world but I am enough of a scholar to back that up with research, facts and hard evidence (where possible). My husband is fact-based but he welcomes my intuitive flashes of insight. Their accuracy never fails to astound him. We work well as a team!

The observer effect and sacred witnessing

There are many signs of things coming full circle in our lifetime. Science has started taking into account *the inner world* again. It is now known that having an observer witness an event has an impact on the outcome of an experiment (called *'the observer effect'* not to be confused with *'the uncertainty principle'*). Particle physics teaches us that, so-called, *quantum entanglement* of individual particles occurs when each particle cannot be described independently of others – even when those particles are separated by vast distances. Instead, a quantum state must be described for the system as a whole.

What this means in terms of everyday language and events is much closer to what is often called the Web of Life: we are all co-existing and co-creating in an interwoven and entangled universe that is in no way separate from our inner world. The concept of a division between inner spiritual or emotional experiences and an outer reality of unrelated factual events is being eroded before our eyes. I am happy about this because it is pulling all of us closer to the holistic tribal worldview of All of Creation as One. Once we truly grasp that we cannot rape and pollute the resources of the planet we live on, what we do to others (including animals and the environment) we *very literally* do to ourselves. I have read many (popular!) books about quantum physics and read out passages from those books to students in class; those passages could have been written by shamans!

Teaching sacred art has taught me just how powerful being observed is. We have come to call it *sacred witnessing* and it is our own version of the Observer Effect. When performed as a

sacred act, it means truly seeing a person on the level of soul. It means not butting in and giving our own interpretation of events, our turn for being witnessed-will come! It means being fully present to another human being 'showing up' and showing vulnerability, baring their soul.

Rebirth and seeing the light

The word renaissance means rebirth, which happens to be a key word in shamanism because Life is seen as cyclical (rather than linear). Life endlessly renews itself through the great cycle of birth, death, rebirth. We are all part of this cycle and no one alive can escape it. Every 'smaller' symbolic death in a human life (illness, misfortune, the death of a beloved pet, the loss of a job etc.) can be seen as a preparation for our own ultimate death. We also see death around us in the seasons, in plants and animals dying so we have food etc. Death feeds Life. Our own personal death will feed future generations on Earth.

I cannot resist closing this chapter by mentioning the other meaning of the word enlightenment here taken from Buddhism: 'a final blessed state marked by the absence of desire or suffering' (Miriam Webster online dictionary).

Light does not come from light, but from darkness.
(Mircea Eliade)

Activity#5 Honouring Our Spiritual Mentors and Ancestors

Find a place where you can be undisturbed for a while. Bring a notepad and writing implements. Start mapping for yourself what religions or belief systems (ranging from established to obscure) you have been exposed to in the course of your lifetime and write those down.

Some of you may have had a religious upbringing. Some of you may have had a secular or actively atheist upbringing even

but you would still have been exposed to organised religions through schooling, friendship and your local community.

Leaving aside (for today) what you think of organised religions and their doctrines, take a moment to map (and list) those influences and reflect on who has been a mentor (or perhaps elder, fairy godmother, kind neighbour) in your life and had a lasting spiritual influence on you. I mean this in the widest possible sense. Did you have an auntie who talked to you about angels? Did you have a neighbour who showed you his war medals and told you about the ordeals and comradeship in serving his country? Was there a family friend who showed you (perhaps only through their own lifestyle) that a pagan or 'alternative' lifestyle can be a positive and valid choice? Did you have a secondary school teacher who had a lasting effect on your own choices and values? (I occasionally hear my old teacher of Latin and Greek speak when I talk to my own students!) Did you have Jewish neighbours or friends who told you about their festivals, Islam, Buddhist, Hindu, or Tamil perhaps?

Now make a list of all those people and influences. Light a candle and proceed to honour them all. Speak their names (dead or alive today) and say: 'Mr or Mrs X, I express gratitude for what you taught me and the positive influence you had on my own life. Thank you!' Feel free to use different words of your own, I am just giving you the spirit of the exercise!

How does that feel? Is there any sense of peace, of being heard and a process of balancing occurring between the worlds? Remember too that the spirits witness our every action and decision.

If you are ready for more, ask yourself what the difference is between organised religion and spirituality. Jot down your thoughts on that matter for a week as you go about your usual activities. Carry a small notepad and pen on your person at all times. If you feel daring, write a blog about your findings!

Notes

1. *The Witches' Ointment: The Secret History of Psychedelic Magic*
Paperback by Thomas Hatsis, Park Street Press, 2015
I also recommend an excellent online article by Bruce
Scofield: http://www.mountainastrologer.com/standards/
editor%27s%20choice/articles/science_ast.html

2. For more information about sacred geometry please view
https://en.wikipedia.org/wiki/Sacred_geometry as a starting
point and follow links from there to other sites.

Chapter 6

The Cosmology and Art of Tribal Peoples

Setting sail

For the twenty years following Art School, my great labour of love was studying the art of Non-Western cultures all over the world. I travelled on five continents and met indigenous/tribal/First Nations peoples. The hardest to reach were the Kuna Indians of Kuna Yala (also known as the San Blas Islands) off the coast of Panama who make *molas*.[1]

A *mola* is a handmade piece of textile that forms part of the traditional clothing of Kuna women. In Dulegaya, the native language of the Kuna Indians, mola means top or clothing. Mola making originated from the tradition Kuna women have of painting their bodies with geometric designs. Over time, those same designs were woven in cotton and later again they were sewn and stitched using fabric bought from the European settlers in Panama. The key technique is called reverse applique. It is assumed that the oldest molas in existence are about 150–170 years old. There is a wall in our house covered with molas. The ones I bought from the Kuna Indians who made them (and some were men) also show animals, flowers and human beings. While our boat was at anchor, the Kuna Indians would tie up their dugout canoes alongside our boat and climb on board to show us their wares.

The Panamanian government actually tried to 'westernize' the Kuna people at the beginning of the twentieth century but this move was met with a huge wave of resistance that culminated in the Kuna Revolution of 1925. The Kuna people were then given the right to govern their own territory autonomously – and that is what they are still doing today. I hope this sets a template for other parts of the world where native peoples have come under

huge pressure to be westernized.

We made that trip in our own sailing boat with three young children as increasingly competent crew. We also met First Nations craftsmen on Vancouver Island (British Columbia, Canada) showing us how they carve totem poles and what the symbolism means. In South Africa, we bought stone carvings and carved wooden masks. In Greenland I was 'found' by a necklace I still wear every day: a polar bear head carved from whalebone by an Inuit artist.

Indigenous/Aborignal/Native/Tribal – lost for words ...

It is difficult to find a collective name for Non-Western peoples. The word *indigenous* is often used but in truth, we are all indigenous! We are all from somewhere! Many people are now having their DNA tested for insights into their ancestry and this can throw up truly surprising and wonderful discoveries.

Aboriginal is another word often used in the context of *'the aboriginal peoples of ...'* When I hear that word I I associate it with the native peoples of Australia. Another phrase in use is Native (as in Native Americans as opposed to white Western dominant culture). Yet one more phrase (common in Canada) is First Nations, meaning people who lived on the land long before white Europeans arrived and created a dominant culture (which did untold damage).

It is very tricky and I want to tread with care. We often call the most Northern area of Scandinavia Lapland but the Sami find this derogatory and prefer their own word for their own territory: Sapmi. We used to call Inuit peoples Eskimos (meaning fish-eaters) and they do not like that, so today we use their own word Inuit.

Taking all of those reflections into account, today I often hear myself saying 'Tribal Peoples' instead. It may have drawbacks but, personally, I like it because it instantly suggests a different

way of life from individualistic Western Dominant Culture. It also awakens deep ancestral memories and questions in the very cells of our body: where do I belong? Who and where is my Tribe? (I often call my spiritual family, my kindred spirits, my Tribe – but I am digressing!) In this book, I will (most often) go with 'Tribal' for lack of a better word.

Spirit at the heart of communal life

One thing that all tribal cultures have in common is that their everyday community life revolves around the spirits and the spirit world. Another way of saying the same thing is that these cultures *practise shamanism.*

Some clarification is needed at this point: shamanism is not (has never been and will most likely never ever be) a homogenous practice globally. However, what anthropologists (most notably Michael Harner) have observed is that these cultures all share commonalities or fundamental principles. Michael Harner[2] (a former American anthropologist who became a leading name in contemporary Western shamanism) bundled these principles together and started teaching courses to a Western audience. He called this *core shamanism.* He was an observer turned participant, an anthropologist who eventually became a shaman, rather than a researcher. His work remains controversial today. Many people feel that he did Western culture an immense favour by returning to spirit work and providing an accessible (safe) way for people to engage with ancient methods and material. Others will say that core shamanism lacks identity and local flavour because it is a construction (not something passed down from our own Elders and Ancestors) and, in truth, the underbelly or more unsavoury side of things (black magic, cursing or psychic warfare) was edited out altogether. *(As a teacher of Seidr and Norse Shamanism this causes me great concern because shadow material will find a way to return via the backdoor, as it were!)*

I feel that there is truth in both viewpoints. Around age 40

I became a student of core shamanism – but soon realised that I had been on a parallel journey for much longer and that my journey was with the Norse Gods. I delved ever deeper into Nordic Tradition and the ancestral pathways of Northern Europe (for various reasons I had not called that practising shamanism to myself). For me that was a solitary path for decades. As a mother of three young children it was manageable for me attend practitioner training in core shamanism in the UK where I am based and this changed my life utterly and completely, for the better! (I would almost go as far as saying I had a personality transplant. Symbolic death and rebirth have a way of rewiring you!) Having said that I do not feel that training in core shamanism can substitute for people embarking on a great ancestral journey of discovery. Indeed, I actively encourage all my own students to do so and set them specific tasks to that effect.

When Western observers do not turn participants

Having voiced both my immense debt to and reservations about core shamanism, I will now focus on what truly matters for the subject matter of this book: all tribal peoples (anywhere on the globe) follow a way of life infused with Spirit. Their communities, ceremonies and daily life evolve around an on-going dialogue with the spirits (meaning their deities, spirits of place, ancestors, weather spirits, helping spirits and so forth). Their way of life inspires my way of life today. I try very hard to live by those principles, not the linear mode of perception favoured by Western Society, as discussed in previous chapters.

Having joyfully embraced this very different mode of perceiving and existing in the world, one thing becomes painfully clear: most books about 'primitive art', cave art or rock art, anthropology and so forth are written by people who 'did not do a Harner', people who write as observers deeply embedded within their own cultural paradigm.

This leads to (often) rather peculiar writings because rather

than practising deep listening and a deep desire to learn from the culture they are studying, they start imposing alien systems of classification and interpretation that say more about them and their own culture than about the culture of their focus!

This is another reason why I am writing this book. I want to offer and share ways into sacred space, the space where miracles occur all the time, the space where untrammelled creativity resides from a place that puts Spirit at the heart of things.

Nothing in the twentieth century can match the Upper Paleolithic for its combination of art and setting, content and context. Nowhere in our lives are there comparable concentrations of modern art with a purpose, art in action, as contrasted with passive art hung in out-of-the-mainstream places designed solely for exhibition. The works [read rock art] in caves speak together, individual styles but with an underlying unity, singing in unison like a chorus of individual voices, expressing collective feelings, collective goals. That is their special power.

(John E. Pfeiffer, *The Creative Explosion*[3])

Activity #6 Deep Listening to the Ancestors

Grab paper and pens and retire to a place where you can be undisturbed for a while. Take some deep breaths and drop into your heart. By this, I mean move your attention down from the monkey mind or brain to the place of feeling that is your own heart. Take a few more slow deep breaths.

For all tribal peoples the honouring and consulting of ancestors is a key practice. Think about it, as without them, we literally would not be here. We would not benefit from their choices and discoveries or from the genetic material they passed on; your talents and unique identifying features were passed on to you by ancestors. Perhaps a talent for art or music? A quirky sense of humour. The mad curly hair. We all have spiritual

ancestors as well.

Now think forward in time: our lifespan on Earth is relatively short. You yourself will be an ancestor for much longer than your time on Earth lasts. Once you go off-planet, what would you like from your descendants (including spiritual children, those whose lives you influenced, not necessarily biological offspring!). Would you like them to think of you sometimes? To actively use the good things you passed on to them?

Now tune into your ancestors. This is a very large field. In mathematical terms, it could be said to run to infinity. Ask one ancestor to step forward (not necessarily someone you know or are aware even existed). Have dialogue across time and generations. Ask if this person has some spiritual guidance for you. Then draw a picture of this person, it does not matter however clumsy or basic your picture turns out. What matters is that you invested time and effort in doing this exercise and drawing it! Also, write down the guidance they gave you. If you enjoyed this exercise – or if it brought you food for thought – do it at regular intervals, allowing different ancestors to step forward.

Consider making a dedicated gallery or Ancestor Tree!

In our house there is one wall dedicated to the ancestors on both sides of the family (meaning my husband's side and my own). I light candles there. I make small offerings on feast days and birthdays. I tell them the family news and ask them to watch over family members in need of extra support, and so forth.

Fellow author and friend Laura Perry has kindly given me permission to share her idea of **An Ancestor Tree** and **One Empty Frame.** She writes:

My ancestors have a special place in my life. They provide a focal point for my shamanic practice and they give me a sense of purpose and direction. I know who I am because I understand who they are. The earliest religious traditions probably centered

around the ancestors, those on whose shoulders we stand. It is not necessary to have a good relationship with your living relatives or even to know who they are (adoptees, take note) in order to honor your ancestors. The people you come from live on within you, in your blood, in your bones. Your DNA is their DNA. In fact, your mitochondrial DNA (mtDNA for short) traces back through the female line in your family to the ultimate grandmother of all your grandmothers. If you are a man, your Y chromosome does likewise for the grandfather of all your grandfathers. They live in you. There are many different ways of honoring the ancestors, many varied traditions from around the world and across time. One of my personal favorites is the Ancestor Tree we put up every year for the winter holidays. On it we display photos of family members who are no longer living, along with one empty frame to represent the ones whose faces we will never know[4]

Notes

1. *Magnificent Molas: The Art of the Kuna Indians* by Michel Perrin, Flammarion, 1999
2. The Way of the Shaman by Michael Harner, 1992, HarperSanFrancisco
3. *The Creative Explosion: An Inquiry into the Origins of Art and Religion* by John E. Pfeiffer, Joanna Cotler Books, 1983
4. You can see a photograph of Laura Perry's Ancestor Tree in her Bread of the Grandmothers project: http://agentleheart. blogspot.co.uk/2014/01/the-bread-of-grandmothers-project.html and her blog can be found on http://www. lauraperryauthor.com/blog).

Chapter 7

Outsider Art and Inner Wisdom

The great cosmic illusion is a hierophany ... One is devoured by Time, not because one lives in Time, but because one believes in its reality, and therefore forgets or despises eternity.

When the sacred manifests itself in any hierophany, there is not only a break in the homogeneity of space; there is also revelation of an absolute reality, opposed to the nonreality of the vast surrounding expanse.
(Mircea Eliade, *The Sacred and the Profane*[1])

William Blake 'neither wrote nor drew for the many, hardly for work'y-day men at all, rather for children and angels; himself "a divine child," whose playthings were sun, moon, and stars, the heavens and the earth.'
(Alexander Gilchrist, *Life of William Blake*, 1863[2])

Colour is the keyboard, the eyes are the harmonies, the soul is the piano with many strings. The artist is the hand that plays, touching one key or another, to cause vibrations in the soul.
(Wassily Kandinsky, *Concerning the Spiritual in Art*[3])

Outsider art

The term Outsider Art, was coined by art critic Roger Cardinal as an English synonym *for art brut*: raw art or rough art. In turn, this was a phrase coined by the French artist Jean Dubuffet to describe art that is created outside the boundaries of official culture (with a particular focus on individuals with mental health histories and children.

The English phrase Outsider Art has come to encompass an even wider range of artists, such as artists who are self-taught or make so-called naive art. People with such profiles often have little or no contact with the mainstream art world or art institutions. Their art can depict a wide range of subjects, such as extreme mental states, unconventional ideas, local customs and village life or even elaborate fantasy worlds.

The term is sometimes used as a catch-all phrase for any art created outside the mainstream art world of galleries and museums. Using this definition, my own art and the art made by my students all over the world could be classified as Outsider Art as much as Sacred Art.

Traditionally, shamans have always lived on the very edges of their communities because this made it easier for them to walk between the worlds. This was not just a physical location; it is as much a mental and spiritual state. Their task is to navigate worlds seen and unseen, and mediate between the inhabitants of these worlds. Often shamans are also 'psychonauts' because they venture deep in the human psyche, even the shadowlands that the average person avoids at all cost, in order to preserve the status quo (their mental stability and social adjustment). Shamans often blur the boundaries of gender identity as well. For more about this please check out my 2017 art video exploring this topic: "Bow Woman and Alder Man".[5]

Your mind is like an unsafe neighbourhood; don't go there alone.
(Augusten Burroughs)

Heyoka or Sacred Clown: renewal through upheaval
While I am on the subject I will also mention the figure of the sacred clown (or heyoka), jesters and jokers as taboo breakers. Heyoka is a Lakota word and refers to someone who speaks, moves and acts in ways completely opposite to the people

around them. They do things upside down or back to front, thus challenging all conventions. They may wear their clothes back to front (and inside out), speak backwards or strip off when temperatures drop below freezing. Their fooling around makes those around them question things.

Even in our culture clowns walk on their hands and make jokes with tears painted on their faces. Children love the way they challenge the established order, which is why we hire them as entertainers at children's parties! In a sense the figure of the sacred clown is related to the archetype (or cosmic blueprint) of the trickster as in any cosmology (or mythology) trickster are forever upsetting the apple cart. In Norse mythology, this is Loki. Through this process of overturning things, renewal occurs as seeds are planted for new beginnings. This is not to say this process is always funny or pleasant, when 'renewal by means of deconstruction of the old' occurs! Nothing is further from the truth! Hiring clowns with balloons at parties may well be an unconscious way of introducing children (the next generation) to this cosmic dynamic of upheaval and renewal in a light-hearted way!

William Blake

One example of an artist who operated almost as an outsider in his own time but who has since gained more widespread acceptance in our time (as such things are not static or carved in stone) was William Blake.[6]

In the art history lectures at Art School I attended in Amsterdam, Blake's artwork was introduced as a private cosmology with many spiritual layers of symbolism. Our teacher did a slide show of his work and I still remember the physical impact of these images. Deep within myself a small voice commented: *'I want to paint like that ... I too want to focus on painting spiritual beings and the alchemical processes of soul transformation ... and though Blake was not understood by his contemporaries, his work*

made sense to people who lived later ... so we can't let contemporary tastes dictate what kind of art we make ... we can only follow a deep inner calling ...' Seeing his work for the first time was a revelation for me.

William Blake was an English poet, painter and printmaker who received little recognition during his lifetime. However, today he is considered a seminal figure in the history of the poetry and visual arts of the Romantic Period. His work was about embracing the imagination as 'the body of God' or human existence itself. His earlier work is described as a protest against dogmatic religion. Blake carves a distinctive vision of a humanity redeemed by self-sacrifice and forgiveness, while retaining his earlier negative attitude towards what he felt was the rigid and morbid authoritarianism of traditional religion. He was ahead of his times (and possibly equally behind his times!) in wishing to *achieve wholeness of body and spirit,* as psychoanalyst June Singer writes in her Blake study *The Unholy Bible.*[7]

Art inspired by people with mental health histories

Those who talk to God are spiritual, but those to who God talks back are schizophrenics.
(David Tacey, *Gods and Diseases*[5])

Der Blaue Reiter (The Blue Rider) was a group artists that joined forces in rejecting an established art association (Neue Künstlervereinigung München) because they felt that its principles had become too strict, traditional and confining. The group was founded by a number of Russian emigrants, including Wassily Kandinsky, Alexej von Jawlensky, Marianne von Werefkin as well as German-born artists such as Franz March, August Macke and Gabriele Munter.

They became profoundly interested in artwork made by people with mental health histories and felt that the very lack

of sophistication in those people's artwork gave it immense expressive power. Examples of this were reproduced in the first (and only) issue of their publication: Der Blaue Reiter Almanac. Der Blaue Reiter movement lasted from 1911 until 1914, the start of World War I. Macke was killed in 1914 and Marc in 1916; Paul Klee was also involved and he continued to draw inspiration from these 'primitives'.

The artists shared a fondness for the colour blue. For Kandinsky, blue was the colour of spirituality: 'the darker the blue, the more it likens human desire for the eternal' (Kandinsky, 1911, *On the Spiritual in Art*). Artistic approaches varied as all artists shared a desire to express spiritual truths through art. They shared a spontaneous and intuitive approach to painting. They believed in a connection between visual art and music as well as the spiritual and symbolic associations of colour. Collectively they were interested in European Medieval Art, Primitivism and the contemporary non-figurative art scene in France. Essentially this means that they had encounters with Cubism, Fauvism and Rayonist ideas *(Rayonism or Rayism was a style of abstract art that developed in Russia in 1911)*.

> The deeper the blue becomes, the more strongly it calls man towards the infinite, awakening in him a desire for the pure and, finally, for the supernatural ... The brighter it becomes, the more it loses its sound, until it turns into silent stillness and becomes white.
> (Kandinsky, *ConcerningtThe Spiritual in Art*[3])

Kandinsky is painting music. That is to say, he has broken down the barrier between music and painting, and has isolated the pure emotion, which, for want of a better name, we call the artistic emotion. Anyone who has listened to good music with any enjoyment will admit to an unmistakable but quite indefinable thrill. He will not be able, with sincerity, to

say that such a passage gave him such visual impressions, or such a harmony roused in him such emotions. The effect of music is too subtle for words.
(Michael T. H. Saddler (trans.) in *Concerning the Spiritual in Art*)

In the 1920s, Dr Walter Morgenthale published a book titled *A Psychiatric Patient as Artist*, about a man called Adelf Wolffli who was a psychotic patient in his care. He produced some monumental works (such as an illustrated epic in 45 volumes running to 25,000 pages!).

In 1922, Dr Hans Prinzhorn published a book that was the first formal study of psychiatric artwork based on thousands of examples from European institutions. This got the attention of well-known avant-garde artists such as Paul Klee, Max Ernst and Jean Dubuffet.

Edward Adamson was a British artist and the Father of Art Therapy. One of his patients was William Kurelek who was treated for schizophrenia. Adamson was the first artist employed by the National Health Service (the public health care system in the UK). He was the Head of the first British Art Therapy training at St. Albans School of art (now merged with the University of Hertfordshire). This is the very course I joined when I first moved to the UK!

Divine madness

When people ask why I paint they usually expect to hear a lofty response about divine inspiration striking like lighting or the Muse visiting, but the stark truth is: *I paint to stay sane!* Not painting for periods makes me ill and profoundly unhappy. For me painting unfailingly restores the connection to both my authentic self (as opposed to the socially adapted self that everyone and I present to the world) and the on-going process of Creation that lives at the heart of the Universe. I have never

been diagnosed with mental health issues; I can't say that I am a tormented soul. I am fortunate to have a stable personality and a rich inner world. Having said that (and having grown up in a family where mental health issues exist), mental health histories are not alien to me. I have seen them close up. I have grown up with them. I have often wondered why I am not affected by this personally. Perhaps it is because I paint.

The focus of Der Blaue Reiter on the art of people with mental health histories leads us into the classic riddle about a connection between insanity *(let's rephrase to mental health issues)* and artistic ability.

Below I will list questions that rise to the surface and continue to spark off regular debates even in the twenty-first century.

1) Does an artist need to be unhappy (a tortured soul) to create great works of art?

2) Is there an inherent connection between mental health histories and art? Are people with an artistic temperament more prone to mental health issues or do people with mental health issues (sometimes) make such amazing art because the normal boundaries we operate in polite society do not apply?

I found a very helpful online article published by the Yale News.[4]

Apparently, the link between creativity and histories of mental health was made at the time of Plato and Aristotle. Plato's work, Phaedrus (composed c. 370 BCE) features Socrates discussing *Four Kinds of Divine Madness*:

From Apollo – the gift of prophecy,

From Dionysus – the mystic rites and (temporary IA) relief from present hardship,

From the Muses – poetry,

From Aphrodite – love.

Socrates essentially says that human beings are ruled by two

principles: one is our inborn desire for pleasure and the other is our acquired judgement that pursues what is best. So perhaps *a dialectic swing* operates deep within us.

Tolstoy, Van Gogh and Nietzsche had brilliant minds and creative gifts but all suffered from mental health issues.

Specific types of psychopathology have been associated with creativity: mood disorder, psychosis-proneness and all sorts of subclinical, eccentric and odd behaviours, even drug and alcohol abuse. Psychopathology and creativity may well share genetic components. One such component is Latent Inhibition (LI), a cognitive mechanism that allows people to filter out irrelevant stimulants. People prone to psychosis have reduced abilities to repress irrelevant information. Creative people also have low LI but their relatively high intelligence keeps them from exhibiting psychopathologic behaviour.

The combination of a very high IQ but low LI is a highly significant predictor of creative achievement. Reduced LI allows such an individual to access a large amount of sensory and internally generated stimuli but their IQ allows them to process the additional information without becoming overwhelmedBut Hessler argued that the link between creativity and mental health issues is less explicit than Carson suggests, though she does believe there is some connection. . Here are words spoken by Moore, a patient of Hessler in the article:

... I think I had the ability to be an artist before my mental illness ever took hold [...] "I was a great con artist in deceiving myself, but through art therapy I was able to use a medium other than drugs to express myself. I try to live outside the box, and whether mental illness is driving that or not, I don't know.

Sylvia Plath and Virginia Woolf are often cited as examples of the correlation between creativity and mental health issues in

women. Successful artists put themselves under pressure to be creative, which may just have consequences for their mental health.

Numerous studies have demonstrated correlations between creative occupations and people with mental health histories. There are cases that support the idea that mental health histories can aid in creativity, but it is also generally agreed that these issues do not have to be present for creativity to exist.

Exploring the connection between 'madness' and 'genius' it seems there is another distinction we need to make: there are different types of geniuses (literary, creative, scientific etc.). My Latin teacher would roar from beyond the grave that the correct plural of this Latin word is genii! People may be a genius in one category (some are all-round geniuses) but perform at average (or even below-average) level in other areas. Have you ever met someone who is a genius in Physics but doesn't know how to conduct him or herself at a cocktail party?

Individuals with mental health issues are said to possess a capacity for seeing the world in an original and unique way. They may literally be seeing things that others cannot perceive. That description also fits shamans!

Expressionism and Impressionism

Expressionism was a movement that originated in Germany at the beginning of the twentieth century where the focus was on expressing the meaning of emotional experiences as opposed to everyday external reality. Often radical distortions are used to evoke moods and ideas.

Some claim that the term Expressionism was coined as meaning the opposite of impressionism. An Expressionist expresses him or herself (their inner world) while an Impressionist focuses on an accurate depiction of light and its changing quality (often using tiny brush strokes to indicate movement). Their focus is in the external world, not the inner world of the artist. Impressionism

originated in Paris where a group of artists gained prominence in the 1870s and 1880s.

Dialectic Swing

This brings us to the concept of the Dialectic Swing. Georg Hegel (1770–1831) was a German philosopher. He claimed that there is an absolute spirit at the centre of the universe who guides all reality. According to the dialectic process, there are three laws that all historical developments follow:

1. Each event follows a necessary course,
2. Each historical event represents change and progress,
3. Each historical event tends to be replaced by an opposite, which is later replaced by a resolution of two extremes.

This third law of the dialectic is also known as the 'Pendulum Theory' often discussed by both scholars and students of art history. It refers to the process whereby we observe how events swing from one extreme to the other before coming into balance at the middle point. The extreme phases of this process are referred to as *thesis* and *antithesis* and the resolution is called *synthesis*.[1]

Hegel believed that humans can comprehend the unfolding of history and he viewed the human experience as absolute and knowable. Not everyone will agree with this but to see the process in action just look at elections and voting. The UK was part of the EU and now just set in motion plans to leave the EU through Brexit. With some luck, the ultimate and balanced outcome will mean finding a middle path, though we won't know for some time.

Muses and museums

The ancient Greeks believed that creativity came from the Muses (often described as mythical personifications of the nine

daughters of Zeus but to me as a shamanic teacher they are divine archetypal or primordial essences – real beings – we can connect with using shamanic techniques).

The Muses were deities that gave artists, philosophers and individuals the necessary inspiration for their process of creation. All ancient writers invoke them at the beginning of their work. In both the Odyssey and Iliad, Homer asks the Muses to help him tell the story properly and they remain timeless symbols of inspiration and artistic creation.

The Greek word 'mosis' literally refers to desire or wish and our word museum comes from the Muses! As an (amateur) cellist and night sky fanatic, I just love the fact that astronomy is a sister of music!

The traditional names and specialties of the Nine Muses, daughters of Zeus and Mnemosyne are: *Calliope* (epic poetry), *Clio* (history), *Erato* (love poetry and lyric art), *Euterpe* (music, especially flute), *Melpomene* (tragedy), *Polymnia* (hymns), *Terpsichore* (dance), Thalia (comedy and *Urania* (astronomy).

Then there is the English verb to muse: 'to reflect, to be absorbed in thought', mid-fourteenth century, from Old French muser (twelfth century). 'To ponder, dream, wonder, loiter, waste time', literally 'to stand with one's nose in the air'. (Or possibly, 'to sniff about' like a dog who has lost the scent.) Also, from muse 'muzzle', from Gallo-Roman musa 'snout', of unknown origin (From my "favourite website": www.etymonline.com).

So if you end up experiencing any form of creative block while engaged in these disciplines, call on the Muses and observe what happens!

Walking between worlds

One of the jobs of a shaman is to 'see with his or her eyes closed', to see what remains invisible to others. In shamanism, we often discuss not only the connection between creativity and

mental health but also the fine line between those with mental health histories and those acting as shamans on behalf of their communities.

What I have concluded from participating in years of lively discussions with teachers and colleagues is this:

People with mental health histories sometimes find that their psyche and sense of self fragments. This means that they become more open to impressions (as well as intrusions) from other realms. Those other worlds remain a closed book for the average person. It is easy to live as if they do not exist. For instance, people with schizophrenia are often found wandering around those astral realms where they get lost, frightened or cannot find their way back to the world of everyday consensual reality. The difference is that shamans also walk between those same worlds, but shamans do so at will. They have a map and destination. They can return (safely and with priceless information).

Taking this shamanic perspective on mental health issues even one step further, I would say that in our current cultural climate most things are seen as coming from our inner world or psyche (the unconscious included). People hearing voices are said to be having 'auditory illusions'. Well, as a shamanic practitioner I have heard voices all of my life, and on many occasions, I have received life-saving or healing information that way.

Hearing voices and the need for spirit release work

Hearing voices is not always a positive experience though. Some people hear persistent voices telling them to harm others. In a similar way, people may suffer from paranoia, the sense that 'someone is out to get them' or that there are intruders in their energetic field or psychic space. Recently, I read a good book that actually explores this issue in a respectful and open-minded way: *Talking to the Spirits: Personal Gnosis in Pagan Religion* by Kenaz Filana and Raven Kaldera, especially Chapter 8: 'Mad Wisdom – Gnosis and Meds' .[8] The authors let people with mental health

issues, who practise shananism, speak for themselves and their conclusion is that the difference between hearing voices (in the sense of mental health issues) and talking to genuine spirits is distinct. They give guidelines for telling the difference between the two, which makes it a welcome book, as there is a lot of fear and prejudice surrounding this subject in our culture.

In our society, we have lost the art of psycho pomp work (escorting the souls of the dead to their proper destinations in the afterlife). This means that large numbers of people now die without a personal cosmology (some kind of spiritual map or understanding of how the worlds hang together) or without firmly believing that our consciousness evaporates when our body dies. From the shamanic point of view, this can mean that the death process (soul transition) is compromised. The souls of the dead then often cling to human beings still alive.

This scenario is called possession. In popular culture this word is often used as an insult, 'she carried on like a woman possessed', but our belief in a Christian heaven stops us from realising what other and older cultures have always known: that having the souls of deceased people attached to us is a serious spiritual affliction requiring specialist help. When shamans do this,we call it *depossession* or *spirit release work*. It has been known to restore sanity to people who were extremely disturbed before.

To sum this segment up, not only is there a connection between creative minds and mental health histories, there are also similarities between people with those histories and shamans. (Some people will read this book and think the author admits to hearing voices, she is clearly insane ...)

What is inspiration?

Back to art and the creative process: what then is inspiration?

By now you will know that I am bit of an etymology freak: here are three meanings of the word *inspiration*:

1. (Theology) A supernatural or divine influence of prophets, apostles or writers allowing them to communicate moral or religious truth with authority,
2. (Physiology) The act of inspiring or breathing in, as in drawing air into the lungs,
3. Exercising an uplifting or stimulating influence on the intellect or emotions of others ('you inspire me!').

In everyday culture, the thinking is that a creative genius has a head full of ideas popping like popcorn. However, committing to shamanism as a spiritual path for me was akin to having the back of my head blown off, so my own mind and the Universe became ONE. The difference between Me and Other dissolved. There is no limit on the amount of ideas I can have because they are drawn from a Divine wellspring that is way larger than my human ability can conceive of.

Writer's block (or the visual artist's version: Blank Canvas Phobia) never comes calling in my life because literally anything can be inspirational. I could look out of the window right now, or listen in on a conversation my children are having (or do a million other things) and write a poem or short story about it. I often do! When I am asked to write an article, I will ask my spirit allies to start the flow and off we go.

The mead of poetry

In Norse mythology, the Mead of Poetry (Old Norse *skáldskapar mjaðar*) is a divine beverage. Whoever drinks from this becomes a skald (bard, poet) or scholar, able to provide an answer to any question or recite any information requested (*Prose Edda*, Skáldskaparmál).[9]

We live in a culture that values intellectual achievement. As discussed earlier, a schism between science and the Church opened up several centuries ago. In medieval times, trees were seen as *the thoughts of God* and everything had its place in a

larger Divine Plan. Today we have become arrogant. We credit our own mental powers and not necessarily the gods that bestow intellectual gifts on us.

When I teach sacred art courses I always say (in class and in the course description) that gods, goddesses and spirits are our true teachers! I open safe sacred space, I facilitate, I share my own process and discoveries but beyond that point, I hand the process over to beings larger than myself. It is in that space that miracles occur and people are blown away by the power of the work.

Activity#7 Write a Poem at a Bus Stop (Or in a Dentist's Waiting Room)

My intention is for this activity to demonstrate that the Universe is always communicating with us (not only that, this same Universe has a great sense of humour!). This means that inspiration is absolutely everywhere around us.

Keep a notepad and pen on your person and start making notes of what comes to attention. You will soon discover that there is a quirky intelligence at work that mirrors your own mindset. By this, I mean that on a good day you may see funny and affirmative messages everywhere. On a difficult day, everything you see seems to confirm that life is a Vale of Tears. The whole reason of becoming aware of this learning is that 'what we focus on grows', meaning that our own mindset very actively co-creates reality. (For the sceptics, this process goes well beyond the rational explanation that we are 'always picking out of our larger field of awareness whatever we want to find'.)

For about an hour, become willing to suspend your disbelief and time-travel back to the magical mindset of the child you once were! (And, yes, you can do this exercise with a child!)

Look at the (disjointed) words you have written on your notepad. Next time you are 'becalmed' in a space no one associates with creative work (bus stop, train, London Underground,

waiting room of a doctor or dentist etc.) write a quick poem stringing and connecting those words together. This poem may well verge on the nonsensical, absurd or extremely whimsical and does not need to be submitted for publication or shared with others. If at all possible share it with a young child who is likely to appreciate it!

Congratulations! You have just written a poem! You did not need a studio to make High Art not did you need to take time out from your hectic twenty-first- century schedule. Well done!

I once performed a shamanic healing session with a client that was all about arriving at better personal boundaries. We looked out of the window and there was a van parked outside my house titled CACTUS SECURITY – you can't make such things up!

Another time the spirits told me that I needed to bring a real tree into the room for an ancestral healing session. I told them: this is crazy, you have gone too far this time! I walked my children to school and came home 15 minutes before the session, someone had dumped a potted Christmas tree by our front gate. Dump isn't the right word perhaps. Someone had kindly *delivered* the perfect living breathing tree we used for our work that day!

Notes

1. *The Sacred and the Profane: The Nature of Religion* by Mircea Eliade, Harvest Book, 1959
2. *Life of William Blake by Alexander Gilchrist*, first edition 1880, reprinted in 2010 by Cambridge University Press
3. *Concerning the Spiritual in Art* by Wassily Kandinsky, George Wittenborn, 1966
4. http://yaledailynews.com/blog/2006/04/20/panel-discusses-link-between-art-insanity/
5. Bow Woman and Alder Man, art video by Imelda Almqvist, 2017, https://www.youtube.com/watch?v=4a1CSgsJV5k&t=19s

After meeting those two deities in the forest in Sweden, I found the following article by Raven Kaldera extremely helpful and insightful: http://www.northernshamanism.org/ergi-the-way-of-the-third.html

6. *William Blake, Complete Collection,* CreateSpace Independent Publishing Platform, 2017

7. *The Unholy Bible: Blake, Jung and the Collective Unconscious* by June K. Singer, 1986

8. *Talking to Spirits: Personal Gnosis in Pagan Religion* by Kenaz Filan and Raven Kaldera, Destiny Books, 2013

9. *The Prose Edda: Norse Mythology* by Jesse L. Byock, Penguin Classics, 2005

Chapter 8

Where Shamanism Meets Art

Creativity is intelligence having fun.
(Albert Einstein)

I remember a moment when I decided that whether or not the world was magic, it was better to live in it as though it were. There is no future in nihilism.
(Caroline W. Casey, *Making the Gods Work for You*[1])

Oracles are never what they seem. For oracles to be oracles, they have to contain something hidden. The more you think you understand them the less you probably do. That's where the danger lies. As ancient Greeks said, the words spoken by oracles are like seeds. They contain a fullness, a pregnancy of meaning, dimensions of relevance that only become apparent with time.
(Peter Kingsley, *In the Dark Places of Wisdom*[2])

What is in and what stays out

In his book *The Sacred and the Profane*, Mircea Eliade[3] discusses the concepts cosmos and chaos. He says that traditional societies understood their own territory as *cosmos*, a world created out of primordial chaos by their gods, with surrounding territory remaining as *chaos*. Any extension of its territory was understood by a society as a repetition of the cosmogony, of the original divine act of creation of its world.

He also discusses sacred places and uses the example of a church, whose door is a threshold between the profane on the outside and the sacred inside. Earlier cultures used sacred enclosures (the Greek word for this was *temenos*, which opened

upwards to the sky or world of the gods.

Temenos (Greek) τέμενος; plural: τεμένη, *temene* is a piece of land cut off and assigned as an official domain, especially to kings and chiefs or a piece of land marked off from common uses and dedicated to a god, a sanctuary, holy grove or holy precinct.

In today's world, we are very much aware of the concept of personal space and boundaries. We all individually make choices about *what is in and what stays out.* We operate privacy settings.

Earlier in this book, we have talked about tribal art being created following fundamentally different principles from Western art. The field of conventional Western art history excludes large groups of people, many periods from history and a very large number of contemporary artists and craftspeople.

Being in right relationship

We have discussed what art is and the manifold expressions it takes across time, cultures and continents. We have also discussed what shamanism is and how that translates into spirit-led ways of working, living and making art.

We live at a time when learning has been chopped up into segments – not unlike a loaf of sliced bread. We now study (and perceive), for example, physics, philosophy, biology, astronomy and art as different subjects. We also know that we only need to look at Leonardo da Vinci (to give the most obvious example) to see that this was not always so. Artists dissected humans to study internal organs, muscles, unborn children in the womb, etc. For the ancient Greek philosophers there certainly was no division between mathematics, philosophy and astronomy. Today those subjects have acquired 'shadow twins' as it were (meaning fields of study seen as dubious, not held in high regard), such as, science/alchemy, mathematics/numerology/sacred geometry,

astronomy/astrology and so forth.

In earlier chapters, I have emphasized and explained that in shamanism All That Is is ultimately One; everything we perceive as separate (including ourselves) is one strand in a much larger Web of Life. In shamanism (and I know most people find this principle hard to swallow) there are no hierarchies, meaning that a human being is not seen as inherently more valuable than a spider, frog or mountain. They/we are all life forms and part of Creation. We all have our unique place. Shamanism certainly does not accept the Christian concept of 'dominion over animals' as that has led to another split: incredible levels of cruelty and abuse in farming for instance. In Pagan times, farmers were aware that they could only exist in partnership with the spirits of the animals in their care. Abusing those animals meant starvation in winter.

This is even more obvious in hunter-gatherer societies (of the past, however, some still exist today). When an animal sacrifices its life and body so we humans can eat (have clothing, shoes, materials for tool making etc.) we owe it respect and honouring. Most hunter-gatherer societies are aware of a fearsome figure called The Lord of Animals (or in the case of the Inuit, a female Sea Keeper called Sedna who lives on the bottom of the ocean). The Greek goddess Artemis was such a Mistress of Wild Animals. Those great cosmic spirit figures (however they present and whatever 'local identity' they take on) are said to control the game. When human actions offend them, they will withhold their children meaning no game or no fish and in earlier times that literally meant starvation and death for communities.

The same thing goes for plant and tree spirits as well as weather spirits. People knew that for survival they depended on being in right relationship with nature spirits, weather spirits, the ancestors, plant spirits etc. It was gratitude, appreciation and proper honouring (through offerings and ceremonies) that closed the circle and kept the larger life cycle vital, healthy.

Indigenous elders are desperately trying to make us (Western individuals, politicians, decision makers) see the error of our ways. And remember, we elect politicians and leaders to make decisions on behalf of the collective but we all individually have decision power too (what to eat, where to shop, what companies or craft people we support etc.). We may well feel small and powerless but taken over an average human life span, even one human being has a tremendous impact on their surroundings and millions of choices to make along the way!

In this light, just take a moment to think of what we are doing to the environment, indigenous peoples who do not live and think in our materialistic money-focused way, animals, rainforests, oceans, the ice caps etc. Look at the enormity of the price those people, places and beings are paying for the Split that we arrived at. For that reason one of the key principles I operate when teaching art is that All Is One – the return to sacred wholeness is a top priority in our work.

In 2017, I wrote an article titled 'Eco Not Ego' for *Pagan Pages* magazine after I had a dream where humanity appeared as a class of children taking roles in the school play.[4] The teaching of the dream was that we must not over-identify with our roles. Our primary job is to function well in a larger eco-system. Sadly, modern humans mostly function in ego-systems. We can learn major lessons from plants and trees in this regard. I recommend the book *The Lost Language of Plants* by Stephen Harrod Buhner.[5]

Even the field of Art has been divided into arts and crafts, sacred art and modern art, high art and low art etc. One of the guiding principles in my own work and teaching is that there are no 'low' or 'high' forms of art. There are only individuals following a unique calling to make things. The materials they use are sacred because they are gifts from the Earth and other life forms. When artists are aware of this dimension to their work, they know that they are making sacred art. For instance, many drum makers and rattle makers or carvers of animal fetishes are

perfectly aware that they are making sacred tools for others. Those objects usually come with instructions for honouring the spirits and elements that went into the making of the item.

I am not overly concerned with the divisions that exist in shamanism today (many different expressions of shamanism in different locations, core shamanism as a very particular form of 'neo' shamanism, Norse shamanism, Celtic shamanism, Mongolian shamanism, reconstructionist forms of shamanism versus traditions from an extant living lineage etc.). In this book I am using the word shamanism in its widest possible sense to refer to spirit-led work, work guided by other worlds and spirit helpers, work involving luminous beings and other dimensions. All of the words one could choose in this context have their associations and limitations. For me, 'shamanism' remains the best (but not perfect) choice for this book!

Activity #8 Self-Portrait in Collage Form

I want to include some art activities that do not require conventional artistic ability. Collage is a good example: anyone (with fine motor skills) can cut pictures from magazines and put together a new picture from the various bits.

People who do not have the fine motor skills to enable them to achieve this could perform this exercise on a computer or iPad (or even their phone) instead. Bring up some pictures you like and select a tool or programme for image enhancement or manipulation. Go mad! Make sure to save many versions and editions you are working on so the process doesn't become too 'precious' (fear of losing the result of a 'happy accident') and later you can select the results you like best.

Get hold of some magazines, they do not need to be glossy and expensive! Here in the UK the Sunday papers often have supplements in magazine form. (Tip: rather than putting perfectly good magazines in the paper recycling, take them to your local nursery or primary school instead. The teachers usually also

welcome the gift of collections of boxes, toilet rolls, spare fabric or ribbons etc., for their classrooms full of budding artists!)

Cut pictures (or segments) from magazines that have some connection to you. Don't take this too literally, I'd prefer you to run wild with this! For instance, I have always dreamed of having a mad mass of auburn curly hair, but, in reality, my ancestors gave me wavy dirty-blonde hair. For the purpose of this collage, I would find the abundant chestnut hair of my dreams!

Do you often feel that a black jaguar follows you around or that your soul has leopard spots (one of my sons is a jaguar boy)? Then draw that in or select a picture of leopard fur for skin. If you enjoy this exercise, you could do several self-portraits along these lines: me with seagull sitting on my head, me as an animal in a family of humans etc. You can play around with the dimensions of gender, skin colour, background or location etc. Try to stretch your own perception of yourself to the very limit so no one looking at this picture would even think it is you. What does this tell or teach you? Did it help you tap into parts of you that seek expression? How can you honour those aspects in your everyday life?

Notes

1. *Making the Gods work for You* by Caroline W. Casey, Piatkus, 1998
2. *In the Dark Places of Wisdom* by Peter Kingsley, Golden Sufi Center, 1999
3. *The Sacred and the Profane: The Nature of Religion* by Mircea Eliade, Harcourt Australia, 1959
4. 'Eco Not Ego', article for Pagan Pages magazine by Imelda Almqvist, http://paganpages.org/content/2017/05/eco-not-ego/, May 2017 edition
5. *The Lost Language of Plants: The Ecological Importance of Plant Medicine to Life on Earth* by Stephen Harrod Buhner, Chelsea Green Publishing, reprint 2002

Chapter 9

Mystery Schools

Darkness inspires awe.
(Euripides, *The Bakchai*)

If rebirth does not take place, the psyche – that part of us that encompasses both the ego and the unconscious – withdraws its energy and we are drawn into a psychic underworld.
(David Tacey, *Gods and Diseases*[1])

It could be said that this process of awakening is profoundly healing. It is. The only trouble with saying this is that we've come to have such a superficial idea of healing. For most of us healing is what makes us comfortable and eases the pain. It's what softens, protects us. And yet what we want to be healed of is often what will heal us if we can stand the discomfort and the pain.
(Peter Kingley, *In the Dark Places of Wisdom*[2])

What is a mystery school?

I appreciate that most people reading this book may not instantly see any relationship between art and mystery schools or indeed know what a mystery school is!

Traditionally, mystery schools were spiritual schools or institutions (some famous ones were in ancient Greece and Rome), where participants experienced spiritual revelations and rites of passage. Generally, only initiates could participate and what actually occurred remains shrouded in secrecy because people were instructed not to share their experiences or any secrets with outsiders. Examples of such mystery schools are the Isis Mysteries, the Mithraic Mysteries, the Orphic Mysteries and

of course the Eleusinian Mysteries.

The Eleusinian Mysteries

The so-called Eleusinian Mysteries were the most famous (and most often referred to today) example of a Mystery School. As the name suggests these 'mysteries' were based at Eleusis in ancient Greece. *(We read Eleusis as just a place name but apparently the Greeks understood the word as Advent, the word that the New Testament uses for the Advent of Christ!)*[3] The core mystery at the heart of all proceedings revolved around the figures of the grain goddess Demeter and her daughter Persephone. According to the dominant accounts Persephone was abducted by Hades, the god of the Underworld. (According to other accounts, Persephone went voluntarily because she needed to leave the domain of her mother, explore sexual mysteries and achieve an independent life. Put this way we can instantly see why Persephone remains an archetype or role model for women to work with even today!) Demeter was so devastated at the loss of her daughter that she stopped the grain from growing. When Persephone returned from the Underworld to be reunited with her mother she had agreed to always spend part of the year underground. This was because she ate some pomegranate seeds while she was with Hades. Myths from all over the world tell us that eating food in the Other World forever changes our ability to live fully and *only* in this world – the world of everyday reality. People who do this become walkers between the worlds, like Persephone. The events of the Persephone myth explain how the seasons came into being.

The Eleusinian Mysteries of the Greco-Roman period were of considerable antiquity. They actually predated, what today we call, the Greek Dark Ages. This period is also known as the Homeric Age (for the fabled poet Homer) or Geometric period (a term from the art world describing geometric motifs in vase painting from that time). This era can be dated (roughly) to

around 1100–900 BCE.

The rites and ceremonies were kept secret. The learning and wisdom gained was only for the initiated. This means that today we are trying to understand what happened by consulting references that are always one step removed from the action (indirect comments or veiled references). We have no eye-witness accounts but we do have paintings (as well as pieces of pottery and other artefacts) depicting aspects of the Mysteries.

What we *do know* is that the return (or rebirth) of Persephone symbolized the eternal cycle of Life-Death-Rebirth. In shamanism today (both indigenous and modern practice) the key mystery (revelation through initiation) is still that Death is not the end. Death is a birth back into the realm of Spirit. People who know this (shamans as well as people who have survived NDEs - near death experiences, for example) lose their fear of death. It is only when our fear of Death (often expressed as denial in our culture) dissipates that we can live life to the full. As long as we are in denial, crucial life force is tied up in maintaining the illusion that 'other people die but I won't' and that illusion usually means that people assume 'there is plenty of time left to do things, or to sort out difficulties and issues with other people' meaning that they do not meet their 'soul appointments' or 'destiny dates' with key people in life. They do not show up for the challenges their own soul has chosen for this lifetime. Inevitably, we *all* die but some people die with more unlived dreams and unresolved issues than others.

For me this is one of the most 'mega' reasons for following a committed spiritual path (no matter which one we choose) because it puts a great deal of focus on living and dying well. As I know from experience (and observe in my students), this also brings us face to face with the fact that we have both ancestors and descendants. We exist on a larger continuum. Life continues even when our own personal life ends. There is a continuation of soul and consciousness after death, which may well have

been the core teaching of all mystery schools. Death means shapeshifting back from physical form to pure spirit.

Exactly the same thing happens in the (classical, tribal) initiations of shamans today: they are put through ordeals and (by Western standards) pretty gruesome dangerous experiences. In surviving those ordeals, they die an egoic death and are reborn as practitioners who can hold the holy office of walking between the worlds on behalf of their communities.

For further reading about the Sanctuary of Eleusis, I recommend the following book by Karl Kerenyi: *Eleusis: Archetypal Image of Mother and Daughter.*[4]

The Western mystery tradition

As I was born in Europe, I also want to mention in this context that European history has known Mystery Schools throughout the centuries. This is often referred to as the Western Mystery Tradition, a scholarly catchphrase for a wide range of ideas and movements that share a spiritual focus with initiates passing through levels of initiation. Well-known examples of this phenomenon are Rosicrucianism, Freemasonry and the Hermetic Order of the Golden Dawn. They all share a focus on occultism The latter exerted a great influence on modern paganism, Wicca being one example of a movement that was developed in England during the first half of the twentieth century. It combines ancient pagan principles with material from the Hermetic Order of the Golden Dawn.

The year 2012 saw a reprint of the book: *The Magical Battle of Britain*. It is a collection of the war letters of Dion Fortune edited by Gareth Knight. This provides food for thought (and meditation or even magical workings) for the times we live in.[4] Groups of people active today draw inspiration from this body of work in terms of working with issues such as political instability and terror attacks in the energetic parallel realms.

Other mystery schools

I will keep this section succinct but I just wanted to give some other examples of ancient mystery schools:

The Arcadian Cult of Despoina
Evolved around a goddess of nature, birth and death and her male consort Wanax, originating in the Bronze Age.

The Cults of Cybele and Attis
Cybele is an Anatolian mother goddess who may well have her origin in Neolithic times. In Rome, she was known as Magna Mater (Great Mother). Like any truly great goddess, she is a mediator between the known and unknown, the civilized and the wild, the living and the dead.

Attis was her consort in Phrygian and Greek mythology and a vegetation god: embodying and modelling the eternal cycle of life/growth, death (harvest) and rebirth (new seeds/new growth).
 -The Mysteries of Isis (also referred to as Isiac Mysteries)

Here rites of initiation were performed as part of the Cult of Isis. An initiate undergoes ritual purification before making the descent into the innermost part of the Temple of Isis where a spiritual or religious revelation occurred.

The Cult of Trophonius
Trophonius was said to have built Apollo's Temple at the Oracle of Delphi with his brother Agamedes. Other accounts say that they built a treasure chamber (with secret entrance) for King Hyrieus of Boeotia and stole his fortune. This Cave dropped into oblivion until the Pythia (High Priestess at the Oracle of Delphi) stated that an unnamed hero needed honouring and devotion.

Dionysian Mysteries
These mysteries used intoxicants (such as alcohol, Dionysus

is the god of the vineyards) as well as other trance-inducting techniques such as dance and music for individuals to dance themselves into a state of ecstasy, shedding all the normal social restraints. This offered opportunities especially for marginalized people in ancient Greek society, such as women, slaves, homosexuals and foreigners. (In Europe, the phenomenon of Carnival is sometimes said to have a similar function: a brief period of excess safeguarding the norm of far greater restraint for the rest of the year.)

Mithraic Mysteries

A mystery school or religion centred around the Persian god Mithras practised in the Roman Empire from the first to the fourth century CE. This cult was for men only! Participants moved through a complex system of seven grades of initiation and called themselves *syndexioi* (united by a handshake). David Ulansey[9] wrote a fascinating book where he arrives at an explanation of their key concepts and symbols based on the night sky of that period (and especially the heliacal rising of the star constellation Taurus). A highly recommended read!

Orphic Mysteries

This mystery school was said to have been founded by the legendary and mythical musician Orpheus. His mother was the Muse Calliope. His music had the power to enchant animals and people both. When his wife Euridyce dies from a snake bite Orpheus ventures into the Underworld to bring her back from the dead. Ultimately, this fails because they break a sacred promise. Orpheus is torn to pieces (please note the theme of dismemberment appearing again!) by a female group of Dionysus followers called the Maenads. Mysteriously (perhaps) Orpheus became known as the founder of a new religion and chief priest of Dionysus. The central myth of this cult revolves around the rebirth of a god.

Sabazios

Was a nomadic horseman and sky father god of the Phrygians and Thracians. A central figure was the Lunar Bull (think of the way the Moon has a phases where she resembles horns as she moves through her cycles of waxing and waning). There have been archaeological finds depicting a right hand, typically with a pinecone on the thumb and serpents encircling the wrist.

Samothracean Mysteries

These were less secretive and (unlike most) had no prerequisites regarding age, gender or nationality. Everyone could participate. Symbols appeared to initiates during a revelation. They were then given certain privileges and also a crimson sash and iron ring during the ceremony. These served the purpose of protective talismans.

Serapis

This cult was introduced during the third century BCE on the orders of Ptolemy of Egypt as a means of unifying the Greek and Egyptians in his realm. The name Serapis is a contraction of Osiris (the ancient Egyptian god of the Underworld) and Apis, a fertility god from Memphis in the shape of a bull. He is accompanied by a three-headed dog who resembled Kerberos. Usually a snake is entwined around his body and he bears the head of a dog, a wolf and a lion. Serapis had a reputation as a healing god that rivalled Asklepios! He became the god of the Gnostic movement.

A word about initiates in indigenous or tribal cultures

All the examples of mystery schools above are taken from a very specific part of the world: Mediterranean Europe. It may leave readers wondering if indigenous (or tribal) peoples operate similar wisdom schools or traditions.

The short answer is that indigenous people do not use the word Mystery School (as that is very much a Greco-Roman concept) but they definitely facilitate rites of passage and initiations. The most common examples are the gruesome initiations and ordeals aspiring (or community-selected) shamans are put through where essentially they experience a symbolic death (often skirting real death by a hair's breadth). A similar thing happens in puberty rites with teenage boys: they are taken away from their families and put through an ordeal (often involving ritual humiliation, exposure and mutilation) and when all is done they return to their communities as young men, ready to shoulder their responsibilities for the welfare of the larger community.

> In tribal cultures, which could not afford the luxury of a long adolescence with its rebelliousness, awkwardness and alienation, the teenage period was terminated by the event of initiation. Nomadic tribes could not allow members to act irresponsibly and antisocially less the fragile social ecology be ruptured. As an Aboriginal elder once told me: 'For adolescence lasts five days – the length of the initiation. Before initiation he is a child, after initiation, he is an adult. (David Tacey, *Gods and Diseases*[1])

We are living in a culture where adolescence is turning into a permanent state of being. I have talked about this a lot in interviews and on summits where I have been a presenter. Our culture is in crisis if children no longer grow up properly and are being parented by people who themselves have not fully embraced adulthood. Art and Ceremony (as well as Nature and Initiation) have a crucial role to play in our understanding of this phenomenon. Once again, I will refer to my first book for more information and practical suggestions but just one final comment: when we do not initiate people in a mature and compassionate way (proper Rites of Passage) Life will initiate us,

and not always kindly. Too many people get stuck in processes of symbolic death (addiction, suicide, self-initiation through thrill-seeking), it is preferable by far to master the sacred art of initiation. Tribal peoples still hold that wisdom in our world today – we are the 'primitives'!

Mystery schools today

Deep art is art located in utter darkness, far from daylight, twilight zones and living places.

It suggests rituals, ordeals, ceremonies and journeys underground for mystical reasons.

The silence amplifies the darkness.

In the words of one veteran explorer: 'The grass must stop growing and the stars hold their breath, to give you, above ground, any idea of that silence'.

(John Pfeiffer, *The Creative Explosion*)

Ancient as the concept of a Mystery School is, they are not (only) a thing of that past. Even today mystery schools exist all over the world, within various traditions and schools of thought. I have tried to formulate a contemporary definition of the term Mystery School:

A group of initiates who dedicate themselves to preserving and perpetuating mystery teachings about the nature of life, death and human consciousness and passing those on to others in turn. Those teachings offer the key to leading an empowered and spiritually fulfilling life.

We currently live in a period of paradigm shift bringing great opportunity and great uncertainty both (as well a great potential for chaos). In this context, it is often said that the Chinese character for Crisis also means Opportunity. Existing structures and institutions are fragmenting and falling apart (in

shamanism we use the world *dismemberment* for this). This frees up the building blocks (think of a child playing with Lego) to be used in brand new structures and creations. Having said that, it is also a time of great danger because the forces of chaos are upon us and different individuals within a collective will move in different (even opposite) directions in response to that. At the time of writing this Chapter (June 2017) the UK is starting negotiations with the EU to navigate Brexit while Donald Trump rampages in the US (many people are waiting for him to impeach himself, hoping such harmful leadership will ultimately be self-limiting). In March 2017 I wrote a blog about this titled 'Trump's Teachings',[5] which caused some controversy. Many people loved it but some Americans felt that, as a European, I had no moral right to write this. Judge for yourself!

Dismantling existing structures is one thing but then arriving at higher-vision-structures that meet the needs of specific times is quite a leap. If all of us learned how to collectively create reality following sound spiritual and energetic principles this process would be easier. If too many of us vote or create from principles of personal or financial gain (rather than the greater good of all) there will be less of a buffer for the forces of chaos and destruction to rip apart our (individual and collective) egoic structures.

Deconstructing (or dis-membering) is not enough if there is not a fully-fledged and sound vision, supported by the collective, to come in. We see this all over the world in the overthrow of dictatorships and the dismantling of walls without the inhabitants of the countries concerned enjoying greater life quality in the chaos that follows. My youngest son, who is a history buff at age 13, often asks me if I think the inhabitants of the former USSR, Union of Soviet Socialist Republics enjoy better life quality today, after the collapse of the Soviet Empire in 1991. We both agree that the old regime was followed by a period of severe instability and we are not convinced that overall

life quality for the average citizen has improved.

Forgotten gods

There is one more term I wish to mention in the context of this chapter. *Archetypal medicine* is an ancient phenomenon. It has been recognised as a potent ingredient in human health and well-being in all cultures we have documentation for. This refers to a form of healing, actively working with archetypes and blueprints of human consciousness through symbolism and myth, that starts in the spiritual realm and then spreads to the emotional and physical planes. C. G. Jung proposed that our 'forgotten gods' have become diseases in our Western society: the warrior archetype represented by the god Mars starts wars in modern times, the god Pan seeds panic and the archetypal crab might just turn into actual cancers if the signs go unheeded. The gods are aspects of us. If we repress or forget them they will appear as destructive forces active in our lives. By giving them their place willingly and honouring them, they lead us back to health, balance and harmony (inside and outside ourselves).

In Ancient Greece, a defiled god would turn wrathful and fierce; further back, in the Stone Age, a friendly spirit would turn demonic and hostile. Not much has changed in this regard

In 1929, C. G. Jung announced that the gods have become diseases, because they seem to have no other option in our lives than to become factors of disturbance. Since our minds ignore them, the only place they have left to make themselves felt and draw our attention is in our bodies – in suffering and sexual disturbances. Then we might listen, but even then, we might not. Some of us seem more prepared to suffer blindly, mutely than admit that the world might be enchanted by forces beyond ourselves.

(David Tacey, *Gods and Diseases*[1])

In my own work and dialogues with the spirits, I kept being directed to 'forgotten gods', long before I read Tacey's book and revisited Jung's work. Forgotten gods have literally knocked on my psychic door to gain admittance, in ceremonial mystery work I have performed with students. When we have responded to this, incredible layers of meaning, symbolism and healing have opened up. When a forgotten god is re-membered (the reversal of dis-membered) a 'hungry ghost' (to borrow a concept from ancient Tibetan Bonpo Shamanism) becomes an ally. It no longer needs to feed on the living or seek expression through the actions of the living. If only Western culture understood this, we would not need to remain stuck in the most brutal history repeating itself until the lesson is learned. (For more about this read C. G. Jung's writings about Nazi Germany.)[6]

If this approach sounds a bit heavy-handed or analytical you could check out the work of Caroline Casey, who calls herself a 'visionary activist astrologer'. She wrote a brilliant book titled *Making the Gods Work for You*[7] where she reminds us that the planets in our solar system were named for gods and that their Divine cosmic essence continues to influence our lives and illuminate our soul's path. (If you are not open to astrology – then it is better to go with Tacey!)

Caroline Casey invites all of us to think of our lives as a detective novel, looking for clues to our destiny and our gift to the world. Our life is a web of meaningful patterns, she says. She explains that there are two primary Buddhist paths toward enlightenment. Himayaha means lesser vehicle and it is a path of strictly personal salvation whereas Mahayana or the greater vehicle is devoted to the salvation of all creation.

I appreciate that this may sound just a little grandiose in a small book about a *big* subject but I couldn't agree with her more that vision and spirituality without social responsibility become ungrounded, narcissistic and even plain dangerous. Think of Germany in the 1930s. Think also of Jung's essay titled "Wotan"

(mentioned earlier) about collective possession by a god.

Casey's book is, above all, an enjoyable read. It gives very entertaining and very engaging descriptions of various personality types. Whatever path you take, embracing the sacred is the most healing force I know and it can release us from a very wide range of disorders, diseases, neuroses and complexes. The road back to health passes through the realm of the sacred. The road back up first leads into the (personal and collective) underworld. Those who survive this journey become teachers for others and elders in their communities.

Activity #9 Audience with a God or Goddess

People like myself who received a monotheistic upbringing often find it liberating when their adult selves are drawn to the more ancient Pagan ways of our ancestors because this allows (encourages) us to build a personal relationship with different gods and goddesses. (I have often wondered if this is not why the Roman Catholic Church operates such an immense pantheon of saints: to satisfy that human need for personal connection to the Divine, but that is an aside.)

Please set a strong intention for a god or goddess (possibly another Divine Being such as angel, giant, deva) to come to attention. Pay close attention. What books are the people around you reading, what films are they seeing, what is on the billboards of buses? Is there a name that keeps jumping out at you? No matter if it is relatively obscure and no matter if you have never felt a personal connection to this being.

For instance if Artemis, Lilith, Loki or Amaterasu are coming to attention, embark on a journey of discovery. Read up on them. Do a meditation (or shamanic journey) where you light a candle and politely request an audience with that being. If you do not get much from that (if it is too pressurized or too direct) ask this Being to send you small gifts or hints. You might be surprised at the way people around you suddenly offer you the loan of a

book or cinema ticket they are not going to use, or they invite you to a concert in their local church etc. Where normally you might say no that is not for me, say yes instead and follow the 'trail' like a spiritual detective. Sooner or later you will find (or be found by) 'something' (a presence, a being, a deity) that will touch strings deep within you. A walk on the beach may lead you into reading up on wind gods. A walk in the forest may lead you to the Celtic Cernunnos or Finnish god Tapio. You may just be led to an obscure saint, for example, Saint Anthony, Patron of Lost Things. Jude the Apostle/Judas Thaddeus, Patron Saint of Lost Causes might just be a good fit for a struggling activist or charity.

Another way is to follow leads in your own life or family. For example, my name is Imelda and I was named for the Holy Imelda, a child martyr. My grandmother was always giving me small devotional prints and telling me stories about the Holy Imelda. There was no mystery there! However, if you have the name of a goddess, read up on him/her. *(Currently Freya has become a very popular name for girls and I am sure that the Norse Goddess Freyja is behind this, coming back into our awareness!)* Read up on the names of your parents and siblings as well. Diana was a powerful goddess; Maria was the mother of God, David and Samuel were characters in the Bible etc.

Try to connect with these beings or characters. If you follow a monotheistic religion, do this only on the intellectual level. No need to compromise your faith but you may still be struck by profound discoveries that hold personal meaning.

Notes

1. *Gods and Diseases, Making sense of our physical and mental well-being*, David Tacey, Routledge, 2013
2. *In the Dark Places of Wisdom* by Peter Kingsley, Golden Sufi Center, 1999
3. Eleusis: Archetypal Image of Mother and Daughter by Karl

Kerenyi, Princeton University Press, 1991

4. 'From Hamlet's Mill: An Essay Investigating the Origins of Human Knowledge and its Transmission through Myth' by Giorgio de Santillana and Hertha von Dechend, David R. Godine, 1977

5. *The Magical Battle of Britain*, the war letters of Dion Fortune edited by Gareth Knight, The Society of the Inner Light, 1993, 2012

6. C. G. Jung in his 1936 essay 'Wotan', http://www.cgjungpage. org/learn/articles/analytical-psychology/47-jungs-shadow-two-troubling-essays-by-jung

7. *Making the Gods Work for You: The Astrological Language of the Psyche* by Caroline W. Casey, Harmony Books, 1998

8. 'Trump's Teachings', blog I wrote in March 2017 https:// imeldaalmqvist.wordpress.com/2017/03/30/trumps-teachings/

9. *The Origins of the Mithraic Mysteries: Cosmology and Salvation in the Ancient World* by David Ulansey, Oxford University Press, 1991

Chapter 10

Sacred Art Process as a Mystery School

Myth is the isthmus which connects the peninsular world of thought with the vast continent we really belong to.
(C. S. Lewis)

Myths form a bridge between the terrifying abyss of cosmological ignorance and our comfortable familiarity with our own recurrent, if tormenting, human problems ...
(Wendy Doniger, *The Implied Spider*[1])

The sceptics continue to argue, however, that God did not make man but man made God. The fact is that God and man make and remake each other, but both are real and yet utterly interdependent.

If we cannot move beyond the ego and return to God through the cultural doorway of mythos (mythology), there is only the pathway through pathos (suffering). With culture committed to the ego, rather than spirit, nature gets its revenge.
(David Tacey, *Gods and Diseases*[2])

Serving the gods and evolving in partnership with the gods

Today everything I teach, the mystery process I lead others through, is based on my own discoveries from the wonderful years of painting, reading anthropology books, travelling the world visiting indigenous peoples, caves, standing stones, grave mounds and rock art sites etc., when my three children were much younger. Of course, I did not know that I was putting together a body of work that would come full circle and travel

the world. My worldly focus was on parenting.

While I was at art school in Amsterdam, I learned to cooperate with the expectations of my teachers (but only to some extent). I obviously attended art school well before the digital age. I remember visiting Het Stedelijk Museum (the museum of modern art in Amsterdam) and seeing only frames on display (putting attention on what frames and limits an age, not the images themselves) or white canvases with rips in them (when we paint we step through portals), blurring the boundaries of what is and isn't a painting. Years later some fine art students from Goldsmith College came to an Open Studio I hosted (in London) and told me about a girl who had decided to make it her graduation art project to make absolutely no art at all, but to keep a daily journal of her reflections and anxieties along the way. The supervisor had approved of this project! I can see how such a project is thought provoking but I also thought Woah! that is nine months (an academic year or a pregnancy!) in a human life where the person could have been painting or drawing! (And I did also wonder what people with genuine writer's block or artist's block make of this.) I would never voluntarily stop painting. I painted through three pregnancies and for several years, I painted with a newborn baby parked by my easel. Just in case I ever go blind, I have already worked out that I could work in clay and make music.

Anti Object Art

The American poet Anita Sullivan kindly read the draft version of this book with a view to writing an endorsement. She suggested I check out the following extreme version of conceptual art (*meaning there is no physical item we can point to and declare art but any experience can be declared art. Audience and artist are the same*): Rirkrit Tiravanija is a conceptualist and Anti Object Artist. His art is viewed as *relational art*, meaning that it aims to bring people together. In 1990, he cooked meals and served food to

gallery-goers. The exhibition was called Pad Thai.[3] He set up a section of the Museum of Modern Art as a cafe or diner where (unsuspecting) gallery-goers were given a bowl of rice and curry. They (people who didn't always know each other) sat around a table eating together. *They became the piece of art.*

In the video on the MoMA website, no reference is made to the fact that starting in the seventeenth century and lasting well into the 1940s in large cities, artists, writers and intellectuals would host Salons, where people would gather under the roof of an inspiring host. This was partly for entertainment and partly to refine the cultural taste *du jour* and increase the knowledge of participants through conversation. These gathering were commonly held in drawing rooms where a lady (reclining on a day bed or chaise longue) would receive close friends and engage them in conversation. The focus would be on poetry, writing, art, philosophy or other cultural pursuits.

I find it a bit odd that that MoMA video does not reference this tradition, lasting centuries, in any way. My very personal take is that if we are going to make an art out of feeding people, we could choose to feed the homeless or dispossessed (people who truly go without square meals, easily found in any city or town, tragically) and call this a *sacred art*. Maybe we had better ask their permission and opinion before we call this 'no object art'.

Here in London the Salon concept has been revived in the twenty-first century by an organisation called Philosophy for All. The organiser is philosopher Anja Steinbauer who aims to bring people from all walks of life together to discuss philosophical concepts (in the largest possible sense) as well as to meet practitioners from other disciplines to expand their general knowledge. They organised a Love Salon in 2014 (a Salon exploring contemporary notions about love) where I made my contribution as an artist and shamanic practitioner. The Love Salon has since been followed by a Death Salon and other events.

And just to state the obvious, there actually were *many objects* involved (even needed) for Rirkrit's installation: tables, chairs, pans, bowls, rice, curry, ladles. Someone designed and made those objects. Trees and other sources provided the materials. Such objects can be made in a sacred way by the artist and/or craftsperson making them. I did not see any crafts people or designers credited in the video clip on the MoMA site.

Before I die, I hope to see proper exhibitions of sacred art at both the Tate Galleries in the UK and at the Museum of Modern Art in New York City (as well as many other places). I will throw out that challenge right here in this book! May my sacred dream come true! Sacred artists deserve no less!

Do we really need art made for shock value in an age of terror attacks?

I graduated from art school with a deep inner knowing I was not destined to make my mark in the field of modern (or contemporary) art. This was the year 1989 and the fashion was for making art that had 'shock value', doing something no one had done before and then calling that art. (All of those things we students did had been done before of course!) One girl in my year made a graduation series of paintings about herself making love to her boyfriend. Another girl made a series of white paintings but discovered that to truly make white paintings, you need to start with colour, or else you are just making unpainted but primed canvases (the way artists buy them from the art material store). By today's standards, those exploits were very tame. They didn't involve pickled sharks or a diamond-encrusted skull! Tracey Emin has since left our cohort far in the shade with installations such as her own unmade bed or a detailed account of having a miscarriage.

I happen to feel that the age of terror attacks we are currently living through provides the world with enough shocks and jolts. I don't think it would be in good taste to refer to such events as

'conceptual art' or 'no object art'. Do we really need art made for shock value in an age of terror attacks? I am playing Devil's Advocate here but some truly horrific events were designed by a visually creative mind (just think of the 'iconic image' Twin Towers in New York City burning and coming down).

Next, I decided to study Art Therapy in the UK. That brought many interesting concepts (and I still use some of those with students and clients today) but ultimately the process was secular. There was no Divinity or Higher Power of any description guiding the work. Spirit was not an active participant in this process. My personal conclusion (around age 26) was that we cannot harness the healing potential of art in optimal ways unless the work has a spiritual framework (any spiritual framework of the artist's choice). For me this was the period of gaining work experience in both psychiatry and education. I concluded that I had learned a lot but still not found my metier in life. I did an artist's residency with slum children in Peru and came home to start our own family. Here I will just repeat briefly that visionary activist astrologer Caroline Casey,[4] has pointed out that the word therapy originally means *to serve the gods*.

The process

Essentially my programmes take people to the place where art meets shamanism. They do not assume or require previous training in art (which in itself can impose limiting beliefs) or a high level of artistic skill or competence. *(Any process people engage in with passion and a serious commitment of time will become a teacher in its own right!)* The main requirement is a sincere willingness to engage with worlds seen and unseen using the creative process. *(Please remember that one of the definitions of the word shaman is walker between the worlds.)* I do ask for an open heart and open mind.

It is my observation, from years of teaching art and shamanism both, that great stress, tension and many power struggles

currently occur between distorted (or wounded) manifestations of cosmic forces (or blueprint). Carl Jung coined the word archetypes. (In the previous chapter, I talked about archetypal medicine.) Tribal (or indigenous) peoples as well as the earlier peoples of Europe perceived those cosmic forces as gods and goddesses. Pagan peoples still do. Author David Tacey says:

> With the absence of 'official' forms of transcendence, the tried and true way of spiritual experience is suffering. If we cannot move beyond the ego and return to God through the cultural doorway of mythos (mythology), there is only the pathway through pathos (suffering). With culture committed to the ego rather than to spirit, nature gets its revenge.

Where the normal self has been ruptured (and author Peter Kingsley uses the word *pierced*), the only option left, apart from running to others for help, is to seek reunion with the wavelike dimension at our core. By so doing, we turn to what is most profound within ourselves and ask it, implore it, to heal us, to close our wounds and grant us life.

A few paragraphs on he says that:

> Today, with so much ignorance and sentimentality attached to the spiritual domain, it is relatively easy to pass off pathology as spirituality. This is one reason why, in previous times, religious traditions insisted that every spiritual journey should be monitored by a spiritual director, who might be able to save us from the possibility of delusion or regression. But in the deregulated area of today's spiritual experience, everyone considers him or herself a master of the way, and many do not submit to genuine teachers, who admittedly are hard to find. Instead, those who are hopelessly lost in the spiritual arena are themselves likely to pose as teachers which gives a bad name to spirituality in society.

Thank you Mr Tacey! One of my reasons for writing this book is to make a strong case for, once again, offering rites of passage and experiences of initiation (in my case this occurs in the place where art meets shamanism but can also take many other forms) so people have access to safe sacred space and a spiritual mentor allowing them to develop a strong relationship to non-physical spirit allies. I sincerely hope that such experiences of secure spiritual holding (not unlike parenting) will ultimately enable people to hold space for others and act as elders (wisdom keepers) in their own communities. I know that this is a lofty ideal and a tall order; however, knowing it can be done has set me on fire as a teacher. That spiritual fire has urged and guided me to write this book.

Sacred art process as mystery school

Just as it took me time to realise that I made sacred art (not contemporary art) and that working in close partnership with spirit comes under the heading shamanism, it took me a number of years before I realised that I was essentially offering my students a Mystery School experience. The process bears all the hallmarks of the mystery schools I described in Chapter 9 such as time out from everyday life to commit shared spiritual quests with others, engagement with the Divine through direct revelation, ultimately seeing that death is rebirth (and so losing the fear of death) and all of these aspects together creating powerful rites of passage, initiations and food for creative expression.

Tomb as womb

As Western society has lost the art of offering rites of passage, people often get stuck: in grief, in chasing their vanishing youth when they ought to focus on becoming trusted elders of the community, in loneliness whereas human beings need communities and community support for their sacred dreams. Women especially can become so busy caring and supporting

others that their own needs go unmet and their inner well dries up. Mystery School work can replenish the well, help heal old hurts and unlock astounding reservoirs of creativity.

> Turner stresses the ambiguity of the novice's position: he exists in a state of limbo, dead and not yet dead since soon to be reborn, in a state of 'liminality' or 'fruitful darkness', confusion and dissociation deliberately promoted in every way, places with a double death-life connotation, caves and chambers which symbolize at once tomb and womb.
> (John Pfeiffer, *The Creative Explosion*[5])

> He (the boy undergoing initiation) may also be buried for a time, painted black or 'forced to live' for a while in the company of masked and monstrous mummers representing ... the dead, or worse still, the un-dead.
>
> The novice exists in a limbo, dead and not yet dead since soon to be reborn, in a state of 'liminality' or 'fruitful darkness', confusion and dissociation deliberately promoted in every way.
> (Viktor Turner of the University of Virginia, in a series of comparative studies of rites of passage (quoted by Pfeiffer))

In this work the boundaries between Womb and Tomb dissolve. These are one and the same.

Dream incubation and Inanna's descent

I invite you to watch a presentation I did about this work in 2016 at Threshold, the annual conference of the Gatekeeper Trust.[6] But I will also try to give more concrete examples.

One module of my 2-year sacred art programme is all about Dream Incubation, honouring the great god Asklepios. We build our own Dream Incubation Chamber (or Asklepion) as a community and then start dreaming together. In that process

various boundaries start dissolving: the boundary between sleep and waking reality, the boundary between self and surroundings, the boundaries between self and others, the boundary between illness and wellness and most importantly the boundary between everyday reality and the realm of spirit.

Last year we built an Asklepion here at my home in London, where all students took turns dreaming. They all reported that a man wearing a military uniform came to check on them and gave them crucial pieces of healing information. Then one of the students said: 'It is the man in that photograph!' The photograph was of my father-in-law in who died almost 40 years ago (and I never met him in everyday reality). My husband was overseas on business that week so I was very touched to hear that his long-dead father stepped forward from the mists of time to support our work instead.

A very different kettle of fish is the module where we stage a sacred re-enactment of Sumerian goddess Inanna's Descent to the Underworld. It is an ancient yet timeless myth. Our group consisted of women from different backgrounds and ages. The sacred enactment of this myth was profound because the ancient Sumerian gods met every person on the road they were walking, individually. They all worked through a personal issue or life experience, meaning that every round of work was unique and healing both. So an ancient myth and script from the very cradle of Western civilization does not only bring revelations and personal healing, it also offers a roadmap for navigating grief and transition.

Another way of saying this is that *when we meet the work, the work meets us*, when we undergo purification, fasting and temporary vows of silence in our desire to meet the gods, those gods will arrive and perform spiritual alchemy before our very eyes. The ancients knew this. They staged an experience, but only up to a point by creating the right circumstances, after that it was up to the gods. It was the Divine Intervention, the Deus ex

Machina (as it were) where what could have been 'just' theatre or enactment crosses over into something else: a profound spiritual or religious experience. A revelation!

A word about group dynamics

Making art yourself is one thing. Taking others into the same zone is another thing altogether. It carries far greater responsibilities. Add shamanism to the mix and things get even more edgy. There are headaches and immense revelations both! Working in the liminal zone between the worlds means working in a place where people's deepest feelings, life experiences and fears reside. Old traumas and family-of-origin dynamics all get triggered and activated in group work. So there is not only the art teaching aspect, there is also the group dynamics aspect.

For that reason, if you are a mainstream art teacher reading this book I urge you to complete training in shamanism (and additional teacher training or an apprenticeship specifically in shamanism) before embarking on something like this. This work is like dynamite. When the space is not held correctly, participants and teacher both can end up scarred for life. Know what you know and know what you do not. Observe your personal limits when you take people way outside their comfort zones!

A word about mythology

Mythology is one of those things some people get 'bitten by' and others feel it has no relevance at all for modern life. One question often asked is which gods and goddesses do people work with in my care? When I put my sacred art programme together, I was told by the spirits to introduce students to the deities and other beings from world mythology that I had an existing relationship with (after two decades of painting). For most students this provides only a starting point (spiritual dive board, if you like) and their quest continues to unfold as their

own helping spirits guide them in directions that reflect their ancestry and special interests.

Another question I am asked from time to time is: *do the gods and goddesses ever not show up?* I know that this can occur, when a group does not raise enough power to work safely, but personally speaking I have not experienced this. When students work flat out for three or four days to receive instructions, make the sacred tools etc., the gods and goddesses unfailingly do show.

What if people are into shamanism and art but not into mythology? Well, shamanism offers direct access to vast realms and their inhabitants. It is perfectly possible to leave mythology aside and go on other-world-hikes to meet spirit partners. However, from the teaching point of view I will always issue one warning: never ever introduce your students to otherworld beings (or call them into the room) unless you have experience of their energy and know you can work with those energies and frequencies safely!

Making sacred art: key principles

When we make sacred art, we work in a place beyond words. Therefore, no words will ever do justice to the process but I will still try to put into words what happens.

Here are some key principles I have formulated over the years:

Hollow Bone

Making sacred art involves becoming a hollow bone for spirit, allowing beings from other realms to come forward and work with us, often through us.

Partnership with Spirit

We are not alone in the process of making art. Beings greater than ourselves will align with us. Not only that, they will also

help the work go out in the world and create openings and opportunities for us. It is a relief beyond measure that we are not alone in this process (unless we want to be; choose to be). We are divinely guided and once we are, writer's block or artist's block does not exist (because it is an egoic condition, not a spiritual affliction).

Place of no Ego
It means pushing our ego out of the way. Sacred art is never about the greater glory of the artist (in this context remember that Medieval artists didn't sign their work because they saw it as a reflection of the greater glory of God's Creation). With my students I explain that we live in the twentyfirst century and, of course, we do sign our work and so forth (or else we will be taken advantage of and someone else will claim credit for our work). However, this is never the key consideration or main focus. We absolutely need to look after all practical aspects of being an artist, but not with a focus on achieving glory and acclaim because the spirits will guide our creations to the right places. Sometimes that is a life-changing personal gift for one person. Other times, it is an iconic image that makes a whole nation sit up and pay attention. We are not in control of that. We trust that our helping spirits and the great spirits of the sacred art process will take care of that. That frees a tremendous amount of time and headspace compared to artists working from the 'struggling and starving artist poverty paradigm'.

Sacred Wholeness, Unity Consciousness
Making sacred art is about working from a place of sacred wholeness. It is about making art that is uplifting. That reminds others of their Divine spark and Divine origin. Sacred art is art that inspires, consoles and supports shifts in consciousness, shows a higher perspective.

Much of modern art is created from a place of woundedness

or separation ('look at me and my pain') or activism ('look how awful this is!') and those things absolutely have their place. Art heals, art reveals, art unveils. However, when we truly make sacred art we pierce the Veil between worlds and our work shows a glimpse of timeless realms and the intelligence of a benevolent Universe at work (if only we let it).

Direct Revelation
On the courses I teach, I say explicitly that the spirits themselves are our greatest teachers. I am only the facilitator who has travelled this road for many years. Shamanism offers techniques for receiving guidance directly from our own helping spirits (as well as Divine Beings, Ancestors and the angelic realms). In sacred art, we take this one step further. We do not only receive guidance, we also receive works of art, messages for the world, images that have the power to touch others to the very core.

Mystery School
Over the years of teaching sacred art, I have come to see it as my task (meaning the task of the facilitator) to create safe sacred space where powerful transformation can occur on the level of soul. The gods and goddesses themselves come forward to work with us. It is not actually important how we individually conceptualize those deities (as cosmic forces, mythological characters or archetypes). As long as we work from our authentic selves and a sincere desire for connection and inspiration, those divinities will arrive! Gods and goddesses honoured this way do not need to creep in through the backdoor like burglars to get our attention and share their great teachings. Peace harmony between the worlds results. Great personal healing occurs as well.

Sacred Witness
Participants in my programmes have received their own rites

of passage from spirit and other participants have played their unique roles in this work acting as sacred witnesses and supporting cast for healing mystery unfolding. Just as one day I realised I make sacred art, not modern art, another day about ten years later I could suddenly put a word to my own teaching process: Mystery School work.

Sacred Container
One of my graduates summed up the process as follows:
'Thank you for creating this safe and sacred container, for us to birth and manifest our sacred dreams so we can leave this training, ready ourselves to create powerful containers for others to birth their sacred dreams and creative projects'.

Global Network of Sacred Artists
Making sacred art can be a lonely pursuit and not every person around you is going to understand the way you work. For that reason, I actively try to put in place local support networks for my students as well as a growing global network where people can show their work and collaborate to deepen and extend their own art practice.

The overall vision is to exchange experiences, skills and opportunities and also to help each other out with challenges that arise. Facebook has turned out to be a wonderful resource for this. I use closed Facebook groups for sacred art communities as well as public pages profiling people's work. I also use my own personal website for this purpose, promoting networks and people arriving at a personal code of ethics for making (and possibly selling) sacred art.

Online Seminars
Virtual classrooms have turned out to be a great asset too and it has been an absolute joy to connect people on different continents in real time and share the process of making sacred art and

witnessing what comes up for others. You can find all my online courses on Learnitlive but I have also made guests appearances on The Shift Network and spiritual publisher Sounds True.

Summary of Imelda's Key Teaching Principles

1) On the absolute and eternal level All Is One – the focus of the work is on a Return to Unity and Sacred Wholeness.

2) By extension, this means making art others perceive as awareness-shifting and inspiring (spiritually speaking). Art that opens portals. Art that shows others glimpses of other worlds and the Eternal Realm that awaits all of us Outside Time.

3) We do not prioritize or privilege any form of creative expression over another: on my courses people have written poetry, composed music, used pyrography, painted, sang, danced, embroidered fabrics and made themselves costumes etc.

4) The True Teachers in this process are beings from other/ higher realms guiding our hands and seeking a partnership with us: the spirits. In that partnership, they gift guidance and limitless inspiration while we provide the physical material and skills. The final product reflects the input of both parties.

5) To make sacred art we need to hollow out and learn to step away from ego consciousness. The art we make is guided by our soul and timeless selves – not our ego seeking attention or wordly gratification (this is not to say that sacred artists do not have exhibitions, sell their work or receive acclaim for their work – it just means that this is not the key operating principle, wordly success is a by-product of this way of working and for some the process will always be small-scale and private. There is no active pursuit for 'fame' and no attention-grabbing and doing things for 'shock value' either.

6) When the spirits guide us to make sacred art, we can trust

145

and request they also guide us to the right venues, contacts and communities to share this art and help it find homes. This process has a commercial aspect (honouring fair energy exchange) but cannot be driven by commercial principles alone.

7) The Art Process *itself* ultimately becomes our teacher. Over time I step back (I have only held the sacred office of guide), and my students become my colleagues in a growing network of sacred artists and sacred projects.

8) By working this way, we discover that miracles will occur! We also discover that we do not need to control how our sacred art affects others – the work has an in-dwelling spirit of its own and will make its own way in the world. Like parents, we conceive, we give birth, we allow a child to leave home and enjoy an independent life in the world.

Did you know that ...

Our word myth comes from the classical Greek word *mythos* and means story.

The most fascinating thing about the word myth is that it has two opposite meanings: basically 'truth' and 'lie', depending on your viewpoint.

In some cultures the Creation Myths are seen as the great truths that underpin human existence, truths that people honour above all else. However, in our own culture, we often use the word 'myth' as a synonym for fable or falsehood, something imagined that doesn't actually exist or didn't ever happen.

In his book *Myth and Reality*,[7] Mircea Eliade reviewed healing practices in a large number of 'archaic societies'. He emphasized that any creative act required the invocation of the myth of creation. One such example is childbirth:

When a child is born among the Osages, a man who had talked with the gods is summoned ... He recites the history

of the creation of the Universe and the terrestial animals to the newborn infant. Not until this has been done is the baby given the breast. Later, when he wants to drink water ((he)) is called in again. Once again he recites the Creation, ending with the origin of Water. When the child is old enough to eat solid food ... ((he)) comes once more and recites the Creation, this time also relating the origin of grains and other foods.

Eliade believed that by means of such rites this moment in time was directly connected to ritual time, receiving a 'super charge' in the process. This may sound long-winded (even tedious in terms of twenty-first-century attention spans and our fashion for 'tweets' and 'soundbites') but we use similar techniques in shamanic healing work where we return to the moment someone or a situation was in its original form or Divine perfection and establish a link to revitalize (or re-member) a current situation. In the anthropology books that I have read, there are accounts of tribes reciting all their creation stories before performing a community healing session. In our times, we have completely lost the understanding and appreciation of the power of such things.

Activity #10 What Is Sacred to Me?

In this book, I have used the word sacred frequently. I now invite you to free up some undisturbed time and reflect deeply on the question: what is my own definition of the word sacred – *what is sacred to me?*

I have explained earlier that the word sacred in origin refers to the inviolate core of something. Meditate on this. Make note of what comes to mind.

Then ask yourself: am I willing to stand up for what I hold most sacred?

Is it perhaps time to widen my own concept of the sacred?

Notes

1. *The Implied Spider* by Wendy Doniger, Columbia University Press, 1998

2. *Gods and Diseases: Making Sense of Our Physical and Mental Wellbeing,* David Tacey, Routledge, 2013

3. https://onarto.com/rirkrit-tiravanija-conceptualist-anti-object-artist/

4. *Making the Gods Work for You: The Astrological Language of the Psyche* by Caroline W. Casey, Harmony Books, 1998

5. *The Creative Explosion: Inquiry into the Origin of Art and Religion* by John E. Pfeiffer, Joanna Cotler Books, 19836. 'Gods of Portals, Life Transitions and Liminal Spaces', presentation at Threshold, annual conference of The Gatekeeper Trust in November 2016 https://www.youtube.com/watch?v=LzxmXAJiPLc&t=189s

7. *Myth and Reality* by Mircea Eliade, HarperPerennial, 1968

Chapter 11

Creativity under the Loop:
The Heart of Creation where Gods and
Goddesses Dance and Dream

Creativity is marked by the ability or power to bring into existence, to invest with a new form, to produce through imaginative skill, to make or bring into existence something new.
(Mark Lissick, *Igniting Imagination*[1])

This was the beginning of many dialogues with the pain god. It was the beginning of a different perception of the pain. I felt the pain now to be a presence, an intelligence, an entity, an extremely powerful demon who was intimately involved with me. The pain was still painful, but it was also a companion, a companion who, though he chastened me, also loved me deeply ...
(Albert Kreinheder, *Body and Soul: The Other Side of Illness*[2])

In alchemical terms, base matter is transmuted through the process of death into gold, the philosopher's stone, the self-realization that heals all by combining opposites and rectifying onesidedness. Illness operates on the stuff of our bodies to reveal and release that spiritual essence – our unique natures, powers and virtues – which lie buried in the body 'like a mummy in the tomb' to quote Paracelsus. It is a process of development that just carries 'to its end something that has not yet been completed', as the alchemists often insisted.
(Kat Duff, *The Alchemy of Illness*[3])

The heart of the creative process

The Heart of our Creative Process is also the Heart of Creation itself. Ultimately, there is no separation between the vastness of the cosmos and the vastness of our own potential and inner world (cosmos).

One online seminar I taught last year, called 'The Heart of the Creative Process'[1] explored the following questions:

What is Creativity?
Are there different forms of Creativity?
What lies at the Heart of the Creative Process?
External and internal creativity.

Years of offering one-to-one shamanic healing sessions showed me that most people have a (what I will call) limited edition definition of creativity. By this I mean that they often think it relates to creating art, music or perhaps architecture, or something else in the external world, that it is not a quality they themselves possess.

External creativity is more obvious: we can all see that buildings, songs, paintings, novels etc. demonstrate creativity. However, I once worked with a young lawyer who was very good at 'thinking outside the box' but did not think of herself as a creative person until I pointed out to her that this too is creativity. Do you perhaps have a friend who can mirror your thoughts back to you in such a way that you feel both cleverer and more clear-headed for the gift of mirroring? That is internal creativity! Psychotherapists specialize in that kind of creativity. Do you know someone who is genius at finding clever storage solutions or can explain complex things using effective simple words? All of those things are forms of creativity in action.

The well ordering theorem

It is my observation that true creativity often involves a marriage (or surprising connection) of two things that are not related to most people's minds.

The Banach-Taski Paradox

When our youngest son, Brendan, was four years old he often said that he prefers the Orange Moon (i.e. the full moon) to the Banana Moon (i.e. the waxing or waning crescent moon). Around the same time Mathematician Robin Whitty[*4] kindly gave me some feedback on my paintings about mathematical concepts. He mentioned that the Banach-Taski Paradox would be a favourite theorem with many mathematicians. I checked this out and learnt that in mathematical terms it is possible to cut an orange in to five pieces which can then be rearranged to form a ball the size of the moon (or sun!). Robin explains on his webpage that this notorious paradox is a bit of a cheat because the pieces must be very complicated and they will make up a moon with a huge amount of empty space. Having said that, a mathematical orange has an infinity of material and infinity can fill up as much space as you need it to. At least it can if it is well ordered! In my painting, my son's comment and Robin's intriguing *Well Ordering Theorem* come together. A reconstructed orange makes an Orange Sun and a reconstructed banana makes a Banana Moon ...

The larger point I am trying to make here is that creative people often see connections and build bridges were others see no such things (until someone shows them! Then many of us can cross the same bridge). We see such creativity in, for example, the naming of products. Flying from Stockholm to London my son was asked recently (in Swedish) if he had a surfboard in his hand luggage! For one moment, I thought the security officer had lost the plot but then it dawned on me: surfboard *(surf platta)* is the Swedish word for an iPad or tablet used to surf the internet. Aha! Someone had fun dreaming up that translation!

Quantum creativity

The best explanation of how I have come to view the operating principles of our universe is provided by Amit Goswani, author

of the book *Quantum Creativity: Think Quantum, Be Creative.*[5] He says that manifest matter is always preceded by quantum possibilities or potentialities. Therefore, you could say that there are two realms of reality: *Potentiality* and *Actuality*. Making a conscious choice 'collapses' those possibilities into a manifest actuality. *(Think of a house of cards where all rooms collapse but only one room or segment remains upright, that then becomes an actual physical room!)*

In everyday language this means making a choice between two things, meaning that one thing becomes matter and another potentiality fades away for now because it 'was not to be'. (Most likely there were many additional potentialities we were not even aware of!)

In other words, we use our *intention* to bring an idea into form! We then focus our *attention* on 'what we invite to dance with us' (and those forces will indeed arrive!).

Synaesthesia

The word Synaesthesia is derived from the ancient Greek syllable *syn* (together) and *aisthēsis* (sensation). It is a perceptual phenomenon in which the stimulation of one sensory or cognitive pathway leads to automatic, involuntary experiences in a second sensory or cognitive pathway. People who report a lifelong history of such experiences are known as synesthetes.

In reality this means that these people can, for example, perceive architecture as music, they can tell you the different colours of the days of the week, they can tell you how colours taste or how a piece of music smells and so forth. I am not a synaesthete, because I can switch this mode of consciousness off and on at will. However, it would be safe to say that most people working in the space where art meets shamanism actively try to develop a mild form of synaesthesia. They do this by actively training all their senses and always being attuned to dimensions and beings just beyond our immediate everyday perception.

The great unmanifest and creation

During my classes, I often speak about the Heart of the Creative Process as 'the place where gods and goddesses dance and dream'. It is the place where reality as we know it is created. It is a realm of undivided Divine Consciousness or Source in the most literal sense: a place where every possibility or potentiality exists and originates.

This is the place, fecund with potentiality that we need to access if we are to create healthy vibrant reality that is not a repeat of the old (wounded, distorted, failing) blueprints that have shaped human history.

Within this realm of undivided Divine Consciousness, the worlds that we sense and inhabit open up. Quantum Physics teaches that communication in this realm is *non local* (in shamanism we communicate effortlessly across – or outside – time and space, with the past, the future, the living, the dead and some people would extend that to star beings and galactic forces).

In ancient texts (and alchemy) creativity is often perceived as *a sacred marriage* (hieros gamos) between Heaven and Earth, sometimes between the Sun and the Moon. Teaching a rock art workshop in caves in Spain my students and I have seen glimpses of the great mystical union behind this principle. I believe that in the timeless realm this reflects the union of sacred feminine and sacred masculine primordial energies as we live in a polarised reality where we perceived those as divided, even conflicting.

This Heart of Creation, or realm of Undivided Divine Consciousness is also called the Void, the Cosmic Womb or the Great Unmanifest (depending on which author you read or what spiritual school of thought you follow).

In my own words, Creativity in the human realm is the phenomenon of using our consciousness to pull things out of The Great Unmanifest or Cosmic Pool of Limitless Divine Potential and birth them as manifest reality on Earth. We do not do this

alone. It is an endless act of co-creation and co-dreaming with the gods (cosmic or archetypal forces if you prefer).

The human craving for meaning

For human beings that interaction (between consciousness and matter) needs to be meaningful (literally meaning-full: full of meaning). The meaning of Life may be up for debate but in the final reckoning *we can choose to assign meaning to our own life* (or not).

I perceive meaning as a Divine gift. I have come to trust it, even when I cannot always see it. As my life unfolds, things that seemed insignificant at the time acquire meaning for example, some voluntary work I did in my twenties working in a field hospital in Bangladesh) or a language I studied and never used again Mandarin Chinese) have, decades later, provided the key that unlocked something profound in a healing session with a client. Nothing is wasted. Every snippet of human experience has its place in the larger tapestry. Even the things my own children discuss over breakfast often provide clues for client work or ideas for teaching that same day. I remember one morning walking my boys to school and on the way home all rubbish bins were out and spilling over (and the waste collection truck running late). Ten minutes later, I was in a session with a client saying: 'I never let anything go ... I am like a human bin spilling over with other people's rubbish ...' Pure coincidence? Mmmmm!

In my observation, profound meaning arrives through devotion and a lifetime of service to a cause or process greater than ourselves. A most wonderful book about man's search for meaning was written by Viktor E. Frankl[6] He was a prominent Viennese neurologist and psychiatrist taken to Auschwitz where he observed very closely how people coped (or not) with the Death Camps of the Holocaust. His conclusion was that everything can be taken away from us except the ability

to choose our attitude in any given set of circumstances. He survived the war and went on to found Logotherapy, the Third Viennese School of Psychotherapy, and became a key figure in *existential therapy.*

Existential therapy is a philosophical method of therapy that operates on the belief that inner conflict within a person is due to that person's confrontation with the four givens of existence. Those givens are the inevitability of *death, freedom* (and its attendant responsibility), *existential isolation* and finally *meaninglessness.*

The view that Frankl brought to existential therapy is that life has meaning under all circumstances, even under extreme suffering. 'Meaningless' in that school of thought is defined as *meaning not yet discovered.* Frankl had already conceived of this theory in the 1920s but put it to the test while incarcerated in Nazi concentration camps.

On a completely personal level (and not claiming to have lived through anything like the circumstances Frankl faced), I always feel an instant and huge shift in well-being when I am able to give even negative things a place and decode their meaning – their *meaning to me,* not necessarily any universal meaning. Some might say that I am not decoding the meaning but *assigning* this meaning. My reply is that in the final reckoning this distinction is of no importance to me because I can choose to live a meaning-full life and I can choose to have a meaning-full relationship with the prospect of my own death as well. For me this is all about embracing *all the gifts that the gods bestow,* even the difficult and incomprehensible ones. I am only human!

The cosmic dance of sacred femine and masculine[2]

Making sacred art is ultimately about dissolving separation and division. Division between our waking selves and our innate Divinity, between us and others, between us and the living breathing cosmos, between us and our shadow (the parts of

ourselves we have disowned and hidden from view, but others see very clearly).

Once again dissolving the boundaries between inner world and outer world (the split that occurred in the Renaissance period) is a radical concept. Everything changes the moment we really take this on board. Polluting our oceans means having toxic blood running in our own veins, any child dying means our child dying along with them (perhaps not literally – and secretly we feel relieved – but our own child, or even our inner child, loses a cosmos worth of human potentialities when even just one human child dies). This means grieving, honouring and paying respect and opening ourselves to extremely uncomfortable feelings and reflections. Zen Master Thich Nhat Hanh teaches that it is our sacred duty not to turn away from suffering (the suffering of others and our own suffering – ultimately they are one and the same).

(On the day of editing this chapter, 18 December 2017, one post keeps popping up on Facebook: so far, 19 women have accused Donald Trump of sexual harassment and assault, yet he is still in office. If that is not a mirror of our times, and one example of the severe imbalances ruling our world, then what is?)

My actions are my only true belongings.

You need to smile to your sorrow because you are more than your sorrow.
(Thich Nhat Hanh)

This means that we cannot critise politicians without having a long and hard look at the way we ourselves parent or lead or mentor others. In the place where the boundary between you and me, between perpetrator and victim, between our creativity and Creation dissolves, everything changes overnight. We literally can no longer 'keep refugees out' because we are all refugees

from the cosmic place of Divine Oneness.

For that reason, I cannot write a book about sacred art (a seemingly soft and safe and elevated subject) without also mentioning world politics, terrorist attacks, wars and refugees. When my colleague Susan Rossi (who soon became a very dear friend) contacted me about bringing my two-year sacred art programme across the Atlantic to Philadelphia we obviously consulted Spirit about this move. We ran some psychic investigations into why a particular place (Pendle Hill, a Quaker's Retreat Center in Pennsylvania[7]) was pulling this course towards it (uncertainty collapse: manifesting one definite outcome out of a multitude of possible outcomes).

We did this work 18 months before Donald Trump was elected president of the US. We were both shown disturbing images of out-of-control warriors and the US dipping into a dangerous state of imbalance and chaos. When moments like that occur, you pray that you got the wrong end of the stick; that the spirits were exaggerating etc. But you also know that this is not how the spirit world works.

We started working on evolving the consciousness at the very heart of this programme. We accepted the powerful mirror of the dangerous distortions in male and female world leadership and the dangers of not meeting the out-of-control warrior god on a level of paradigm shift. We kept (and still keep today) receiving strong guidance that our work is to involve profound spiritual work to balance the sacred feminine and masculine within ourselves. If we are to (help) create this balance (and this new paradigm) in the world around us, we need to act from a place of having achieved this within ourselves first. This too is a sacred art, the process of inner alchemy and soul marriage of possible selves.

I invite you to watch the free online seminar.[2] You will see that I decided to take our students into this zone through a lens of two Sami deities who are said to argue about the gender of

unborn babies.

Some of the questions I then asked the students were:

Does the struggle between Juksahkka (Bow Woman) and Leibolmmai (Alder Man) within the time-space limitations of Earth represent a struggle any soul feels when it is invited to incarnate and shoulder the mantle and perceptions of one sex only? Coming into form means coming into limitation as well as opportunity...

Did you get any glimpse of gods like these being able to guide us into fuller, healthier expressions of balanced feminine and masculine within ourselves?

Do the struggles (and projections/attacks) transgendered people in our society encounter cast light on this issue at the heart of the human condition?

To what treasure can our fears and projections guide us? (Did you see any glimpse of this?)

What do the images of a warrior woman carrying a bow and man associated with both menstrual blood and bloodshed in the Hunt mean to you?

In your lifetime, has anyone (a grandmother/elder/teacher/other) offered you any form of initiation into Blood Mysteries or the shamanic mysteries of The Hunt?

Have you ever used your own blood for painting? (Many of my students have ... of their own choice, never coerced by me.)

We also dipped into music to get a handle on what might be required of us: Bow Woman has a bow she uses for hunting. String musicians face the challenge of creating just the right tension on the bow and the string. Learning to play the cello has been a great teacher for me in this process through the beautiful curves of the bow, its flexibility and beauty. And its delivery of death and silence. This (creating the right tension) is what musicians of string instruments need to practise endlessly and daily.

For some of you this may be too much information but I am

trying to illustrate that a real commitment to making sacred art sometimes means 'painting with our own blood' and facing the most uncomfortable stirrings within ourselves. Our deepest fears, our inner dragons all play their part in the process! They become our greatest allies.

Our deepest fears are like dragons guarding our deepest treasure.
(Rainer Maria Rilke)

Activity #11 Does a God or Goddess Reside in My Dis-ease?

This activity is not for the faint-hearted!

Do a meditation and ask yourself if a god/goddess may reside in an illness or disease (dis-ease, an area where you are not at ease) or dysfunction that has followed you throughout this lifetime. This does not need to be a well-known or conventional deity. For example, I have worked with 'a goddess called Insomnia' and discovered that rather than tripping me up permanently (as I often perceive her) she is encouraging me to slow down, do less, focus more on being and less on doing. To honour my own limits and not always barge through every boundary I perceive as a 'restriction'.

Ask: who are you? Who is coming to attention? If someone responds, ask how you can embrace his/her/its core teaching positively. Ask what the gift is, however hard to grasp. If you can find a positive way of engaging and listening/honouring, will this be backing off, knowing that you are willing to be in a positive relationship? (*In my case Insomnia did not back off but I learned major life lessons from honouring her, pacing myself and accepting her loving protective presence in my life.*)

Seminars

Here are links to the FREE online sacred art seminars mentioned

in this chapter:

1. The Heart of the Creative Process: https://www.learnitlive. com/class/9334/The-Heart-of-the-Creative-Process
2. The Cosmic Dance of Sacred Feminine and Masculine: https://www.learnitlive.com/class/9335/The-Cosmic-Dance- of-Sacred-Feminine-and-Masculine
3. The Lady of the Labyrinth: https://www.learnitlive.com/ class/10002/THE-LADY-OF-THE-LABYRINTH
4. The Leavings of the Wolf: https://www.learnitlive.com/ class/10003/THE-LEAVINGS-OF-THE-WOLF
5. Where Art Meets Shamanism: https://www.learnitlive.com/ class/6862/WHERE-ART-MEETS-SHAMAMISM-SACRED- ART

Notes

1. *Igniting Imagination* by Mark Lissick, Kindle Edition e-book, Bookbaby, 2012
2. *Body and Soul: The Other Side of Illness* by Albert Kreinheder, Inner City Books, revised edition, 2009
3. *The Alchemy of Illness* by Kat Duff, Random House USA INc. Bell Tower ed., 2003
4. For more information about the Banach-Taski Paradox, please check the following webpage by Robin Whitty: theoremoftheday.org/Theorems.html#17
5. *Quantum Creativity: Think Quantum, Be Creative* by Amit Goswani, Hay House UK, 2014
6. *Man's Search for Meaning: The classic tribute to hope from the Holocaust* by Viktor E. Frankl, Rider, first published in 1946, New edition 2004
7. Pendle Hill Quaker Retreat and Conference Center in Wallingford, Pennsylvania, https://pendlehill.org/

Chapter 12

Arts & Crafts: Power Objects and Sacred Tools

A Small Inuit Vocabulary

Unganaqtuqnuna: a deep and total attachment to the land.
Tautoguuq: the occurrence of light on the winter landscape.
Taimaigiakaman: 'The Great Necessity' (to kill living things).
Issumatujuk: turning things over to see what the underside looks like, moving through shadows, never staying in one place.
(Gretel Ehrlich, *This Cold Heaven: Seven Seasons in Greenland*[1])

Imelda once had a painting with a potent image that hid itself, so when it was time to leave for a new home, it could not be found. I know the image well, but in some wisdom (or wariness of chaos) never considered myself strong or wild enough to live with such a Being.
(Jill Hunter, shamanic practitioner, London UK)

Hierarchy of artistic expression

In this chapter, we return to an issue I introduced in Chapter 1. There we established that the English word *art* is wide-ranging. We speak of fine art, martial arts, children's art and so forth. Yet the English language also offers the term *arts and crafts* to describe a wider category of making things than just fine art.

The term Fine Art implies a hierarchy of artistic expression. I can understand the reasoning behind this: is grandma knitting a scarf, say, (my children's Swedish grandmother has knitted them a large collection of rainbow scarves over the years) on the same level as Michelangelo painting the Sistine Chapel? Most people will agree that those activities are a world apart,

though both involve making something. This same grandmother masters other art forms: she is a published poet!

What this discussion opens up is the awareness that there are many levels of doing something. Art can range from a toddler scribbling on a piece of paper to Leonardo da Vinci's exquisite drawings. Practising shamanism can range from someone attending just one ceremony or weekend introduction workshop to someone steadily performing healing miracles on behalf of their community. Many people make art. Not all of those people call themselves artists. Many people now use shamanism in some way or form to enhance their lives, their ability to solve problems or their professional skills; most of those people are *not* shamanic practitioners.

I love some of the terms that astrologers use: *the higher or lower octave of something.* If my behaviour dips into the lower octave I am showing up 'in my shadow self' and not demonstrating a skilful expression of a certain trait. If I put more focus on my behaviour reaching the higher octave, I need to be vigilant and bring never-ending self-awareness to every word I speak and every action I perform. This is one of the functions a committed spiritual path has in a person's life, the never-ending commitment to self-monitoring and opening to nudges from spirit: 'You can do better!' or 'Choose different words!' 'Know the power of silence!' The question that any helping spirits will ask over and over is: *'Is this truly the course of action that serves the highest good of all or are you just getting back at someone who ... (hurt you, annoyed you, offended you, belittled you etc.)? Reflect before you act!*

I have come to see that something similar goes on in the realm we call arts and crafts. Shamanism teaches that energy is neutral but it acquires a direction or focus (energetic trajectory) as soon as we marry it to intention. This takes us into the zone of amulets, talismans and effigies and so forth. Objects deliberately invested with special powers.

The vibrational essence of objects

When an object is made with a specific intention and imbued with specific energies, we speak of *a power object* assuming the maker is working on the higher octave. When an object is made with an intention to harm, the opposite is true, we then speak of dark magic or black arts.

Some people have a vocation to craft sacred objects or power tools for others. Examples are drum makers, rattle makers, animal fetish carvers (thinking of the Zuni people of New Mexico here), makers of singing bowls, gongs, Tibetan prayer flags, ceremonial robes etc. Most cultures and religions have people who specialise in making devotional objects supporting and mirroring that belief system. My own mother (who is a Roman Catholic) once gave me a hand painted icon of Mother Mary that I use in spiritual work. (She also gave my brother a necklace from Egypt but he refused the gift!)

One distinction that needs to be made here is that it is believed that some objects are innately powerful because of their vibrational essence: gems and precious stones are an example of that. People who specialise in working with stones or crystals have an amazing reservoir of knowledge about the properties of certain stones.

However, shamanic practitioners know very well that absolutely every object on earth has a vibrational essence and can be used in magical ways. Personally speaking, I have been collecting stones that speak to me for all of my life. I also collect feathers, shells and bones. We are then speaking of frequencies, vibrational essence or properties that something possesses of its own accord.

Object empowerment

The next level of working with such things is called object empowerment in shamanism: we can ask a stone, or twig or feather (etc.) to perform a certain function for us. A feather might

be attached to a drum to represent one of the power animals of a practitioner. A stone may be carried in someone's pocket as a reminder of a promise or it may have been charged with special properties (I have sometimes made dreaming stones for clients or for young children with frequent nightmares). What then happens is that an object is chosen for its vibrational essence (or frequency, innate properties and often symbolism) but something is added: an energetic layer of meaning/significance and intention. A regular stone becomes a dream stone. A feather becomes part of a ceremonial bundle used for smudging. Most of the objects mentioned above fall into this category. Let's look at different examples of empowered (or magical) objects:

Amulets

Amulets have special powers to protect their owner from danger or harm. Gems are often used this way (perhaps worn as a necklace. I myself have a polar bear necklace carved by an Inuit artist I wear daily). The word amulet is derived from the Latin word *amuletum* and the literal meaning is *'protects a person from trouble'*.

Talismans

Talismans are slightly different in that they are believed to actively bring their owner luck or other benefits (this could be clarity or a good outcome to a difficult situation). This word comes from the Arabic word talsam which originates in the older Greek word telesma. The verb *teleo* means *'I complete or perform a rite'*.

Charms

Charms arebelieved to have magical power or force. They are supposed to be attractive in the literal sense: attracting good things (high vibration outcomes). The word is also used for verbal formulas spoken for magical effect. You will find this

word in folk magic and grimoires.

Totem

A totem can be either a natural object or animate being, (for example, an animal or bird) which becomes the emblem (symbolic representation) of a clan, family or group. Most people will have seen pictures of totem poles. The animals on those poles represent different clans. When people from two different clans marry (for instance) the different totem animals (clan symbols) for wife and husband are carved on the totem pole to mark the occasion of their wedding. It is essentially a Native American word and some of my colleagues prefer not to use it to avoid the issue of *cultural appropriation*.

Fetishes

In New Mexico, there is a lively trade in, what is commonly called, fetishes. In that meaning of the word, it is generally a small object (often a stone carving of an animal) believed to have magical powers. (This word has another meaning as well of course: the sexual fixation on a non-living object or non-genital body part for sexual gratification. That meaning has no relevance for this chapter.) As you see, there is overlap between all of those terms. My polar bear necklace could be described as a fetish as well as a talisman.

Effigies

Yet another order of objects we work with in shamanism is the effigy. This word carries the meaning of representation, usually a person. For instance when you do long distance healing work you may bring a stick into the room to represent the absent person (while you perform extraction work or soul retrieval etc.).

Voodoo

Using the word effigy in the Western world often suggests the

practice of voodoo. Especially the dreaded image of wax dolls with pins stuck into them for the purpose of black magic and intentional harm. This association is not fair because Voodoo is actually an ancient and proper religion. It travelled across the Atlantic Ocean from Africa to the Caribbean and US in the days of slave trading. This eventually led to a variety of different groups. However, the West African word voodoo means spirit (and comes from the term *vodun*). This religion teaches that absolutely everything is connected and that nothing happens by chance. Therefore, accidents do not exist. Practitioners work with the magical principle that what we do to one thing affects the whole Web of Life, which is an operating principle in the practice of magic from all over the world.

Sacrament

In this context, it is worth mentioning the word sacrament again. In the traditional Roman Catholic sense of the word, a sacrament is an outward sign or manifestation of an inner state of grace.

Grace is a gift from God, not from the priest or bishop (etc.). The priest is only a conduit for Divine blessings and energies. This is very similar to the way that a shaman (shamanic practitioner) is a hollow bone for spirit. The difference between the two is that shamanism does not impose authority figures between people and their god(s). It places more emphasis on direct revelation and a personal relationship with the Divine.

In my personal experience, forgiveness is an example of a divinely granted state of grace. We only need to become *willing*, a power greater than ourselves then meets us halfway and takes care of the rest.

On the courses that I teach, we have been guided to make elixirs and use ointments. Those were physical expressions of spiritual essence. They brought a state of Grace.

Sacred objects

To pull the discussion back to the more narrow focus of this book, many objects have innate properties and power. We can imbue objects with (additional) magical power by adding layers of intention (additional vibrational frequencies or energetic fields). We then arrive in the place where many sacred artists work, making power tools or sacred objects for other people to use in their spiritual practices.

One of my sacred art students in the US made rattles from the same deerskin for our whole circle and painted personalised symbols on all of them (so they all looked different). The same deerskin and wood from the same tree unite as all. When we all rattle together, we call the deer spirit and tree spirit into the room as allies and we strongly feel their presence!

A close friend wove me a beautiful scarf I wear during powerful group ceremonies. She used my favourite colours (blue and green) and made the weaving an act of devotion. She imbued it with love, she carefully monitored every thought she had while weaving the scarf (if we suffer lapses of attention, then, any low vibration thoughts will be embedded in the energetic field of the object and we don't want that!). She also wove me (what she calls) a tea towel but it was so beautiful that I only use it as an altar cloth!

The same principles apply to painting. One of my greatest discoveries (ever!) was that when I make sacred art, I essentially offer a home/embodiment/physical container/vessel for great spirits to move in to. In that very special moment, a painting suddenly becomes something 'other', a sacred object, because the spirit has moved in. That is the moment where others will observe that a painting 'seems to be moving, dancing or speaking'. People may even report that a piece of art is moving, singing and dancing and *keeping me up at night*! This means that the spirit has arrived! The painting is no longer 'just an image on canvas', it now exists in two realms at the same time: it is

a spiritual object and home for spirit – as well as a painting in everyday reality.

Ongons and Inuksuit: Homes for spirits

Speaking of homes for spirits, I also need to mention ongons. In Mongolia, the ongon is one of the most important tools of the shaman and they come in many different forms, shapes and sizes. In essence, they are empowered shrines or ritual houses for spirits. Most ongons are occupied by ancestral spirits or animal spirits but they can even offer an abode to nature spirits or house the souls of powerful dead shamans. For more information of (and pictures of) ongons I recommend the following (free) article in *Sacred Hoop* magazine by Nicholas Breeze Wood: http://www.sacredhoop.org/Articles/ONGON.pdf.

We find a similar concept in the Arctic where the Inuit make striking but mysterious stone figures (some of them very large in size) called Inuksuit (plural of *Inuksuk*). The word Inuksuk means 'in the likeness of a human being'. These structures are built from rocks at hand, meaning that no two rocks are identical; they all have an unique shape. One single Inuksuk can even have different silhouettes when approached from different directions (say human from one direction but raven from another).

The word Inuksuk literally means 'something acting in the capacity of a human'. They can be viewed as silent messengers that can indicate many things and perform different functions:

Indicate danger or safe passage,

Provide clues for hunters,

Act as spirit homes and objects of veneration,

Reference points to help people find their way to or from certain sites.

Author Norman Hallendy calls them the Silent Messengers of the Arctic in his wonderful and evocativ book (with many full colour illustrations) *Inuksuit*.[3] According to him Inuit elders say that the building of Inuksuit began in the time of the first

humans, those who prepared the land for our first ancestors. They are referred to as the Tuniit or the Ancient Ones. The best Inuksuit are found at waiting places, where people had time on their hands to build something. One type of Inuksuk is called a *tupqujag*. It is a structure in the shape of a doorway or portal through which a shaman enters the spirit world.

A painting speaks ...

Years ago, I was working on a painting when a fellow mother I often spoke to at the school gate asked to come on a studio visit. She walked in, froze in front of the easel and then burst into tears saying 'This painting just told me to enrol in art school!' And that is exactly what she did!

Two paintings I made moved to a school of shamanism here in the UK. I soon started receiving emails from their students saying that the spirits embodied by my paintings had appeared in their dreams and given careers guidance and useful pointers for their shamanic work!

However, the moment you work in this way additional responsibilities come into the process. I have already mentioned the layers of energy that can accumulate, so you need to monitor your own thought forms closely while working on something. You also need to honour the spirit waiting to move into the piece you are working on so the process becomes a dialogue: 'More of this, change that ... I really want ...' Spirit guides both the process and our hands.

Some dos and don'ts when it comes to sacred art as spirit embodied

Once your creation is finished, another dimension of consideration kicks in. In the mainstream art world, it is considered an indicator of success when other people wish to buy your pieces. However, working the spirit-led way this is not straightforward! I have had occasions where people wanted

to buy a painting and the spirit in the painting did not want to go. I once promised a painting of The Morrigan to someone. When I tried to find her in my storage unit, she was not where I had left her. She actually disappeared completely for nearly three years. Fortunately the person concerned was happy to take home another painting instead. I had some rather *uncomfortable* years (to put it mildly!) of feeling the wrath of The Morrigan every time I walked into my own studio. I apologised. I told her I had learned a big lesson from her about consulting the Spirit of any Painting before agreeing to sell or rehome it. One day she unexpectedly reappeared. There she was, leaning against the wall in my Studio again. Thankfully, I had been forgiven.

Another time someone tried to buy two paintings from me but the spirits became very agitated. They said, 'Don't do it! He is not really interested in your paintings; he is trying to steal a piece of your soul by buying your paintings!' I used my shamanic abilities to look into this and saw that they were right. I informed this person that I was not able to sell him those paintings. Soul theft was narrowly avoided!

The opposite scenario means receiving strong guidance that a particular painting needs to be with a particular person. Often because it depicts one of their key allies or because it embodies a strength or quality they need to bring into their lives. I always tread with care when this happens. I check if the person actually wishes to receive the painting. If they do, I do not charge. I consider it a sacred office to match my paintings up with the right person. I am able to do so because I earn my living from teaching sacred art and shamanism. If I had to live off painting sales alone, this would pose great difficulties. Therefore, it's probably not the right approach for every person who makes sacred art.

Activity #12 Making a Sacred Art Gift

I invite you to make a sacred art gift for another person.

Ideally perform a shamanic journey or meditation to receive guidance on this so the process is fully spirit-led. If that poses insurmountable obstacles, you could work from your waking self or everyday mind.

When I set this activity in class, I ask that the name of the person comes from Spirit because this often opens the door for a piece of healing to occur.

However, the person you make the gift for must be available to you, meaning that they cannot be dead and that they cannot be famous and completely out of your reach (you don't want a movie or rock star's PA to open this gift from you!). Experience tells me that making such gifts for people from whom you are estranged or people with serious mental health histories can be problematic so please avoid this.

Follow the guidance (or follow your inspiration) and make the piece. Do this as an act of attention, pouring love and devotion into this. Monitor your own thoughts while you are working (you don't really want to give someone a gift that absorbed many negative thoughts you had while working!).

Then hand the gift over and observe how this feels: how does the person respond? How do you feel? What impact does this have on your relationship?

Notes

1. *This Cold Heaven: Seven Seasons in Greenland* by Gretel Ehrlich, ASIN, 2008
 On a related note, if you would like to learn some Inuktitut:
 https://www.sheswanderful.com/2014/07/21/15-inuktitut-words-to-know-before-visiting-iqaluit/
2. FREE article in *Sacred Hoop Magazine* by Nicholas Breeze Wood: Nicholas Breeze Wood: http://www.sacredhoop.org/Articles/ONGON.pdf.
3. *Inuksuit: Silent Messengers of the Arctic* by Norman Hallendy, Douglas & McIntyre, Reprint edition, 2001

Chapter 13

Body Art: Scared – Scarred – Sacred

If you bring forth what is within you,
What you bring forth will save you.
If you do not bring forth what is within you,
What you do not bring forth will destroy you.
(The Gospel of St Thomas, verse 70)

Our bodies remember it all: our births, the delights and
terrors of a lifetime, the journey of our ancestors, the very
evolution of life on earth.
(Kat Duff, *The Alchemy of Illness*[1])

On the sacred art courses I teach, I actively try to dissolve all
divisions. People are encouraged to try any and all techniques.
Often my students have specialist skills and I invite them to be
guest teacher for an evening or afternoon. That opens up a wider
range of techniques and materials for everyone.

It has been claimed that one of the mysterious ancient peoples
in Scotland, the Picts, covered their bodies in elaborate blue
tattoos of animals and other shapes. This was said to be their
way of honouring the sacred realms that in turn shaped their
existence. This reference appears to come from the Romans,
who wrote about them nearly 2,000 years later. I did some
research, hoping to see photographs, but only found picture
stones and divided opinions on the matter. Did they disappear
mysteriously in just a few generations? Did they inter-marry the
people who became today's Scots? No one has the hard facts.[2]
But we can of course investigate this using shamanic journeys
or meditation!

Women painting women

On a number of occasions in my circles, we have gone as far as stripping off and using our own skin as canvas. We have painted symbols on one another's bodies with body paints or red ochre. In doing so, we came to understand why tribal peoples use body paint in ceremonies. In this context, we also contemplated the concept *sacrament*: 'an outward manifestation of an inward state of grace'.

I have observed that powerful spontaneous soul retrieval can occur as part of this process. When participants receive personalised ceremonies from Spirit, where the rest of us witness and support in whichever way the process requires, sacred wholeness is achieved; wholeness on the very level of soul. This is the root stem of the word *holy*: wholeness, health.

The world 'whole' is etymologically related to the Old English word *halig* (holy, consecrated, sacred). Scholars take the root stem *hal* to mean *that which must be preserved whole or intact, that cannot be transgressed or violated.* Purely in terms of meaning, it is also related to the word integrity, which comes from the Latin word integer: whole. In mathematics, an integer is a whole number, a number that can be written without a fractional component.

Sacred art is made from a place of wholeness, or reflects sacred journey back to wholeness. The direction sacred art takes will always point away from fragmentation and division. People who need to make sacred art need to make an active effort to work from a place of integrity.

Whenever I have been in a situation where women are painting women, I feel that my sense of time dissolves: I am part of an ancient wisdom tradition that was written on the skins of women (and not in any book). It brings back very physical memories of sitting around a fire under the starry sky and participating in rites of passage with other women. Being held and witnessed on the level of soul by a circle of wise compassionate women is a healing force in its own right. After such a rite, we often feel

whole/holy/healthy for the first time in decades (sometimes for the first time ever during our lifetime on earth). Obviously men in tribal societies do this too, but I happen to be a woman and most (but not all) of my students happen to be women too!

Body art, tattoos, piercings

Using our own bodies to make sacred art – our whole body becoming a piece of sacred art – got me researching body art. It is believed that human beings have always gone to great lengths in changing or shaping their bodies to achieve a certain look or style. Sometimes this is about achieving beauty and looking attractive; I suppose that the world of makeup and beauty products comes under this heading.

The shadow side of this is that commercials, magazines and films constantly present us with beauty ideals that are out of reach for most people. There are links between such (often photoshopped!) images and the earliest age of children being diagnosed with anorexia dropping to a staggering four years old. On a personal level, I am extremely tired of the beauty industry: the impossible ideas that set people up for failure and self-disgust, the animal testing of many beauty products, the false claims and sense you are abnormal if you do not buy into any of this.

One very important distinction here needs makingbetween using body art for positive expression and using it to hide supposed flaws, weaknesses or bits of ourselves we are ashamed of.

Body art is alsoused to make a statement about what group in society you choose to belong to. Teenagers will often get a tattoo or piercing at least in part to shock their parents, or to indicate that they are not like their parents. However, at the time of writing, tattoos and body piercings are so common that they no longer have the shock value they used to have. Perhaps some teens now make themselves stand out by *not* having tattoos.

It is my belief that there is a strong spiritual dimension to this. We have lost the (sacred) art of initiating our teenagers and this drives some of them (unconsciously) to initiate themselves. Having tattoos or piercings sends out the message that you can endure serious pain. Therefore it resembles aspects of tribal initiation where teenage boys were often marked in, by Western standards, severe physical ways (such has having a tooth knocked out, being left to fend for themselves in places where dangerous animals roam, or incurring wounds that left permanent scars on their skin).

A beautiful contemporary example of body art is women who opt for a tattoo after breast cancer surgery. Those photographs have touched my very soul. These women say that they wanted to move away from 'the harshness and ugliness' of cancer[3] because breast cancer had brought them blessings and beautiful things as well. Please read the whole article and open yourself to those amazing photographs.

> I am a free spirit. Cancer has given me back my true self. My tree of life tattoo has given me back my self-esteem. I am a flat and fabulous warrior. P.ink, I thank you for giving me back my beauty (Eve Donaldson[3]).

Initiation opens the door on Mystery. In that process, people are touched by the Divine, by powers greater than themselves and that brings change on the level of soul. People who have been initiated by the Elders of their Tribe know their place in the world. They know who they are, who their Tribe is and where they belong. It is my belief that the 'longing for belonging', that very human yearning, inspires much of the body art we observe everywhere today.

Body art often explores issues around gender and personal identity too. I have set students tasks inviting them to deliberately cross or blur gender boundaries. We can learn an incredible

amount from walking around looking utterly different from our everyday selves.

The Art World saw a movement called Performance Art, where artists work directly with their body, often in staged or choreographed events. It can dissolve boundaries between performer and viewer, between artist and canvas (our own body *is* the canvas!) That blurring of lines invites viewers to drop their contours, their assumptions about themselves and think again about who they truly are. *(Are there perhaps characters living within us that are quite unlike our everyday selves, unlike the social mask we present to the world?)* It can also invoke danger, violence and abuse, as we will see in a moment.

I will keep on stating in different ways that the spiritual path of making sacred art is a journey back to wholeness. That journey can take an unlimited amount of manifestations and detours. Often we need to travel deep into 'ugliness' to find beauty. To (mis)quote the Bible we need to lose ourselves in order to find ourselves. We need to scream and howl before we can sing.

Scared – scarred – sacred

The word *scared* is an anagram of the word *sacred* and the word *scarred* doesn't trail far behind (it has got one extra R).

This book may just give the impression that I teach deeply spiritual people who only ever make pretty and uplifting art. This is not the case!

The gross, the repulsive and the disgusting take their place along with the scary, the frightening, the creepy, the irreverent, the hilarious.

William Blake said that *colours are the wounds of light.* As a rainbow person (I take a childlike delight in using and wearing bright colours) his words pluck at the cello strings of my soul. Maybe childbirth hurts so much because it reflects the pain our Divine Creator Being felt when calling us all into being and allowing us to exist as separate from Her or His Mysterious

Essence. (Personally, I feel this Being transcends and pre-dates gender but using the pronoun *it,* just doesn't sound respectful!)

I have actively encouraged students to get dirty, to use their own blood or even their own urine or excrement in artwork, if they felt called to do so. Sometimes, as part of our healing journey, we need to make deeply painful, profoundly disturbing art. There is no inherent harm in that (as long as we draw boundaries around who gets to witness and observe this, obviously we don't want children or disturbed individuals seeing such raw art). There can be an immense release in creating safe space for releasing profound pain or trauma. Placing something painful or shocking outside ourselves, in a safe container, is one way of releasing it from our minds and bodies and embarking on a healing journey with it. The object or in other circumstances the therapist or safe group can hold something until the person is ready to take it back, in transfigured form.

To arrive at wholeness we need to gather all the pieces of the jigsaw puzzle that is our life. We cannot cut corners. We might struggle with all the similar-yet-unique pieces of the blue sky. To transform something (pain into wisdom, a long-held hurt into a joke, resentment into forgiveness), we first need to honour every single lesson a puzzle piece brings. We need to be fully present to its struggles and gifts; only then can we truly let it go and *let Go(d/dess).*

Body memory

I have been told that our body *still* holds the memories that even our minds drop. This is why it has been said that our bodies cannot lie, or if we try to make our body live a lie, we fall ill because disease (literally *dis-ease,* feeling *ill at ease*) creeps in.

Many people live 'in their heads' paying only the minimum of attention to their bodies. I did that for the first 25 years of my life. Shamanism forced me to change my ways during the second 25 years of my life. Today I listen to my body and the spirits, I try

to live from my heart, not my mind (only).

> Your body, believe it or not, remembers everything. Sounds, smells, touches, tastes. But the memory is not held in your mind, locked somewhere in the recesses of your brain. Instead, it's held in your body, all the way down at the cellular level. Ever notice how, on a stage full of professional dancers, everyone still moves in their own way? That's because our cells store memories – information – about our experiences, habits, sensations, everything. We are all unique and it's in our bodies – our skin, muscles, tendons, nerves – which we actively participate through our day to day experiences; good ones and bad.
>
> Sometimes, the memories that our body stores are not always memories that we consciously, as the survivor, remember. You may have been too young to remember. You may have blacked out. For whatever reason, you don't know what your body knows
> (*Survivor Manual*[4])

As I am growing older, I more and more see my own body as the sacred map of my own life. This is why I have no intention of resisting wrinkles or silver hair. As I grow older (I am 50 years old at the time of writing) my body increasingly resembles what it actually is: a miniature version of Mother Earth (our ultimate mother who gives us our body or human coat on loan for a time) with rivers, mountains, forests, roads and silver scars.

To me scars truly are sacred. My scars are my tattoos: they show where I have been touched and chiselled by Divine Hands. In not resisting the natural processes of ageing and my own body's journey through life, I hope I am teaching my children not to fear old age and death. I am proud of the ordeals and initiations I survived; they made me the person I am today. I am proud of the three pregnancies my body lived through. I doubt

I will ever have a flat stomach again, but who knows ... I may have grandchildren one day and truly take my place as a Silver-haired Elder of the Community! *(And please don't photoshop me into something I am not, or to make me shrink and fit into your concept of beauty!)*

Word of caution

I have also learned the hard way that taking this process to its extreme can have consequences. While teaching a rock art workshop in Spain I once called out to the spirits: 'Make my body your canvas!' A few days later I was back in London and developed very strange clusters of red spots all over my body. They resembled the rock art (ancient calendars) our group had been looking at in caves and they also resembled some of the star constellations we had been working with! I was forced to seek a medical opinion and was told I had chickenpox (or possibly shingles). I had already had chickenpox as a very young child and fully assumed I was immune. No one in our group in Spain came down with the same thing and those clusters of spots looked most odd, until today I think the spirits acted on my invitation and taught me a powerful lesson!

Soul making and the alchemy of illness

The Alchemy of illness is the title of a beautiful book by Kat Duff.[1] Illness needs a mention too in this chapter because it is a universal experience that often leaves us scared (sometimes leaves us scarred) and pulls us into the realm of the sacred. We often make the journey unwillingly and unwittingly. In Western culture, we have come to believe that perfect health is our birthright and the norm. In her book, Kat Duff describes how years of serious illness taught her that illness has its own geography.

What struck me so much about this book are her beautiful reflections on how illness is another example of a liminal state:

we view Life differently when our own body pulls us closer to Death. In that process, done with awareness, we unearth and un-cover valuable insights. We engage in (phrase borrowed from James Hillman) soul-making. As Duff points out: all we can think of is our recovery, but actually recovery literally means 'covering up again'.

Duff takes things one step further even: she believes that ill people perform a sacred task on behalf of society by carrying, and intensely engaging with personal and cultural shadows, they free the healthy to do their own sacred work and that is to keep the structures of society oiled and running. Those lives may look more 'productive' but actually both parties are engaging in hard work on behalf of the collective.

She compares serious illness to being abducted like Persephone into the underworld of sickness. To bring this discussion back to the main topic of this book, I would then observe that by offering Rites of Passage and profound (soul-changing) experiences of initiation, we provide a safe and kindly held version of this archetypal process. Art and creativity play a *huge* role in doing this safely. When we do it as a work of sacred art, we survive the journey, the descent, and emerge as a fuller version of ourselves. We have re-membered ourselves by linking back to (*re-ligare* in Latin) to our timeless and unchanging selves. I have no words to describe how *luminous* participants look in such moments; they literally shine and are visibly different (reborn) people.

Therefore this book urges others to actively use art, song, poetry and sacred theatre to provide in a beautiful and uplifting way what Life will (most likely) unleash in a devastating way, if the soul work set Outside Time is not met. It is kinder. It is also the work of miracles!

Now let's examine a shocking example of the opposite phenomenon.

De-humanise or re-humanise

Some people call Yugoslavian performance artist Marina Abramovic 'the grandmother of performance art'. In one of her earliest performances,[5] she staged a performance titled 'Rhythm 0' at Studio Morra in Naples, Italy, in 1974. The concept was that she would stand still for six hours straight while the people who came to see her were urged to do whatever they wanted, using 72 objects that she had placed on a table. Her instructions stated that people could use the objects on her in any way they desired and that during this period she would take full responsibility.

There were harmless objects (feathers and flowers) as well as dangerous items (razor blades and a loaded gun). Some people humiliated her. Others changed her position. Someone touched her somewhat intimately. Then one man used a razor to make a cut on her neck. In the third hour, all her clothes were cut off her with razor blades and minor sexual assaults were carried out (in full view of all observers and cameras). She was so committed to seeing this through that she would not have resisted rape or murder ... Someone made her point the gun at herself. When the six hours were up, Abramovic started to walk around among those people and they could not look her in the face. People avoided any confrontation with her. They did not want to be held accountable or judged for what they did.

This piece showed how easy it is to dehumanise a person who does not fight or defend herself. Given the right circumstances, it would seem that most 'normal people' apparently can turn shockingly violent.

Forty-three years have passed since this performance. Some would say she invited this by choosing to put razor blades and a loaded gun on the table. Others would say that no matter what objects she offered and no matter the lack of accountability, people could have chosen to become fellow actors in her performance by doing kind and beautiful things (or standing up for her when things got out of control). Some would say she was

brave and others would say she was actively inviting *big* trouble. It is the proverbial elephant again: all those people have a point.

For me this performance shows the exact opposite of the concept sacred art as I am presenting it in this book. It was the polar opposite of uplifting. Depressing is too mild a word for the way it appeared to activate the evil side of many fellow humans present that day.

She did not open sacred space, the way any shamanic practitioner would, and ask spirit allies to turn the physical venue into a Temple of Light. She did not set a strong intention that only 'higher octave uses of those objects' would come into play. She did not screen her audience (the way any self-respecting teacher does when taking registration for courses). She herself put a loaded gun on the table (and I mean metaphorically speaking as well in the most literal sense). Other than the terrors and evils she unleashed (and this undoubtedly helped build her name and fame as it was not a complete accident) it teaches us that not setting positive intentions and a strong focus on what we wish to create can amount to creating unwanted things. That is a lesson I hope any reader of this book will give serious thought to!

Discussing the 'origin and true nature of evil' falls outside the scope of this book. Some of the greatest thinkers in human history have wrestled with the concept evil without arriving at a satisfactory explanation. What I will say is that my own meditations on this phenomenon have led me deep into the territory of personal responsibility and shadow work. Might evil just be the collective accumulation of all the things we will not face in ourselves on a personal level?

Temple or deity work

In my experience, art process with a focus on all things sacred can start healing that terrible affliction, that terrible dis-ease within ourselves: the denial of our Inner Monster, Inner Perpetrator, Inner Mass Murderer. Personally speaking, I would not offer

myself up for a piece of performance art like this. In the courses I teach, any 'performance' is taken to its higher octave: a sacred enactment that facilitates a personal encounter with the Divine. In that process we never de-humanise, we re-humanise as it were, we pull in dimensions and reservoirs of cosmic energy that were not available to us before. We become *fully human* and we truly become *alchemists! (Someone once mis-spelled my name as Imelda Alquemist – I like it!)*

As part of the shamanic practitioners programme I attended (taught by Simon Buxton), we were encouraged to organise an event called Temple of the Gods or 'deity work'. This involved a group of shamanic practitioners working together to host a day where 'pilgrims' (earning the right to attend by completing a series of preparatory tasks and challenges) could have an audience with deities embodied and brought forth by this group of shamanic practitioners.

I organised such a day and hosted it at my house in London. The guidance I received was to work with the (dark and often demonised) goddess Lilith, who wished to return to human awareness and show her 'true face', stripped of centuries' worth of shadow projections. She told me my 'costume' involved stripping off and appearing naked (as well as dancing with a soft toy snake). My unconditional trust in Spirit meant actually doing this, with pilgrims arriving who I had never met before. This event lasted four hours (not the six hours Abramovic put in) and it was a great success. The deities and spirits guarded the sacred space.

My stripping off allowed the pilgrims to bare their souls and show their true selves. Nothing remotely untoward happened. Not just that, for months following, Lilith actually received fan mail! People sent me cards, letters and emails to thank Lilith and tell her how their life had changed since they started following her guidance. In the end, I told everyone that 'Lilith had returned to the world of spirit' as it didn't feel right to engage

with these messages claiming connectivity and communication. An audience with a god or goddess is a very rare thing, a true gift from Spirit. The gods and goddesses do not reply to emails. To communicate with them, we meet them on the inner planes instead.

> Last night as I was sleeping,
> I dreamt—marvelous error!—
> that I had a beehive
> here inside my heart.
> And the golden bees
> were making white combs
> and sweet honey
> from my old failures.
> (Antonio Machado, 'Last Night as I Was Sleeping')

> We are the bees of the invisible. We deliriously gather the honey of the visible, to accumulate it in the great golden hive of the Invisible.
> (Rainer Maria Rilke)

Activity #13 Using Our Own Body as a Canvas

Experiment, in a mild and fun (impermanent) way using your own body as a canvas. Young children do this naturally: my sons spent years coming home from school with 'impromptu tattoos' made using biros. More recently, my eldest son's girlfriend wrote on his neck that he was her property; that was a little more disturbing to me!

Buy a cheap box of face paints and experiment with painting on your own body. In the courses I teach, we sometimes use red ochre and other pigments.

Take things further and ask someone you trust to paint something on your skin. Even a symbol or image that later fades (or washes off) can reinforce meaning on the energetic level.

Example: if you have major issues with personal boundaries and you feel a resonance with Norse Shamanism you could experiment with drawing the Ægishjálmr or Helm of Awe on your skin. (It can also be drawn in your energy field, using no ink, only intention!)

The possibilities are endless: host a party where face paints (normally the domain of children's parties) are available for adults to use. I have often used my own makeup bag to give my children (or the children in my Time Travellers[6] group) a quick make-over. (In truth, I no longer use my makeup bag for conventional purposes. Turning kids into tigers or pandas is far more fun!)

And if you are thinking of getting a tattoo or permanent body marking, perhaps try on an impermanent version first before you commit.

Notes

1. *The Alchemy of Illness* by Kat Duff
2. For a good article on the subject of the Picts please see: https://erinsromance.wordpress.com/2012/08/25/who-were-the-picts-and-what-about-those-tattoos/
3. From http://www.womansday.com/life/real-women/g1939/mastectomy-scar-tattooos/
4. http://www.survivormanual.com/how-to-deal-with-body-memories-as-a-survivor-of-sexual-assault/
5. https://observerink.com/artist-stood-still-for-6-hours-to-let-people-do-what-they-wanted-to-her-body-the-results-are-heartbreaking/
6. The Time Travellers group is a shamanic programme for children and teenagers I run in London. Please see my first book for more information: *Natural Born Shamans – A Spiritual Toolkit for Life:Using shamanism creatively with young people of all ages*, Moon Books (JHP) 2016

Chapter 14

Mother Earth, Father Sky

Songlines, geoglyphs, geomancy

The truth surely is that what we ultimately may come to do is destroy the particular type of planetary environment that sustains us and life as we know it. If that happens, then, of course, our species would die off (alas taking many other species with it): in the grim final analysis, the problem would be self-correcting. The Earth can be seen as a bountiful mother, and were we to disappear she would have the ages that belong to her in which to restore herself before giving birth to other orders of Life. Earth's song will go on, whether or not we are part of it.
(Paul Devereux, *Re-visioning the Earth*[1])

It was here that I first saw how the wastelands of the earth would be restored by the flowering of ourselves. We would not be able to regenerate anything outside ourselves until we regenerated our own inner landscapes, until our true wild nature had burst through the broken rubble and tarmac of our city-based worlds.
(Charlotte DuCann, *52 Flowers that Shook My World*[2])

Earth divination

The previous chapter leads seamlessly into this one. The moment we widen our understanding of what sacred art is we must also look at Earth Works, landscape art and the sacred art of reading the landscape, of receiving its communications and hearing its songs.

This is a vast subject and many other authors are far better

placed to write about this. I invite you to check out books by
Paul Devereux[1] and Nigel Pennick.[3]

I have been blessed to co-teach courses (in the zone where
geomancy meets sacred art) in Andalusia with Karmit Evenzur
(I invite you to Google her name and Earth Speaks). When she
contacted me about working together, she set me some journey
work (as we call it in shamanism). She asked me to tune into
a piece of land near her (the Laguna de la Janda) where a
natural lagoon has dried up due to intensive farming, creating a
knock-on effect on all aspects of the local eco-system, including
the migration pathways of birds stopping them on their epic
journeys between Europe and Africa.

Later she admitted that she had been testing me! For me those
journeys were a revelation. Up to then I had focused on working
with humans and detecting blocks and imbalances in the human
body. I now discovered that I could read land with the 'X-ray eyes
of the shaman' in exactly the same way. That revelation opened
up a whole world of more learning and greater awareness. Co-
teaching with Karmit out on the land, taking people into caves
to look at rock art (and then inviting them to make their own art
inspired by this) was no less than a crash course in geomancy!

The word geomancy (from the Greek *geomanteia*) literally
means earth divination: interpreting markings or the ground or
patterns created by tossing soil or small pebbles on the earth.
Today the field of geomancy refers to working with the deep
dreaming that is held in the land: memories and energetic
patterns. Opening portals and healing imbalances, so energy
(life force) can flow freely and create healthy spaces.

Songlines

'So a musical phrase,' I said, 'is a map reference?'
'Music,' said Arkady, 'is a memory bank for finding one's
way about the world.'

'I shall need some time to digest that.'

'You have got all night,' he smiled, 'with the snakes!'

(Bruce Chatwin, *The Songlines*[4])

The indigenous peoples of Australia (the aboriginal tribes) have a beautiful word for those dreaming tracks that run through the land (and even across the sky!): *song lines*. Those mark the pathways that the deep ancestors and creator beings walked in the Dreamtime. It is believed that those primordial beings live on as features in the land today. Here we must try to grasp that the Dreamtime does not refer to a period that happened 'once upon a time', it is happening all of the time; all sentient beings together dream the world into being. If you are reading this book, you are contributing your own dreaming right now. All people practising shamanism know that by changing the collective dream, we can change collective reality. Considering the mess we have collectively made of being earth keepers, this is a very important concept to return to our collective awareness. As the author, John Perkins says, 'the world is as you dream it!' This is a fundamental truth in shamanism.

Geoglyphs

A geoglyph is a large design or motif (generally longer than four metres) produced on the ground and typically formed by clastic rocks or similarly durable elements of the landscape, such as stones, stone fragments, live trees, gravel, or earth.
(Wikipedia)

Today we consider certain places in the world great mysteries: the Nazca Lines and Machu Picchu in Peru, Stonehenge in the UK, the great pyramids in Egypt. No written records have been preserved of how and why those monuments were created. Some of them seem to defy modern technology and they most

definitely challenge our scientific linear perception of reality.

Examples of world famous geoglyphs are the Nazca Lines in Peru, the Works of Old Men in Arabia, the Great Serpent Mound in Ohio and the stone labyrinths of Scandinavia. Also, think of figures cut into chalk here in the UK: the Uffington White Horse or Cerne Abbas Giant etc.

I mention them here in this book because these things, too, are sacred art. They are human-made creations that most likely served as places of worship and ceremony. Today, it is believed that the Nazca Lines in Peru were used for ceremonial walking (walking as part of a larger group in a deep meditative state of altered consciousness). We know that the stone labyrinths found on the coast in Scandinavia were walked by fisherman to trap 'evil spirits' and call in good winds for sailing. (For more about that I refer to the Pennick book listed under Notes.)

Some people believe that standing stones were used as a form of acupuncture for the Earth, in the same way that human beings benefit from acupuncture sessions. Geomancer, Marko Pogacnik creates cosmograms, glyphs he places on the Earth to restore balance and harmony.

The Ages of Gaia and collective karma

All civilisations impose (these) restrictions on living beings, and hold their life force in artificial containers.
(Charlotte Du Cann, 52 Flowers that Shook My World[2])

It seems to me that what we human beings call history is only one slice of a much larger cake, upon reflection of the Devereux quote at the very top of this chapter. There may well have been earlier civilizations that self-destructed without leaving a trace (and if so, we urgently need to learn a lesson from this). Though I cannot provide physical evidence of this, I certainly come across ancient memories of this held in people's souls and family

fields (speaking as a shamanic practitioner who often encounters blocks or imprints that originated in previous lifetimes in healing sessions). I also observe (again with clients and students both) that many people are on this planet today to help avoid wholesale destruction and create a wiser outcome that honours future generations as much as our ancestors and the past. Deep dreaming shows that they were here before, *as part of the problem.* Now they are here again *to be part of the solution.* Often they seem to arrive in groups to work out collective karma from a long time ago.

I am not asking you to believe me! I appreciate that these claims will sound way out. When I first started offering one-to-one shamanic healing sessions, I thought my work was going to be limited (mostly) to the classical methods of extractions and soul retrieval. However, this work very soon moved on to encompass a far wider range of issues. I was not expecting to see those. I had not received training in working with those issues. I often felt an edge of panic when that material came into the room (am I not hopelessly inadequate as the practitioner supposed to deal with this?). Over time, my trust in my own helping spirits deepened. I realised that they unfailingly send me the clients or students I most need to learn from. They guide me through this work and I can hand the larger picture over to them. The work that unfolded was so powerful and life changing that today I am training my own students in using the methods I received from spirit. This is, by means of some background, so people realise what my claims here are based on. My learning was accomplished by working closely with real-life breathing people on a committed healing journey! This work is the work of miracles. By stepping outside Time and Space, we are no longer governed by the rules thatinfluence time and space on Earth. When we change cosmic blueprints, a completely new reality manifests on Earth.

Stone circles, ship burials and passage graves

I have already mentioned Stonehenge but in this context, I also want to mention stone circles, passage graves and the skeppsättningar (ship burials) of Scandinavia. These are human-made creations meticulously placed in specific locations.

Geomancy teaches us how we can perform energy or shamanic work in such places. They are often places where powerful lines in the land cross. In addition, these features are in sacred alignments with the heavenly bodies and night sky.

When colleague Anna Kjellin and I visted Alestenar[5] near Ystad in Southern Sweden (sometimes referred to as The Stonehenge of Sweden), we all felt very strongly that the proposed explanations offered for this site were very masculine and academic. As a group of ten women and two men (with a well-developed sense of intuition), we all felt that Alestenar was used as a ceremonial site for initiations and rites of passage. The mandorla shapes of ships is also the shape of the vulva as the great doorway between worlds; an obvious place to experience symbolic death and rebirth.

Sacred alignments with the night sky and Milky Way

I am a night sky fanatic. Wherever possible I try to bring the night sky into courses I teach. I did powerful work with a group of colleagues at Chaco Canyon (New Mexico) in October 2016.[5] Describing this work could fill a whole book and I invite you to watch my presentation on YouTube! What I will say is that the night sky can connect us to the multi-dimensionality of human perception.

One major feature observed by most civilizations (excluding the Inuit who live on top of the world and see a slightly different night sky!) is the Milky Way. One interesting thing to do is Googling names for the Milky Way in different languages. You will soon see a direct link to the cosmology and mythology of different cultures. In some Northern European languages

(Finnish, Estonian, Lithuanian), it is called the Pathway of Birds. Indeed, scientists have proven that migratory birds flying at night use the Milky Way for navigation! In Central American, the Milky Way was viewed as the double-headed serpent Quetzalcoatl. In Middle Dutch (I am Dutch), an old name for the Milky Way was Vroneldenstraet (the street or highway of Frau Holle). For more about that please visit my Youtube channel and watch the 2017 art video titled 'The Wild Hunt of Frau Holle' and her Heimchen.

Quite a few cultures believe that when people die a mystical canoe (or spirit boat) takes them on the great celestial river that is the Milky Way to the Land of the Dead. Often this Land of the Dead is also the Cosmic Womb of the Great Goddess, meaning it is the place that the souls of babies comes from as well as the place where the souls of the dead return. (For more about this please Google Egyptian goddess Nut or the Mayan deity Quetzalcoatl.)

In the southern hemisphere, people see a number of star constellations that those in the northern hemisphere cannot see (and vice versa!). Australian Aboriginal people see a great emu in the sky, defined by dark spaces in the Milky Way. This emu appears in local mythology and petroglyphs as well. I have read articles about how the way this emu appears tells people when the time is right to harvest emu eggs on Earth.

The wondrous thing is that all of those correspondences and cosmologies work. We all see a slightly different night sky, depending on where we are and what our spiritual beliefs are. Yet, whatever we see has spirit; it enters into direct communication with us and guides us. Following that principle, even the western star constellations are not just patterns of stars in the sky incomprehensible distances apart. No, those patterns have both meaning and indwelling spirit.

It does not really matter if you work with the Great Emu or the Pathway of Birds, with the Great Bear and Little Bear or Odin's

wagon and The Lady's wagon. Whatever pattern or ancient story you work with, you will unlock profound meaning and deep cosmic teachings. The universe does not need to be nailed down and pigeonholed. Left all to itself, it will always present us with meaning, beauty and guidance.

This is not unlike saying that two human beings having sex is 'a sweaty noisy business with two bodies rubbing together'. As we well know, these humans may experience ecstasy, step through cosmic portals and see glimpses of Divinity. If it is a man and woman doing this to conceive a baby, then a brand new and sacred human being may just result from this coming together. Giving a purely biological or physiological description does not even begin to do the miracles of Life and Sacred Sex justice. The same thing holds true for star constellations and great cosmic mysteries.

Maybe our night sky was the first painting a Mysterious Creator Being made.

Activity #14 Make a Temporary Art Installation on the Land Uusing Only Material Found in Nature

I invite you to Google the work of artist Andy Goldsworthy at http://visualmelt.com/Andy-Goldsworthy and create a piece of art (or earth work) in nature inspired by his creations.

He is a British artist who works very closely with nature to create unique and personal artworks. There is never a lack of materials in nature: leaves, twigs, barks, ice, snow, stones, feathers etc. He uses those to create outdoor sculptures (or installations) that he then allows to disappear again (but he makes a point of taking high quality photographs to preserve the memory).

One of the great lessons of Mother Nature is indeed *impermanence*: nothing lasts forever, change is the way life lives itself. Death (as discussed elsewhere in this book) is our great (if severe) ally because it gives meaning and helps us focus on and

make the most of what his.

Make your own art installation. You could bring a friend if you like and make it a small group project. Work with the materials at hand. Experience that 'limitation' as a form of liberation: we do not need to carry paints or chisels into the woods (mountains, seaside etc.) to make art! Take photographs and allow Nature to run her course. Welcome and embrace the dissolution (deconstruction or dismemberment) of what you have created.

If you are city-bound and you have difficulties getting to an open green space, here is another idea. I was in Beijing in 2007. On Sunday mornings, people would gather in Beihai park and engage in various pursuits ranging from singing in small choirs to pavement art. A group of artists used plain water to write words and messages in Chinese characters, in beautiful calligraphy, on the pavement tiles. For obvious reasons the pavement dried and the writing faded within perhaps five minutes; this just provided a fresh canvas for new calligraphy. The ephemeral beauty of this process was mesmerizing!

There is nothing to stop you from filling a bucket with water and using a large brush to write messages (or draw art) in the streets. It does not count as graffiti (so it is street art but no one will perceive it as vandalism!) and it will certainly stop people in their tracks and bring you an instant audience.

Notes

1. *Revisioning the Earth: A Guide to Opening Channels between Mind and Nature,* by Paul Devereux, Simon and Schuster, 2007
2. *52 Flowers that Shook My World: A Radical Return to Earth* by Charlotte Du Cann, Two Ravens Press, 2012
3. *Pagan Magic of the Northern Tradition: Customs, Rites, and Ceremonies* by Nigel Pennick, Destiny Books, 2015
4. *The Songlines* by Bruce Chatwin, Vintage Classics, 1998

5. Alestenar: https://en.wikipedia.org/wiki/Ale%27s_Stones

6. Gods of Portals, Life Transitions and Liminal Spaces, Presentation at Threshold, annual conference of The Gatekeeper Trust, November 2016 https://www.youtube.com/watch?v=LzxmXAJiPLc&t=189s

Chapter 15

Daddy as a Pregnant Spider – The Art of Children

In the year 2006, I was working on a series of paintings about the Inuit Goddess and Keeper of Sea Animals, Sedna. One morning I came downstairs and caught all my three sons in the act of drawing pictures of Sedna too. 'Look Mum! We felt she might be a bit lonely living in her house on the bottom of the sea – so we decided to give her a family!' I admired the happy pictures of Sedna surrounded by three smiling children with fish tails ...

Walking home down the hill from the nursery my youngest son Brendan (aged 4) attends, my eldest son Quinn (8) says, 'I am pretending that Brendan is a famous artist. I have just bought a drawing from him Mum, for 3 pence. That is the price he named, haha, 3p!' (2008)

'Any child could have painted that ...'

There have been occasions in my life where people have tried to insult me and I have wrong-footed them by embracing their words as the ultimate compliment. Once example is when people have visited my Open Studio and said, 'My three year old could have painted that!'

Another example was when a fellow participant on a course in shamanism raged at me: 'You will never grow up, will you, Imelda? You will be a child forever! Just look at the clothing you are wearing, you are Pippi Longstocking!' Now, Pippi Långstrump (as she is called in Sweden, her land of origin where the stories play out) was one of my great childhood heroes. She is brave, she has magical powers and she takes on the world.

If my paintings show even a hint or modicum of seeing the

world through the eyes of a child, then I am painting from the right place within myself. If I possess even an ounce of the magical spirit and special powers of Pippi Longstocking, then I am a decent shamanic practitioner! And yes, I do like rainbow clothing and stripy tights. One great advantage of being self-employed is that I am not subject to the dress code of the corporate world!

> In his book *The Elements of Drawing* (1857), John Ruskin encouraged artists to try to recover what he called the 'innocence of the eye', to represent nature with the freshness and vitality of a child, or of a blind person suddenly restored to sight. 'A child sees everything in a state of newness,' reiterated Baudelaire in *The Painter of Modern Life* (1863), 'genius is nothing more nor less than childhood regained at will.' Subsequently, many artists tried to scramble academic convention by embarking on experimental regressions to an imagined childhood state of visual grace. Monet and Cézanne, for instance, sought to re-create the Damascus moment, conveying a structured idea in paint of the sensory explosion of first sight. In 1904, Cézanne told Émile Bernard: 'I would like to be a child.'
> (Tate website, *Through the Eyes Of A Child*[1])

Earlier in this book I described how (so-called) 'primitive' artists in the first decades of the twentieth century took a great interest in the paintings and drawings of young children. In florid condescending language they spoke of 'primitive art' (meaning the art of indigenous and tribal peoples) as a throwback to the 'childhood of man' (the offensive assumption being that tribal people operate on a level of functioning similar to children in the Western world). Children were hailed as 'home-grown noble savages' (Tate website). The fact that the twenty-first-century's collective awareness would never tolerate such language

gives me hope. Could it be some proof of collective human consciousness evolving?

Many of the great artists of the twentieth century personally collected children's art: Kandinsky, Matisse, Picasso, Klee, Miro and Dubuffet (several of them are discussed in Chapter 7). They actively studied these pictures very closely and took inspiration from the spontaneity, x-ray views, bright colours and happy distortions of 'reality'. It was felt that children's art, just like dreams, offers a 'royal road to the unconscious' (Tate). These artists were known to include work by children in their exhibitions. The 1919 Dada exhibition in Cologne displayed the scribbles of infants next to work by Max Ernst and colleagues.

It needs to be remembered here, that this was the same period where Sigmund Freud and Carl Jung were intrepidly exploring and mapping the realm of the human unconscious!

I am not the only artist by a long stretch of the imagination who has been told 'any child could do this!' It is just something a professor of Mathematics does not need to deal with! I already explained in my first book (*Natural Born Shamans*[2]) that the notion of childhood as a domain of innocence and freedom was only invented in the eighteenth century (stemming from the work of Rousseau and Locke). Before that period, children were viewed as *mini-adults.* The (so-called) innocence of children is an issue I address in that same book (Chapter 10, 'Spiritual Warriors with Water Pistols').

Having mapped the influence of children's art on adults, let's now have a closer look at how the art making process unfolds in children.

Daddy Is a Pregnant Spider!

Something I often hear from sacred art students is that their technical skills fall short of their imagination, meaning that they cannot quite create what they see in their mind's eye. My reply is that the 'opposite problem' exists too: art professionals who

are so skilled at drawing (or carving etc.) exactly what is in their mind's eye can end up 'killing the image'. By this I mean that it does not come alive. It does not dance and sing. Spirit does not move in because the image is too rigidly controlled from the waking/rational mind. There is no room for Spirit, for happy accidents, for a crack to open between the worlds. It is the very lack of sophistication and overkill of technical skill that makes the art of children so enchanting and striking.

Personally speaking, I adore the way that children often marry very unlikely concepts in their drawings (just the way shamanic artists do). My own eldest son once made a drawing titled 'Daddy Is a Pregnant Spider'. I was pregnant with our third son at that time and on a magical level he felt that if his Mum was pregnant, his Dad also had to be pregnant somehow. Spider Dad was stripy (because he often wears a pin-stripe suit to work). Spider Dad had a slightly scared or overwhelmed expression on his face. This represented quite accurately (I felt) a sense of overwhelm that he felt at a third pregnancy occurring in our house over a space of three years!

The art of children and child art

Children's Art, Child Art or the Art of Children refers to paintings, drawings and other artistic creations made by children. The term Child Art is sometimes used to refer to a genre where children are depicted in art made by adults, or to art made by adults for children (such as illustrations for picture books for young children).

Children did not always have access to art materials (the way Western children do today). There are many places in the world where children will use a stick to draw on the ground or make dolls from pieces of wood and rags.

The first European exhibition of drawings by children was organised by Robert Ablett in London, in the year 1890. The first person to appreciate children's art as 'untainted by adult

influence' was Franz Cizek. This appreciation was continued by several groups of early twentieth-century painters. In 1897, Cizek Opened the Juvenile Art Class, a weekend school for children, free of adult standards. This Class accepted students aged 2–14 years old, free of charge, with no selection. Cizek claimed that he was 'working as an artist, not as a teacher' and that he was actually learning on the job. I (think I) know exactly what he means because I feel this way about my shamanic group for children and teenagers (The Time Travellers![2]).

Developmental stages in child art

While I was at Art School in Amsterdam, I did a project on how child art passes through a number of developmental stages. It depended quite heavily on the work of Piaget (who worked within cognitive psychology). Jean Piaget[3] was a Swiss clinical psychologist. He established the discipline of genetic epistemology.

His theory of cognitive development explains how a child constructs a mental model of the world. He disagreed with the idea that intelligence was a fixed trait, and regarded cognitive development as a process that occurs due to biological maturation and interaction with the environment.

The following stages are currently commonly acknowledged in the art of children:

Scribbling
Around their first birthday, most children develop the fine motor skills to hold a crayon or thick pencil. They scratch back and forth a lot and then add circular motions (loops). They will happily go off page and decorate the kitchen table as well. (Time to buy an oil cloth!) Children especially adore drawing on surfaces not generally meant for drawing such as walls, their own bodies and their siblings. They don't stick to what artists consider art materials either. I remember my eldest son covering my middle

son in sudocrem, using it to sculpt his hair (like styling gel) and then getting out the scissors to achieve an even more pleasing shape (at that point I walked into the room!). My own father once stumbled across my middle brother on the carpet in the living room busily using 'modelling clay' that turned out to have been sourced from baby brother's nappy. Children display a refreshing (if smelly) disregard for limitations!

Around their second birthday, children start drawing shapes defined as 'more controlled scribbling': simple shapes, circles, start bursts, primitive trees and animals. At that point, they love naming their scribbles. It may still look like a scribble to you but they will proudly tell you this is grandma! On close inspection (with a lot of imagination) that circle does indeed resemble grandma's reading glasses ... somewhat!

Pre-symbolism
At about age three, children start combining circles and lines. This is the period where the famous 'head-footers' appear! They will draw people and animals consisting of a circle for a head with arms and legs extending directly from the head (no body). Animals and humans look pretty similar at this stage. You will not be able to tell if this is grandpa or the family dog without the child's help!

Symbolism
At this point children have acquired a vocabulary (or storehouse) of basic images. They have a way of drawing a tiger, or a person, or a car. Then they will do many drawings modifying those 'templates'. My youngest son was obsessed with tigers at this age. He arrived at many ways of differentiating them: thick stripes and thin stripes, large ones and baby ones, some wearing hats or outfits showing their 'profession' or what action they were engaged in. My eldest son's drawing of Daddy Is a Pregnant Spider originates from this phase.

You could say that the child develops a range of symbols (or visual shorthand) without being overly concerned with what things actually look like in reality. I remember asking my own children questions such as: do our arms grow from our head? And the answer being 'No, but that is how I choose to draw them!'

The next thing that happens is that children start drawing a landscape or context, rather than figures floating in space. They may draw people that have a relationship to each other (Mum and Dad *huge* and the family baby tiny, but all looking the same otherwise). They may draw houses or a tree. Perhaps a sun in the sky (often smiling) and grass at the very bottom of the page. Blue clouds are common (it is more difficult to draw white clouds against a blue sky on white paper because it means understanding negative space).

I remember my own children telling me elaborate stories at this point. I would often try to entice them to draw more pictures to illustrate the whole story line, including the ending. We would make the artwork into a book and use full colour photocopies to send those books out to the grandparents. I remember my middle son writing a book about A Lonely Star (who eventually became best friends with the ever-shining Sun). He would also write books inspired by words. His Swedish grandmother often exclaims 'oi oi oi' when life is tough. As we have three sons he wrote a book based on 'oi oi oi' rhyming with 'boy boy boy', illustrated with pictures of Farmor (Grandma) surrounded by three (head-footer) boys doing unspeakable things!

This magical stage eventually morphs into the beginnings of photographic realism. This coincides with children starting school, learning to read and write. (In the UK, this occurs the term before their firth birthday). At this point frustration kicks in. Children will tie themselves into technical twists and shout 'I can't do it!' They will struggle with a person being half hidden by a house or tree and not knowing how to draw that for example.

We have now arrived at the stage of

Realism

As children progress through primary school (UK) or elementary school (US) realism increasingly takes over. Everything they draw is judged by 'does it look exactly what it is meant to be?' This is the point where some children will demonstrate talent for drawing and put in hard but enjoyable work at achieving a better likeness or solving a perspective problem. (I remember being this age and someone showing me how to draw a horizon and two points to draw squarish objects, with different sides, in perspective.) Other children will now realise that their abilities do not match their aspirations and give up on drawing.

Comments from others (especially teachers) can play a strong (encouraging or devastating) role. As a teacher of sacred art people often tell me that it was around this age they either received compliments (they were told they had a talent for art and continued making art) or a parent or teacher told them to forget about the whole thing. Some people are marked for life by being ridiculed in class. When these people appear on my courses, I have to start all over again tenderly nurturing a different set of (supportive) beliefs:

I can draw or paint.

I can make beautiful things that do not need to follow the laws of (photographic) realism.

I can draw for my own sheer joy (not to please anyone else).

I can arrive at my own partnership with spirit and make sacred art without being 'a great artist' in the mainstream sense. My gift for imbuing images with spirit will more than compensate for lack of technical skills.

If acquiring technical skills is of importance to me (in terms of what I wish to create), I can join an evening class at absolutely any age and acquire such skills.

Art therapy[4]

Let us give art therapy another mention here. Art therapy can be used effectively with children because children can express in images what they cannot always say in words. It can also be used with children who are extremely young, non-verbal or challenged in other ways (for example, learning disabilities) meaning that psychotherapy (focused on talking) is not suitable. In such cases play therapy, music therapy or drama therapy can also be wonderful resources for healing. The range of therapies continues to extend. There are many therapies available today that did not exist when I was a child. Well worth a bit of research and asking around!

My closing comment for this chapter is that some art children make really *is art*. It can radiate spirit and luminosity the same way (sacred) art made by adults can.

Activity #15 Make Art with a Child (or Make Art from Your Inner Child)

I invite you to, if at all possible, make art together with a child. If you have access to a child (grandchild, godchild, child next door, children you teach etc.) set out an irresistible display of art materials and some chairs. (Younger children love glitter paints and fancy craft materials. The messier the better, as parents do not always want their living room to look like a play-dough bombsite!) Then invite a child into that space and start working together. Let this child (or children plural if you are lucky) take the lead! Let them make the suggestions. Let them boss you around. Where possible work from your Inner Child (for this purpose, meaning the part of you that has never grown up and can still access the fresh perception of the child you once were. We are all ex-children).

Later, reflect on what this exercise gave you: did you perhaps drop your attachment to perfection or photographic realism for a few hours? Did you suddenly realise that cats do have blue

tails with orange stripes on some occasions and that you are really a mermaid (or merman) in disguise?

Ask the child or children if you can keep and frame one of their creations for inspiration. Or stick it on your fridge with fridge magnets. Take this fresh perception into your own life. Try to hold on to this precious gift. Try to see everything (including the people around you) with fresh eyes.

I remember our childminder once saying to our own children that if a teacher really annoys you or frightens you, try to imagine them sitting on the toilet. It will help you see they are only human after all ...

Notes

1. You can find this article online, on the Tate website: http://www.tate.org.uk/context-comment/articles/through-eyes-child

2. Please see my first book: *Natural Born Shamans – A Spiritual Toolkit for Life: Using Shamanism Creatively with Young People of All Ages)*, Moon Books (JHP), 2016

3. For more information about Jean Piaget and his theory of cognitive development: https://en.wikipedia.org/wiki/Piaget%27s_theory_of_cognitive_development

4. *Art Therapy Theories: A Critical Introduction*, Routledge, 2015

Chapter 16

A Unified Theory of Sacred Art

Many a woman is burdened by paying out the dark side of a creative man: many a man is drained by carrying the dark side of a woman that is the by-product of her creativity. Worst of all, children often have to carry the dark side of creative parents. It is proverbial that the minister's child will be difficult and the wealthy man's child is in danger of leading a meaningless life ...
(Robert Johnson, *Owning Your Own Shadow*[1] (courtesy of Helena Partridge))

Often penetrating criticism, the life-blood of science and scholarship, is offered and taken as a vicious personal insult, a direct attack on one's moral character, as if being wrong were a crime rather than the inevitable consequence of working hard and learning by experience.
(John E. Pfeiffer, *The Creative Explosion*)

The critic

At Art School in Amsterdam, one of the subjects we studied was Art Theory. I remember the teacher taking us on field trips all over the city. We looked at architecture as well as visiting many of the wonderful museums Amsterdam offers. Around age 20, this was not my favourite subject. I much preferred setting up my easel and actually painting. (I also vividly remember all of us pouring our dirty turpentine down the sink at the end of every school day and I shudder to think of this now! Some of the shadows of creativity are long-lived and toxic indeed ...)

I had mixed feelings about this teacher. Not him as a person so much as the voices and viewpoints he represented. The 'dirty

secret' was that he could not actually paint or draw yet he spent many hours a week critiquing art and criticizing artists. He introduced us to some of the great voices in art theory. As time went on, and I started teaching courses in making sacred art, I felt a belated gratitude to this man. He introduced models for looking at art and interpreting art.

I have conducted tutorials with students who claimed that they liked making art in a vacuum, that the viewer played no role whatsoever in the process. By gently questioning them, they would eventually realise that art becomes meaningless when there is no viewer, no dialogue or no communication. It, kind of, goes back to the hypothetical tree in the forest falling. *If no one saw it fall, did it really fall? Does it exist?*

Even if you never show your work to anyone, you yourself bear witness to what you have created. The spirits too witness your creations. Unless you rigorously burn every single item you create, you will face the question of who becomes the guardian or your creations once you die. Who will go through your things? Who will decide what happens to your art – you or the person you find to execute your wishes? And are you willing to sell your work?

The psychology of perception

Ernst Gombrich wrote the book *The Story of Art*.[2] He was Austrian but arrived in England in 1936. At the time, Art History was primarily concerned with connoisseurship but Gombrich was more focused on the wider issues of cultural tradition and the relationship between art and science.

In Gombrich's view an artist compares what (s)he has drawn or painted with what (s)he is *trying to draw/paint* and uses a feedback loop to correct the artwork to look more like what (s)he is seeing. This process does not start from scratch because every artist inherits *schemata* that designate reality by force of convention. *(Think back for a moment to what I wrote*

about children acquiring a vocabulary of forms and symbols in the previous chapter.) These schemata and the techniques or works of previous masters are the starting point for any artist. Here they start their own journey, their own process of trial and error. Gombrich was influenced by Karl Popper's[3] philosophy of science (especially the growth of scientific knowledge). He felt that Popper's description of *conjecture and refutation* (read trial and error) applies to discoveries and narratives in the history of art. He felt that artists need to have a starting point, a standard of comparison, a process of making and reshaping ultimately leading to a finished image. Therefore an artist cannot start from scratch but (s)he can criticise his forerunners.

This is interesting because Gombrich has the artist turn critic. Artists of my own generation generally perceive the artist and critic as two different people. (Having said that, no person making art ever escapes criticising other people's art, even if only in their own minds!) It could also be stated today, that many lay people (*'non artists'*) have become the critics as often they can no longer follow the visions, theories or concepts that shape or inform modern art.

Then again, over time, in my own quest and teachings, the Critic has often morphed into other archetypes such as Clown or Divine Messenger. I opened the previous chapter with comments I received to the effect that 'any child could paint that' and 'you are Pippi Longstocking'. It could be said that there is *an uneasy but potentially fruitful relationship between Artist and Critic.* Especially so when any artist can own their Inner Critic (do their shadow work) and listen creatively, constructively (without feeling 'attacked' or undermined) to what the (external) critic says.

The shadow side of creativity: being as destructive as we are creative

In this book I have tried to describe and substantiate with quotes

and references to other authors that Sacred Art is uplifting and deeply inspiring in the final reckoning, but this is only achieved if the Descent or Journey into Darkness is embraced and made fearlessly (ideally with sacred witnessing and supportive participation from a community of kindred spirits).

We cannot speak of the Critic, the Descent and the need to do Fearless Shadow Work without also addressing the very shadow side of creativity itself! London-based participant Jane Moynihan often quoted the work of Robert Johnson in our classes. This led fellow participant Helena Partridge to his books, where she discovered a powerful passage about exactly this. Thank you Helena for the quote at the top of this chapter and for sharing your reflections with me and with all of us! Helena also introduced me to the PointZero Approach to Creativity[4]:

PointZero is both a practice of spontaneous expression in paint, and a whole approach to creativity and dissolving creative blocks. It is about the process not the product, and explores the freedom and mystery of what happens when we surrender judgement, desire for product and the control of our ego. It gave me my first experience of the sacred in painting, and also taught me that true creativity – that is creativity that comes from my intuition which lies in the spacious place below my conditioning – has a sacred function: to return us to our healed and holy wholeness.

In his book *Owning Your Shadow*, Johnson asks an extremely important question that is very relevant to this book: *how, then, can one produce something of beauty or goodness without doing an equal amount of wreckage?* He answers this question by saying it is through ritually acknowledging this other dimension of reality. The unconscious cannot tell the difference between a 'real' act and a symbolic act. (We teach the same thing in shamanism: the spirits do not make a distinction between a real even or a

ceremonial event, both are equally real to them, which offers great opportunities through ritual acts of healing and even prevention of accidents and disasters!)

This means that we can aspire to beauty and pay out the darkness in a symbolic way. Johnson gives the example of two Jungian analysts sharing a household: the person who had enjoyed some especially good fortune that week was the one who was expected to carry the rubbish out of the house ...

If our own shadow is triggered (by someone who overstays, offends us, pushes our patience to the very limit etc.), I can either do a five minute ceremony to greet and honour my shadow – or in my own case I could draw a pictures of my shadow and have a word with the image. However we approach this, *if we do not do it, those around us will suffer!*

> Does this mean that I have to be as destructive as I am creative, as dark as I am light? Yes, but I have some control over how or where I will pay the dark price. I can make a ceremony or ritual soon after doing some creative work and restore my balance in that way. This is best done privately and need not injure my environment nor anyone near me. I can write some blood-and-thunder low-grade short story (I won't have to look far for the characters since the other side of my seesaw has already been set into motion) or do some active imagination which will honour the dark side. These symbolic acts serve to balance my life, do no damage and injure no-one. Much religious ceremony is designed to keep the left-hand side of the balance functioning in a compensatory way. (Robert A. Johnson)

A similar thing occurs in the world of music. The French music critic Camille Mauclair describes the howls, stampings and cheers of an intoxicated audience to the growling of savage beasts before Orpheus. He says that this stage is an essential part

of returning to ordinary life after experiencing musical ecstasy. It also calls the performers back: they must acknowledge their music yet become human again.[8]

Gods, saints, cannibals and Holy Mass

Johnson goes on to describe the Roman Catholic Mass as a masterpiece of balancing our cultural life. He points out that it is full of the darkest things known to humanity: incest, betrayal, rejection, torture, death and worse. He says that offering a sanitized modern version of the Mass is a mistake because it loses so much of its effectiveness. *We ought to pale with terror at the Mass!*

'This is my blood you drink, this is my body you eat' – cannibalism? And I do not want to stray too far off topic but actually I have read up on cannibals and discovered that they have strong spiritual beliefs and justification for their act. The eating of a person often means absorbing their spiritual essence so that it is honoured and lives on.

I have been deeply engrossed in reading ancient grimoires recently, especially the *Book of St. Cyprian: The Sorcerer's Treasure* (a handsome and scholarly new edition by Jose Leitao).[5] I had a Roman Catholic upbringing. I cannot deny that the Saints are wired deeply in my psyche and ancestral field. So I have been conducting dialogues with St. Cyprian and one thing he said to me recently, and hit me very hard indeed, is that it is a grave illusion for me to think I can ever really walk away from my religious upbringing and the forces that shaped me. So if I am to embrace the Norse gods fully and really understanding their teachings (in the context of teaching this material to others) *I need to honour and revisit the saints of my childhood. I need to make my peace with them. I need to find the places in my own body where they live and left their mark on me.* OUCH! But also, *yes.* I can hear the truth in this.

For that reason any unified theory of sacred art will always

demand that we embrace and navigate the contradictions, the shadows, the very things we have walked away from.

Looking and seeing

> Archaeological records include many cases of art overlooked. The eye never comes innocent to its subject. Everything seen is a blend of what actually exists out there, the 'real' object, and the viewer's expectations, upbringing and current state of mind.
> (John Pfeiffer, *The Creative Explosion*[6])

A lifetime of making and studying art has taught me that there is a world of difference between looking and seeing. Assuming that we are not visually impaired, we like to think that we see what we look at. *In reality we see mostly what we think is there.* Our own mind plays tricks on us. (And I am pretty sure this phenomenon makes the life of detectives investigating crimes very difficult indeed!) Previous experiences, preferences, assumptions and expectations colour what we see.

Looking means casting your eye over something. Seeing means actually comprehending and fully absorbing the information your eyes relay. In shamanism, we go even one step further: what matters is *seeing with our eyes closed*, seeing with our Inner Eye or the 'X-Ray Eyes of the Shaman'.

Overlooking *what is there* is often as much of a problem as seeing *what is not there*.

Did you know that Edgar Degas painted some of his most influential and best-known works while nearly blind from macular degeneration? Quite possibly his work was so fresh and unique because he saw the world differently.[7]

Sacred art theory

At the moment, there is no unified Theory of Sacred Art. Most

people think (assuming they give the issue any thought) that sacred art is the same thing as religious art. I have already debunked that 'myth' earlier on in this book.

The material 'out there' is fragmented in the extreme. There are books about icon painting, about indigenous art, about arts and crafts, about drum making and so forth. There are also books about individual artists who open the door to spirit in their work. Here I am thinking of Frida Kahlo, Georgia O'Keeffe or Leonora Carrington *(to mention some vibrant female artists to balance the spiritual male artists already mentioned earlier)*. However, as far as I am aware, there is no twenty-first-century[t] version of Ernst Gombrich out there, writing The Story of Sacred Art.

Just as there are books about rock art, cave painting, sand painting, Tibetan mandalas, Hindu mythology, Inuit carvings and African Masks, up to now there was no book explaining that the universal key to understanding all of these art forms *may well be* gaining some practical experience of shamanism. Even a one-day introduction course will help greatly in understanding what many learned authors of such books are not quite grasping: concepts such as power objects, rites of passage and initiation, hunting magic, fertility magic and so forth. They tend to use these phrases without having any personal experience of such things. This means that their statements are, at best, dry and theoretical (their descriptions do not come alive, they don't make anyone's heart sing) or at worst, inaccurate and riddled with arrogant cultural assumptions about non-Western cultures.

I read a most wonderful stimulating book recently: *The Creative Explosion* by John E. Pfeiffer.[6] I thoroughly enjoyed it but then he spoilt things rather by, in one of the final chapters, concluding that *shamans were charlatans, leading people into caves, using light effects and sound effects, to demonstrate false power they obviously don't have.* It is obvious that Mr Pfeiffer never asked a true tribal shaman to take him on a tour of caves, in a lifetime of studying rock art. To me that is very sad. If you are going to study

something, any discipline, make every possible effort to check your own biases and question your own lenses of perception. Shamanism may not be your thing, and that is fair enough, but most likely it was a huge influence for the early peoples you are studying, permeating your whole field of study.

By means of this book, I hope to open the door on a greater understanding of sacred art (in its abundance of manifestations) as well as making sacred art a viable option in the larger landscape of contemporary art and spirituality. With an unapologetic insistence on including shadow work in making sacred art.

Dissolving divisions between disciplines

A key theme in my own personal journey has been the dissolving of established divisions and boundaries. My work is entirely spirit-led, meaning that even I do not-know exactly what I will be doing a year from now (other than teaching courses I have committed to teaching). I often follow guidance that comes in the moment (whispered in my ear as I speak or from a significant dream I had that night).

My own understanding of sacred art is forever evolving and widening. It can never be a static thing. A number of years ago I started making art videos because I wanted to bring narratives, movement and music into my work. Then things got to the point where I felt I needed, even, to create the music (as I am hardly a professional composer, *soundscapes* is a better expression) myself. I first did this the 'hard way' by actually composing (for lack of a better word) simple pieces of electronic music on LMMS. Then I discovered software such as Wavepad Sound Editor and Mixpad. At the moment, I am having fun creating a library of sound tracks. Wherever I find myself (this is one perk of teaching in very different locations). I always have one ear out for an unusual soundtrack which can be used in a small film. Recent examples of *sound gifts* include: deer barking in

the forest in Sweden, cranes calling to each other outside my window (Sweden again), wolves howling at a reserve I visited in New Jersey and fireworks in London on Guy Fawkes Night. Only yesterday, I was on a train home from central London with a three-year old-boy holding a cuddly fox wishing to tell a story. Obviously, Mr Fox said some things I absorbed very carefully. That is how it goes!

I have become attuned to sound now in the same way I have always been attuned to colours, shapes and patterns. I just wish I could incorporate smells in those art projects as well! (But I have not yet figured out how to!)

Teachers, gurus, monsters

In terms of teaching, I never fail to be moved and inspired by my students. Their work is so gutsy and beautiful. They truly are fearless explores of inner worlds, not unlike Carl Jung. Their artwork maps those worlds for others and invites them in on their own explorations. This is why I have invited them to write a part of the Foreword for this book – only those who felt called to do so. In the end, we called it The Forward as in mapping ways forward. Amazing synchronicities occur as work we do on the Inner Plane is unfailingly mirrored by events in the outside (everyday) world. This work truly weaves worlds seen and unseen together!

I witness how profound healing occurs. I see people singing home their own souls as well as their ancestors'. For them too, sacred art becomes a way of life, the walking in beauty. Students have created beautiful altars when family members died. They have composed their own songs without worrying about 'having perfect pitch or a decent singing voice'. They are forever expanding my own learning and challenging my own conceptions of things. I would not have it any other way.

Obviously the Teacher figure or archetype also has a pretty large shadow looming! Some people join my courses and bounce

straight out again, because I am 'too tough a teacher' or because I include academic-style tutorials in my art courses to provide cultural context.

Just recently, I have had the word 'guru' thrown at me one time too often. (I dread doing shadow work on that one!) So, I obediently trotted off again and had many fruitful dialogues with my Inner (self-appointed) Guru, who is indeed one nasty scary shadow of the self-employed teacher of sacred art and shamanism ... *Mea culpa* ... It never ends.

What I will say about this is *do not dehumanise your teachers* (if you are lucky enough to find a good enough one) by putting them on pedestals. They are really your peers and companions on the path and you will unfailingly (and unknowingly) teach them as much as they will ever teach you. You just need their expertise and experience for part of the journey. This will accelerate your own journey and make it safer. (The human psyche can be as dangerous and thrilling a place as the Red Light District in Amsterdam!)

Do not make icons of the people you admire or they will carry a lot of weight and shadow on your behalf. Do that shadow work yourself instead! Don't say they or *you*, if they are in front of you, are *amazing*. Say they are *skilled* or *resourceful* (meaning they inspire me to become more skilled or resourceful myself). I have been called 'amazing' too many times and unfailingly taken a nasty fall off the pedestal by writing one critical article, prioritising self-care over socializing, or doing just one thing that failed to please the person 'amazed by me'. Let's try to close that particular *dialectic swing* by owning our shadow and also taking back the luminosity (our own brilliance) that we project onto others until we are ready to own both. (This is called our Golden Shadow.) Only then can we meet in sacred space as peers and co-creators without psychic backpacks full of junk.

Human beings have made music since the earliest times.

Soviet archeologists digging at a site on a tributary of the Dnieper River northeast of Kiev unearthed a set of mammoth bones painted red, which they believe served as percussion instruments: hip bone xylophone, skull and shoulder blade drums, and jawbone castanets.

Flutes and fragments of flutes have been found in caves, about twenty in all, generally made of bird or cave bear bone with three to seven holes or stops, measuring up to about 8 inches long, and designed to be played by holding clarinet-style and blowing through one end.

(John C. Pfeiffer, *The Creative Explosion*[6])

As I said earlier, this year I have been composing some music for my own art videos (essentially to escape copyright problems). If I compose it, no one else can claim theft or ownership of it). Now, just writing this I already feel a jolt of anxiety at using the words *composing* and *music*. I feel an impulse to delete that and write 'make soundtracks' instead. The voice of my Inner Critic immediately shouted, 'Composing music, *who* do you think you are?' So, I will leave those words in and own them. I did compose a soundtrack for a short film about a bear (Wintersleep[8]) which was meant to convey the snoring of this dreaming bear and everything slowing down during the Arctic winter. And you know, I was quite pleased with the result. The soundtrack I did for the next one, The Poison Mother,[9] was not too bad either. Anyway, no one complained.

Activity #16 Audience with Our Inner Critic

No human being escapes trauma incurred from interactions with other human beings. If we are lucky the 'damage done' is mild and we have a strong healthy self that realises when we are being engulfed by old hurts, and we can side-step that or actively choose to heal that and rewrite the script.

If we are less lucky, those voices of the people who criticised

us and traumatized us, will become internalized to the point where we are barely aware of what is going on. We hear these voices decades later as self-talk, running a scathing commentary on everything we do.

We also need to acknowledge here that we all need the Inner Critic to at least some extent. Being able to step back and reflect, with a healthy criticism, on our own actions and creations, is an entirely welcome thing. (Have you ever met a person who has not mastered this sacred art? Gives rise to ugly situations, right?)

So today, I invite you to do a shamanic journey (or meditation) and request an audience with your Inner Critic, who may appear as a man, woman or take a different form. In this dialogue, thank the Inner Critic for the gift of self-reflection and being guided away from making a complete fool of yourself. Next, tell the Inner Critic in which areas of your life he/she is welcome to take a step back because you don't need their help any longer. You could even agree to a gesture or code word meaning 'back off!' When you make that gesture (for example, a small wave) he/she will give you space. Say thank you and goodbye.

When you return, attempt to draw a picture (or create something) that is completely beyond your ability range. The point of this exercise is about giving yourself permission, about failing without feeling like a failure and learning that many a masterpiece started with the creator being unsure of what they were embarking on! Artists or authors do not say to themselves let's start a master piece today ... Instead, they think, I have had a great idea and I will start painting or write one chapter today ...

Notes

1. *Owning Your Own Shadow: Understanding the Dark Side of the Psyche* by Robert Johnson, Harper One, 1993

2. *The Story of Art* by Ernst Gombrich, Phaidon Press Ltd, 16th edition, 2006

3. *Conjectures and Refutations: The Growth of Scientific Knowledge* by Karl Popper, Routledge, 1969

4. www.paintingyourpathway.co.uk, www.michelecassou.com
 I also invite you to check out Jane Moynihan's work: https://stoneandstar.weebly.com/

5. *The Book of St. Cyprian: The Sorcerer's Treasure* by Jose Leitao, Hadean Press 2014

6. *The Creative Explosion* by John E. Pfeiffer, Joanna Cotler Books, 1983

7. http://www.visionandartproject.org/authors-forum/looking-vs-seeing

8. Mauclair is quoted by Joscelyn Godwin in his online article: https://hermetic.com/godwin/musical-alchemy

Art Videos

8. Wintersleep, art video by Imelda Almqvist, https://www.youtube.com/watch?v=-0j_32U-Nes&t=384s

9. The Poison Mother, https://www.youtube.com/watch?v=YpEfiuthtYo&t=334s

Chapter 17

Global Sacred Art Network – The Community Aspect of Art

The sacred is the emotional force which connects the part
to the whole; the profane or secular is that which has been
broken off from, or has fallen from, its emotional bond to the
universe. Religare means 'to bind up' and the traditional task
of religion has been to bind up the pieces that have broken
away from ecstatic Oneness.
(William Irwin Thompson, *Beyond Religion*[1])

There is danger as well as safety in numbers. Often and
especially during crises we tend to act as loners, deeply self-
immersed, and the more of us living together, the greater the
trouble.
(John E. Pfeiffer, *The Creative Explosion*)

A rich collective tapestry of connections and nested layers of meaning

In this book, I have described my own process of weaving
connections between my need for solitude (as a deeply introverted
person) and my need for community and connection with others
(as a mother, teacher and active member of various groups and
communities). I certainly do not find it easy to navigate these
waters, these continents – to go on 'wild hunts' up and down my
own personal Milky Way, between the worlds, between Father
Sky and Mother Earth, between gods and humans.

I have been fortunate beyond belief in that a vast amount of
material I studied privately (following my bliss, when my very
young three children were tucked up in bed in the evenings)
turned out to have relevance, resonance and profound meaning

220

for others. What started life as a large collection of spirit-led paintings eventually also became a large collection of spirit-led teachings. Teaching the material then led to the making of art videos and a desire to merge many different forms of expression, to dissolve the boundaries between art forms. That is where my heart is today, in the rich and glorious autumn of the year 2017 and my heart brims with gratitude and child-like wonder. (Yes, Pippi Longstocking goes strong in me!)

It is in group work with other talented people that this material has come alive, so I (and others) have been able to (begin to) access multiple nested layers of meaning by means of working in the place where art meets shamanism, For that reason, I invite all readers of this book to find (or found) their own groups and sacred art and/or spiritual communities. I will repeat: *what matters is not the path you choose but your wholehearted commitment and surrender to the discipline and ordeals this path imposes.* Feel-good fluffy spirituality ('there are no limits, I can attract or create absolutely anything I like') fails sooner or later because it is an ego-led spirituality.

I have already taken (certain) steps to start a global network of artists dedicated to the sacred. There is a page to that effect on my personal website and I also run various groups on Facebook with different privacy settings. You will find a convenient listing for all of those options at the very back of this book!

Collaboration not competition

It has taken me years to shake off a vague irrational feeling that I was somehow in competition with other people. Early on, I chose a very unconventional direction within an unorthodox field (sacred art as a little-understood domain within contemporary art practice). I opted out of the world of mainstream art. I opted out of 'office life' as I much prefer working from home with my children running around me and inspiring me. I focused on motherhood almost exclusively for about eight years and gave

no thought to whatever 'career opportunities' I might be missing out on. Despite all of those choices (and I never regretted any of them) there was that vague niggling feeling that other people might just 'get in there first and perhaps take something that belongs to me'. It was only when I did my shamanic teacher training with Sandra Ingerman[2] in the US that I discovered how she is actively promoting models of professional cooperation and non-competition. I instantly felt at home! I started consciously promoting this new template with my own students and network with immediate effect and good results.

Extreme forms of competition (beyond a general focus on doing well and being a good sport about losing) are based on *poverty-consciousness*. The belief that if you have something beautiful or valuable, there is somehow less left for me. That was the unpleasant niggle that followed me until I finally released it from my life as *yet another limiting belief!* If we all choose to think that there is enough to go around and that there will be more good stuff if we actively help and support each other, then that is the new vibrant reality and norm we will all co-create. Why not start *right now?*

The shadow of community

Of course, communities have a shadow as much as individuals do and the larger communities get, the larger their shadows loom (see the Pfeiffer quote at the beginning of this chapter).

When we live or work in close proximity with others, the opportunities for conflict increase just as exponentially as the opportunities for learning and collaboration. Did you know that there is such a thing as 'the mathematics of conflict'?

I am the kind of person who needs a lot of space and solitude to be able to venture out into the world and lead large groups of people through professional trainings or mystery school experiences. In a way, it would suit me to be snail and always have my house with me so I can retreat at regular intervals!

Instead, I am a bear. I 'go cave' and seek creative forms of hibernation.

Having said that, many of my most profound experiences and soul lessons have occurred through working with other people. So I know not to go 'overboard' and become the Wild Woman of the Forest who is feared and only rarely sighted. She certainly lives within me but in order to learn and evolve we need to leave the comfort zone. That goes for me as much as for my students!

Visions and missions

My dreams for the future include sacred art taking its place alongside other forms of art in the twenty-first century. Making sacred art never died out but it lost popularity and visibility, especially in the late twentieth century.

Before I die, I hope to see shows of sacred art in mainstream museums and galleries. About one year ago, I attended an event at Tate Modern where I ended up tipping cheese straws all over a woman who turned out to be the Managing Director of Tate. I have certainly wasted an opportunity in getting in touch, reminding her of this incident and attempting a dialogue about the relationship of the Tate Galleries to sacred art! She may still hear from me ...

My dream is that the making of sacred art will be stripped of the 'slight coating of ridicule' or 'whiff of the outcast' so it once again becomes a viable option on the larger spectrum of artistic expression in the twenty-first century so it can be studied, practised and shown without apology. Fancy being 'allowed' to use the words holy, Divinity, grace, sacrament, miracle and pilgrimage again.

Painting with a large brush stroke

On an even larger (systemic or cultural) level I hope that the schism that opened up (Chapter 5) is now gradually closing as the divorce between mind, spirit and matter has brought

imbalances in all areas of life and *within ourselves* even.

If we can once again see those fields as connected and as an intricately interwoven tapestry, we can start enjoying those inter-connections, discovering the multiple layers of connection between all of those things.

My children often mirror what I am working on (even if I do not actively share that with them). Not infrequently, they will give me the missing piece or remind me to read up on something. Just yesterday, my eldest son flopped down as I was typing away and said, 'I need to talk to you about Nietzsche and the idea that God is dead!' This was (of course) as I was putting the final touches to the chapter about forgotten and neglected gods creeping in through the backdoor as diseases. The same evening my youngest son climbed into bed with me and said, 'How can we find words to describe ghosts to people who have never seen a ghost? We then need to ensure we also tell them what makes spirits different from ghosts.' And so it goes.

Activity #17 Vision and Organise a Community Art Project

Embark on an art project with a group of kindred spirits. This does not need to involve painting or drawing (necessarily). It could also involve performance arts, dancing or a Christmas panto. Allow everyone to have their say and to own their own part of the collective piece.

During my art therapy course, we were once set a group task where about 15 of us were drawing on a large roll of paper. This inevitably meant that we reached the 'social boundary' (meaning the place where our work met the work of others). Some people found it extremely upsetting when others entered (and scribbled across) what they considered 'their territory'. Personally, I loved this encounter on white paper. Where other people started drawing in the place where I had made the first marks, a great meeting occurred and fresh shapes arose from that encounter.

I think this was because I had a strong art practice of my own, away from this university, so I viewed this as a community project from which I could actively learn something. If someone broke into my studio and started drawing all over my personal paintings overnight, I would not be quite so happy! (Though I'd still be fascinated, I suspect.)

A related task I would set is this: actively embrace connecting and linking with others (either nearby or far off) and organise some small community projects. Such things are already taking social media by storm (at the time of writing there is a wave of posting 'black and white photographs of your life – no people and no pets' and I observe people getting very creative with that).

Facebook allows you to run groups (with various privacy settings) free of charge and this is an easy way for people in different locations to share and work together. From years of teaching, I know that many artistic types are not too keen on social media and that is fair enough. I do think that in today's 'global village' one needs to be aware that this means excluding oneself from many opportunities. Having said all that, Facebook groups can never replace real people (who have met in life) working together in real time and face-to-face. Every artist will need to find their own place on that spectrum and accept the pros and cons, or perhaps pick and mix.

Notes

1. *Beyond Religion: The Cultural Evolution of the Sense of the Sacred, from Shamanism to Religion to Post-religious Spirituality* by William Irwin Thompson, Lindisfarne Books, 2013

2. The personal website of Sandra Ingerman is www. sandraingerman.com and you will find a listing of practitioners and teachers trained by her on www. shamanicteachers.com. If this book has inspired you to undertake some training in shamanism this is a good place to start your search for a local teacher!

Chapter 18

The Greatest Piece of Art You Will Ever Make ...

Hail thee, gods and goddesses!
Hail thee, all-nourishing Earth!
Right speech grant us, and keen mind
To that, lifelong, healing hands
(*Edda*, 'The Song of Sigfrida', verse 2, c. early thirteenth century)

Whoever is in love with Music is in love with Death.

All one can be entirely certain of is Time, for there is change in this world. And yet there is something beyond it still: for occasionally a silence peeps through the music, and with that silence a glimpse of yet another order of being. When the music ceases, this Other is revealed. If the music was spaceless, this is timeless, too. When the music stops, time may, just possibly, stop for a moment, and then annihilation is complete: no individual, no music, nothing. The purpose of music is to lead us, time and again, to the threshold of this Void, in the hope that one day we will be strong enough to step across it. We practise through music during life in order that when we die we may catch that ever-open door, that needle's eye, and willingly leave behind all that we are to vanish through it.
(Joscelyn Godwin, 'Musical Alchemy: the Work of Composer and Listener for Hermetic Library[1])

Your Life's Work
The greatest piece of art you will ever make is your own life!
I wrote this book in the hope of challenging some deeply

ingrained beliefs and conventions in the Western culture I was born into. As goes for all of us, I was (and continue to be) shaped by the lives and decisions of personal and collective ancestors as well as political decisions and cultural periods. Living and working abroad (in various 'foreign' countries) for all of my adult life has taught me that I am a profoundly European person! Not just that, after three decades abroad I remain Dutch at heart. Being an authentic person in the world means standing up for my deepest beliefs and for perspectives and modalities at risk of extinction.

As a teacher of art and shamanism, it is my job to walk between many different worlds. I believe that my talents and gifts need to find expression in service to other people. I also believe that every person alive (however seriously challenged) has such gifts, divine in origin. That the world becomes impoverished for every person who does not turn his or her life into a piece of art, or dies a compromised death.

It is my dream that one day *the art of living itself* will once again be perceived as *a sacred art* in the West. That all art forms (in the widest possible sense) are valued, and not placed in hierarchies devised (largely) by privileged white men with a Western education. It is my dream that we will follow the example of Sandra Ingerman and fill our house and existence with prayers, songs and sacred art in its myriad of manifestations. *Frog is always singing the world into creation!* Creation is always happening in every moment – and we are all part of it!

As artists we are forever dancing that tightrope between the sublime and the subversive, between art and crime, between what stays out and what is in, between private inner world and collective outsider world. Did you know that graffiti already existed in ancient Egypt, ancient Greece and the Roman Empire? In our day (as then, one assumes) there is a very fine line between art and vandalism, a punishable crime!

It is my dream that everyone who feels a desire to make art

can release all limiting beliefs and engage in this life-enhancing process, finding the right form of artistic expression. Materials have never been cheaper, accessible and abundant and YouTube tutorials abound. I myself have enjoyed fabulous cello lessons courtesy of YouTube, how amazing is that? On the higher octave, YouTube (as well as many other sites) is a living testimonial to collective generosity. On the lower octave we find internet trolls (and I much prefer the Scandinavian trolls).

It is my sincere hope that we can welcome back the gods and goddesses and evolve in partnership with them so that the gods no longer needs to creep in at night, through the backdoor, as diseases, political tyrants and 'psychic burglars'. I also hope that we can start actively creating (perhaps conceiving is a better word) the gods and goddesses of the future! In about one hour's time I am doing a New Moon Call to Action with Michael Stone (producer of the Shamanism Global Summit on The Shift Network) on that very topic![3] I will talk about a powerful dream I had recently where young people showed me that we need to co-create the Gods and Goddesses of the Future.[4]

The active paths of art, healing and myth are, on the whole, so much kinder than the path of pain.

I have spoken at length about the benefits of marrying art to a committed spiritual path (resulting in sacred art). The spiritual path that called me and *chose me* (and it was really that way around) is shamanism. Have no illusion shamanism is pure dynamite! If people think that they can coat their existing life or profession with a sprinkling of shamanism, they had better think again. Practising shamanism means building spiritual muscle and embracing all the ordeals the spirits send us as the right medicine for our soul (if not our ego or comfortable everyday selves). There is *nothing comfortable* about this process of being torn to pieces and completely rewired, but our lives improve beyond comprehension when we commit to the process. Like birth, once it has started, the only way out is *right through*!

In order to do powerful spirit-led work, we hollow out. We become a hollow bone for Spirit. I am 50 years old at the time of writing this book and I feel that this process is happening on a very physical level indeed! As women age, their bones lose mass and density. This occurs especially after the menopause. Our human bones then become more like bird bones: hollow bones. I have no doubt that this aids our soul flight and shamanic work! I seem to recall that some anthropologists have written that the first shamans (in Siberia) were post-menopausal women. Mesolithic peoples carved flutes from swan bones for example, and my personal dream is to become one note in the Music of the Spheres as I die. One author who writes beautifully about this concept and process is Terence Tempest Williams in her book *When Women Were Birds.*[5]

I am well aware of the irony that I have written a book about sacred art that will sadly not contain pictures (because this will make the book too expensive to produce). Therefore, I invite you again to visit my website and look at sacred art. I also hope you will check out work by many other makers of sacred art and sacred objects following links I have provided. I hope that you will read some of the books I have recommended and pay close attention to your dreams and to the rich manifestations of your Shadow (we have introduced and named a few: the Inner Critic, the Inner Perpetrator, the dreaded inner Guru ...).

Often the spirits only whisper and we confuse their voices with the wind, but if we do not pay attention, they may well unleash a hurricane in our lives. They certainly did with me and with many of my students because we were slow responding – but we lived to tell the tale and it was a tale of rebirth and miracles.

The night following the day I wrote this chapter I woke up at 2 a.m. to a voice saying: 'The memories – they are the gods.' I had a vision of gods and goddesses sitting in a circle

around a pool that is the Void, the Cosmic Womb, the Great Unmanifest. (It looked like a giant inkwell.) They show me that they store the shapes in the process of returning to no shape, pure potential. They are the great cosmic archives of form that we human beings mirror back for them. They are configurations of the Knowing Field or Morphogenetic Field. They show me that 'dying' is a slipping back into that inkwell, that delicious darkness, that cosmic pool of black light, in order to be reborn as something else. That process is not supposed to be a struggle it is meant to be as natural as falling asleep and waking up again. So is the process of creating – our reality is the ink in the inkwell.

In preparation for bringing my sacred art programme to the US, I called a meeting with my spirit allies. They told me that we human beings get things upside down at times. They said that *Life is not in service to us, we are in service to Life!* That message hit me like a punch in the solar plexus. Our creativity does not belong to us alone! The real question is how do we harness our creativity so *that too* is in service to Life and all life forms?

Years of teaching have brought me the discovery that part of my own creativity is creating sacred supportive containers for the creativity of others to flourish and find fuller expression. Being facilitator and sacred witness both is an immense privilege!

Remember, your own life is the greatest piece of art you will ever make!

Miracles do not, in fact, break the laws of nature.
(C. S. Lewis)

Activity #18 Write the Story of Your Own Life as a Work of Art

Write the story of your life as a great piece of art. Flip negatives into positives and find the heroic, the uplifting, the beautiful.

However 'negative' (as you perceive it) the influences that shaped you, they still made you who you are today. As any writer knows that a story where nothing happens is a boring story, a non-starter.

Become the author of this unique book. Where circumstances allow, write a different script. There are many things we cannot change or edit out (deaths, accidents, serious illness, traumatic yet formative personal experiences), but we do remain responsible for our own response to those events and forces that shaped us. We also remain responsible for where we put our focus. (And living in a vibrational universe means that what we focus on will grow or attract more of the same.)

In shamanic healing work with people, I have sometimes been shown a book, the book of their life. I was shown that in the moment of Death we are presented with this book (for some it may be a film, story or slide show) and invited to read it again.

I cannot guarantee that I am right about the existence of such a book. However, I do believe that we live our lives better, with greater self-reflection and awareness, if we treat our own life as a book, or movie, or tapestry and make conscious choices about what we welcome in and what we edit out. Move beyond the view of life 'just happening to you' and take some control over what you want to happen. Follow your vision, be clear about your mission, savour every drop of human life while you have it.

And of course this 'book' (or film, or movie, piece of music, theatrical performance etc.) could be a picture book for children, an adventure story, an Aga saga or beach read, a collection of poems or even the next War and Peace. You are the author and editor both – you decide!

Notes

1. Joscelyn Godwin in his online article 'Musical Alchemy: the Work of Composer and Listener' https://www.patreon. com/hermeticlibrary?utm_content=thlpatreon&utm_

medium=website&utm_source=hermetic.com&utm_campaign=thl

2. Sandra Ingerman is the author of *Soul Retrieval* and *Medicine for the Earth* as well as many other books. Her websites are http://www.sandraingerman.com/ and http://www.shamanicteachers.com/

3. The dialogue can be downloaded from https://www.patreon.com/conversations

 Michael Stone's website is http://www.welloflight.com/

4. The Gods and Goddesses of the Future, blog by Imelda Almqvist, April 2017, https://imeldaalmqvist.wordpress.com/2017/04/07/the-gods-and-goddesses-of-the-future/

5. *When Woman Were Birds: Fifty-four Variations on Voice* by Terry Tempest Williams, Saint Martin's Press, 2013

Author Biography

Imelda Almqvist is an international teacher of shamanism and sacred art. Her book Natural Born Shamans – A Spiritual Toolkit for Life: Using Shamanism Creatively with Young People of All Ages was published by Moon Books in 2016 (ISBN 978-1-78535-368-0).

Imelda was a presenter on the Shamanism Global Summit with the Shift Network in 2016 and 2017 and she is a presenter on Year of Ceremony with Sounds True. She divides her time between the UK, Sweden and the US. This is her second book.

From the Author

Thank you for purchasing *Sacred Art a Hollow Bone for Spirit: Where Shamanism Meets Art.* I hope that you enjoyed reading this book as much as I enjoyed visioning and writing it! May I ask to you please take a moment to add your review of this book on your favourite online site. If you'd like to receive updates on courses and events, I invite you to subscribe to my newsletter. Please contact me through www.shaman-healer-painter.co.uk and I will add you to the relevant list!

You are also welcome to contact me about events, public speaking and teaching in different locations. I love adventures, meeting new people and learning new things! I have (limited) availability for online consultations and supervision sessions for shamanic and sacred art practitioners.

In Spirit – Imelda Almqvist

Website www.shaman-healer-painter.co.uk

Blog https://imeldaalmqvist.wordpress.com/

Youtube channel https://www.youtube.com/results?search_query=imelda+almqvist (YouTube channel: interviews, presentations and art videos)

Art videos

Oooo ... I got goosebumps when I watched this beautiful, mystic, magickal video! (Menglod and The Nine Maidens of Lyfjaberg). You put together a Masterpiece (Mistress-piece?). THANK YOU. Also watched the one on Frau Holle ... perfect for this precious season.

The more people who are able to see your videos the better! I feel they are for the whole Earth!

Peggy Andreas

2018

The Resurrection Bone, January 2018

https://www.youtube.com/watch?v=k-v_-YAGpHY&t=5s

2017

Swan Maiden's Song

https://www.youtube.com/watch?v=zIRn_ciIoAA

The Wild Hunt of Frau Holle and her Heimchen

https://www.youtube.com/watch?v=9pB5iiXMSrY&t=20s

The Poison Mother

https://www.youtube.com/watch?v=YpEfiuthtYo&t=3s

Wintersleep

https://www.youtube.com/watch?v=-0j_32U-Nes

The Woman and Her Snake

https://www.youtube.com/watch?v=ovzeI3ekZVU&t=36s

Menglöð and the Nine Maidens of Lyfjaberg

https://www.youtube.com/watch?v=2TaixdHbF-0

Bow Woman and Alder Man, https://www.youtube.com/watch
?v=4a1CSgsJV5k&t=6s

Mother Night, Reindeer Mother
https://www.youtube.com/watch?v=yY7AdwI-r5Y&t=463s

2016
My Inuit Ancestors, a Reflection on Spiritual Heritage
https://www.youtube.com/watch?v=vpeJiIufd6E&t=35s

Sedna, short film about the Inuit Sea Keeper and Global Warming
https://www.youtube.com/watch?v=pXspnn8Ere8&t=5s

Gods of Portals, Life Transitions and Liminal Spaces
https://www.youtube.com/watch?v=LzxmXAJiPLc&t=14s

2015
Gnosis of the Earth, Rock Art Seminar in Andalucia
https://www.youtube.com/watch?v=wz9n5SwcjsI
Seven Desert Maidens, https://www.youtube.com/watch?v=NlP
VEVdw5d0&t=7s
Seal Mother of Souls, https://www.youtube.com/watch?v=5t5
VP0Me24Q&t=14s
Fire Bird, https://www.youtube.com/watch?v=Nu1SohOQWo
I&t=1s
Raven Man and Killerwhale Woman, https://www.youtube.
com/watch?v=mf39UHN2-mU
Where the Forest Meets the Sea, https://www.youtube.com/
watch?v=NmwBdjJXa5g
**The White Land beneath the Bear, https://www.youtube.com/
watch?v=UZ37BzX1GPA&t=6s**

2014
Spirit Children https://www.youtube.com/watch?v=GpSLQL
HN2B4

Videos about young people and spirituality
The Forest Magic of a Natural Born Shaman, https://www.
youtube.com/watch?v=ousLzxLjflg&t=25s
Reversing Global Warming, Message from a Natural Born
Shaman
ttps://www.youtube.com/watch?v=fDNc4eM-ax0&t=13s
Psychopaths and Psychopomps
https://www.youtube.com/watch?v=g1EG8DJZ3os&t=3s
Time Travellers Interview with Ruby
https://www.youtube.com/watch?v=yNPJlTAEsO8&t=1s

Facebook Groups I host and moderate
Natural Born Shamans, https://www.facebook.com/search/
top/?q=natural%20born%20shamans
The Global Apology Project, https://www.facebook.com/
groups/1902301606465391/
Global Grid of Spiritual Practitioners for Young People
https://www.facebook.com/search/str/global+grid+of+sp
iritual+practitioners+for+young+people/keywords_search
Seidr and Edda Work in Sweden, SAP Rising at Pendle Hill,
USA 2017–2018
Norse Shamanism and Seidr Trainings in the US, https://www.
facebook.com/groups/105959476853726/?ref=br_rs

Archive of FREE online classes
The Lady of the Labyrinth, https://www.learnitlive.com/
class/10002/THE-LADY-OF-THE-LABYRINTH
The Leavings of the Wolf, https://www.learnitlive.com/
class/10003/THE-LEAVINGS-OF-THE-WOLF
The Heart of the Creative Process, https://www.learnitlive.com/

class/9334/The-Heart-of-the-Creative-Process

The Cosmic Dance of Sacred Feminine and Sacred Masculine
https://www.learnitlive.com/class/9335/The-Cosmic-Dance-of-Sacred-Feminine-and-Masculine

The Tree of Life, https://www.learnitlive.com/class/10597/THE-TREE-OF-LIFE

Natural Born Shamans, https://www.learnitlive.com/class/8833/NATURAL-BORN-SHAMANS-THE-FOLLOW-ON-CLASS

Where Art Meets Shamanism, https://www.learnitlive.com/class/6862/WHERE-ART-MEETS-SHAMAMISM-SACRED-ART

Ancestral Healing Work Introduced, https://www.learnitlive.com/class/8132/ANCESTRAL-HEALING-WORK-INTRODUCED

Shamanic Dreaming for SAP Rising! USA
https://www.learnitlive.com/class/8834/THE-DREAMING-for-SAP-Rising-USA

Collective Dreaming for SAP Rising! USA 2, https://www.learnitlive.com/class/8835/DREAMING-for-SAP-Rising-USA-2

Online Classes for Teenage Girls

Daring Dreamers, https://www.learnitlive.com/class/9113/DARING-DREAMERS

Daring Dreamers Class 2, https://www.learnitlive.com/class/9293/DARING-DREAMERS-CLASS-2

Daring Dreamers Class 3, https://www.learnitlive.com/class/9620/DARING-DREAMERS-CLASS-3

Daring Dreamers Full Moon Ceremony, https://www.learnitlive.com/class/10005/DARING-DREAMERS-FULL-MOON-CEREMONY

Selection of articles and blogs

Shamanism and Sensitivity, The Empath Magazine, spring

edition 2017

https://issuu.com/theempathmagazine/docs/the_empath_
magazine_-_issue_1

Toxic People – Toxic Concept, The Empath Magazine, summer
edition 2017

https://issuu.com/theempathmagazine/docs/the_empath_
magazine_-_issue_2

The Voices and Visions of Young People for Personal and
Planetary Healing, Pagan Pages, July 2017

I Love Me Too, Pagan Pages, June 2017, http://paganpages.org/
content/2017/07/i-love-me-too/

A Spiritual Toolkit for the Exam Period, Pagan Pages, May 2017
http://paganpages.org/content/2017/05/a-spiritual-toolkit-for-
the-exam-period/

ECO NOT EGO, Pagan Pages, June 2017
http://paganpages.org/content/2017/05/eco-not-ego/

Shamhat and the Shaman, Patheos Pagan, 25 August 2016
http://www.patheos.com/blogs/throughthegrapevine/2016/08/
shamhat-the-shaman/

Suicide: Answering the Call for Symbolic Death and Rebirth,
New Spirit Journal, May 2016

https://www.newspiritjournalonline.com/suicide-answering-
the-call-for-symbolic-death-and-rebirth/

Lynx Potion: Magic Is Our Birthright, Mystic Living Today,
September 2016

http://mysticlivingtoday.com/view_page.php?ID=1684

Children & Sweden's Witch Trials, Patheos Pagan, December
2016

http://www.patheos.com/blogs/throughthegrapevine
/2016/12/912/

A Special Sense for Worlds Seen and Unseen, article for new
magazine The Empath, 17 March 2017

https://issuu.com/theempathmagazine/docs/the_empath_
magazine_-_issue_1

Selected Blogs

THE GERMANWINGS PLANE CRASH: *A Shamanic Perspective,* 28 May 2015

https://imeldaalmqvist.wordpress.com/2015/03/28/the-germanwings-plane-crash-a-shamanic-perspective/

FLIGHT MH17: A Shamanic Perspective, 19 July 2014

https://imeldaalmqvist.wordpress.com/2014/07/19/flight-mh-17-a-shamanic-perspective/

THE SHAMAN DETECTIVE, 4 February 2015

https://imeldaalmqvist.wordpress.com/2015/02/04/the-shaman-detective/

NOT CURSING OURSELVES: A Blog about Spiritual Hygiene, 2 February 2015

https://imeldaalmqvist.wordpress.com/2015/02/02/not-cursing-ourselves-a-blog-about-spiritual-hygiene/

NOT ENOUGH - Ancestral "Debt" and Ancestral "Credit", 28 September 2014

https://imeldaalmqvist.wordpress.com/2014/09/28/not-enough-ancestral-debt-and-ancestral-credit/

THE WEIGHING OF THE HEART CEREMONY, 15 September 2014

https://imeldaalmqvist.wordpress.com/2014/09/15/the-weighing-of-the-heart-ceremony/

THE OEDIPUS COMPLEX REFRAMED, 2 May 2015

https://imeldaalmqvist.wordpress.com/2015/05/02/the-oedipus-complex-reframed/

MOON BOOKS

PAGANISM & SHAMANISM

What is Paganism? A religion, a spirituality, an alternative belief system, nature worship? You can find support for all these definitions (and many more) in dictionaries, encyclopaedias, and text books of religion, but subscribe to any one and the truth will evade you. Above all Paganism is a creative pursuit, an encounter with reality, an exploration of meaning and an expression of the soul. Druids, Heathens, Wiccans and others, all contribute their insights and literary riches to the Pagan tradition. Moon Books invites you to begin or to deepen your own encounter, right here, right now.

If you have enjoyed this book, why not tell other readers by posting a review on your preferred book site.

Recent bestsellers from Moon Books are:

Journey to the Dark Goddess
How to Return to Your Soul
Jane Meredith
Discover the powerful secrets of the Dark Goddess and
transform your depression, grief and pain into healing
and integration.
Paperback: 978-1-84694-677-6 ebook: 978-1-78099-223-5

Shamanic Reiki
Expanded Ways of Working with Universal Life Force Energy
Llyn Roberts, Robert Levy
Shamanism and Reiki are each powerful ways of healing; together,
their power multiplies. *Shamanic Reiki* introduces techniques to
help healers and Reiki practitioners tap ancient healing wisdom.
Paperback: 978-1-84694-037-8 ebook: 978-1-84694-650-9

Pagan Portals – The Awen Alone
Walking the Path of the Solitary Druid
Joanna van der Hoeven
An introductory guide for the solitary Druid, *The Awen Alone* will
accompany you as you explore, and seek out your own place
within the natural world.
Paperback: 978-1-78279-547-6 ebook: 978-1-78279-546-9

A Kitchen Witch's World of Magical Herbs & Plants
Rachel Patterson
A journey into the magical world of herbs and plants, filled with
magical uses, folklore, history and practical magic. By popular
writer, blogger and kitchen witch, Tansy Firedragon.
Paperback: 978-1-78279-621-3 ebook: 978-1-78279-620-6

Medicine for the Soul
The Complete Book of Shamanic Healing
Ross Heaven
All you will ever need to know about shamanic healing and how to
become your own shaman…
Paperback: 978-1-78099-419-2 ebook: 978-1-78099-420-8

Shaman Pathways – The Druid Shaman
Exploring the Celtic Otherworld
Danu Forest
A practical guide to Celtic shamanism with exercises and
techniques as well as traditional lore for exploring the Celtic
Otherworld.
Paperback: 978-1-78099-615-8 ebook: 978-1-78099-616-5

Traditional Witchcraft for the Woods and Forests
A Witch's Guide to the Woodland with Guided Meditations and
Pathworking
Mélusine Draco
A Witch's guide to walking alone in the woods, with guided
meditations and pathworking.
Paperback: 978-1-84694-803-9 ebook: 978-1-84694-804-6

Wild Earth, Wild Soul
A Manual for an Ecstatic Culture
Bill Pfeiffer
Imagine a nature-based culture so alive and so connected,
spreading like wildfire. This book is the first flame…
Paperback: 978-1-78099-187-0 ebook: 978-1-78099-188-7

Naming the Goddess
Trevor Greenfield
Naming the Goddess is written by over eighty adherents and
scholars of Goddess and Goddess Spirituality.
Paperback: 978-1-78279-476-9 ebook: 978-1-78279-475-2

Shapeshifting into Higher Consciousness
Heal and Transform Yourself and Our World with Ancient
Shamanic and Modern Methods
Llyn Roberts
Ancient and modern methods that you can use every day to
transform yourself and make a positive difference in the world.
Paperback: 978-1-84694-843-5 ebook: 978-1-84694-844-2

Readers of ebooks can buy or view any of these bestsellers by
clicking on the live link in the title. Most titles are published in
paperback and as an ebook. Paperbacks are available in traditional
bookshops. Both print and ebook formats are available online.

Find more titles and sign up to our readers' newsletter at
http://www.johnhuntpublishing.com/paganism
Follow us on Facebook at https://www.facebook.com/MoonBooks
and Twitter at https://twitter.com/MoonBooksJHP